GIACOMETTI
PURE PRESENCE

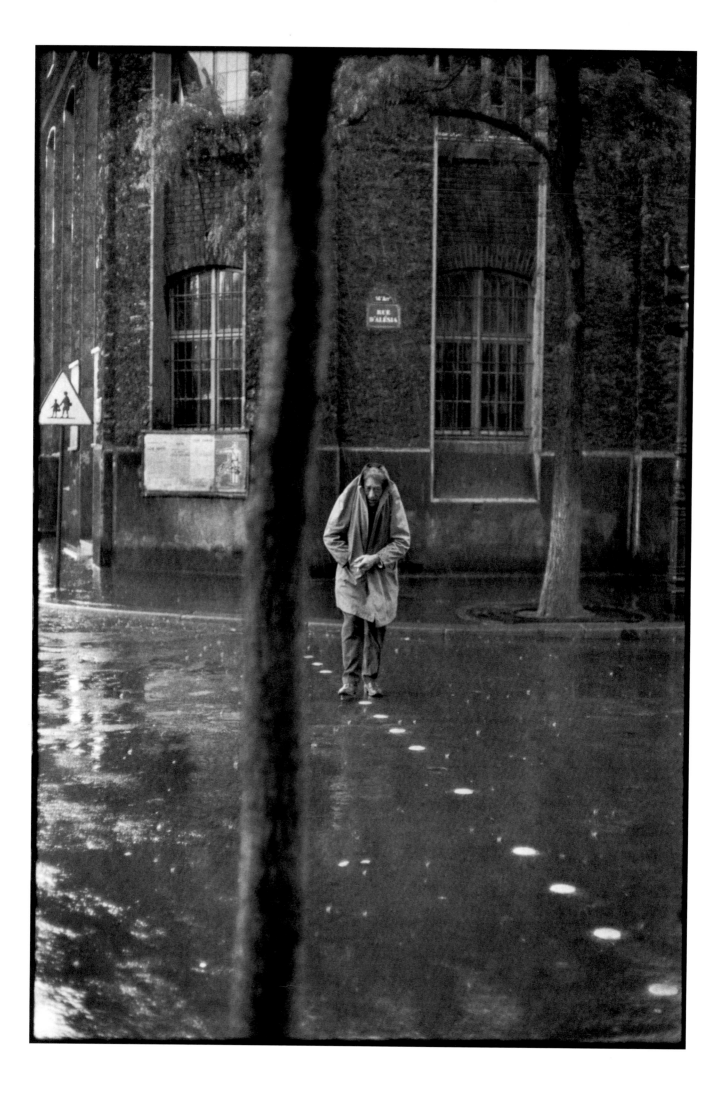

GIACOMETTI
PURE PRESENCE

PAUL MOORHOUSE

National Portrait Gallery, London

Frontispiece
Alberto Giacometti on rue d'Alésia,
Paris, photographed by Henri
Cartier-Bresson, 1961.

Published in Great Britain by
National Portrait Gallery Publications
St Martin's Place, London WC2H 0HE

Published to accompany the exhibition
Giacometti: Pure Presence at the
National Portrait Gallery, London,
from 15 October 2015 to 10 January 2016.

This exhibition has been made possible by the
provision of insurance through the Government
Indemnity Scheme. The National Portrait Gallery,
London, would like to thank HM Government
for providing Government Indemnity and the
Department for Culture, Media and Sport and
Arts Council England for arranging the indemnity.

Supported by the Giacometti: Pure Presence
Exhibition Supporters Group

For a complete catalogue of current publications,
please write to the National Portrait Gallery at the
address above, or visit our website at www.npg.org/
publications

ISBN 978 1 85514 532 0

A catalogue record for this book is available from
the British Library.

10 9 8 7 6 5 4 3 2 1

Printed in Italy

Managing Editor: Christopher Tinker
Editor: Andrew Roff
Copy-editor: Patricia Burgess
Picture research: Kathleen Bloomfield
Production Manager: Ruth Müller-Wirth
Designer: Peter Dawson, www.gradedesign.com

Every purchase supports the
National Portrait Gallery, London

Sponsored by

Bank of America
Merrill Lynch

With support from

swiss arts council
prohelvetia

The Henry Moore
Foundation

Front cover: Bust of Annette, 1954 (cat. 32)
Back cover: Woman of Venice VIII, 1956 (cat. 29)
Page 50: Ottilia, c.1920 (detail, cat. 2)
Page 66: The Artist's Father, (Flat and Engraved),
1927 (detail, cat. 17)
Page 92: The Artist's Mother, 1950 (detail, cat. 27)
Page 106: Portrait of Annette, 1954 (detail, cat. 31)
Page 124: Man Seated on the Divan while Reading the
Newspaper, 1952–3 (detail, cat. 42)
Page 144: David Sainsbury, 1955 (detail, cat. 53)
Page 162: Caroline, 1965 (detail, cat. 61)
Page 176: Diego Seated, 1964–5 (detail, cat. 65)

CONTENTS

DIRECTOR'S FOREWORD

'It's impossible to paint a portrait.' So Alberto Giacometti stated unequivocally to the young writer James Lord while the latter spent eighteen days sitting for the artist in 1964. If Giacometti truly thought portraiture impossible, then this exhibition – the first devoted to his work in this genre – reveals how often and how profoundly he wrestled with it during a career that spanned five decades and encompassed painting, sculpture and drawing.

This vivid depiction of an important aspect of Giacometti's life and work has been created by Paul Moorhouse, Curator of Twentieth-Century Portraits, who has researched and selected this exhibition with his characteristic skill and flair. I am very grateful to him and to all our colleagues who have worked so hard to bring the exhibition and this publication to fruition, particularly Pim Baxter, Rosie Broadley, Nick Budden, Robert Carr-Archer, Naomi Conway, Tarnya Cooper, Joanna Down, Andrea Easey, Neil Evans, Clare Freestone, Ian Gardner, Michelle Greaves, Susie Holden, Justine McLisky, Ruth Müller-Wirth, Sandy Nairne, Andrew Roff, Nicola Saunders, Jude Simmons, Fiona Smith, Liz Smith, Christopher Tinker, Sarah Tinsley, Ulrike Wachsmann, Helen Whiteoak, Rosie Wilson and Lucy Wood.

Nor could we have mounted this ambitious exhibition without the help of many collaborators and supporters, including museums and private collections from around the world who have loaned important works. In particular, I would like to thank Christian Klemm, Conservator at the Alberto Giacometti Foundation in Zürich; Catherine Grenier, Director of the Alberto and Annette Giacometti Foundation in Paris, and her predecessor Véronique Wiesinger, as well as Alexandre Colliex and Stéphanie Barbé-Sicouri for making key loans possible; Thomas Gibson at Thomas Gibson Fine Art Ltd; Christoph Becker, Director of the Kunsthaus, Zürich, and his colleagues Philippe Büttner, Collection Curator, and Claire Hoffmann, Research Assistant; Calvin Winner, Sainsbury Centre for Visual Arts; Pieter Coray; Alex Corcoran, Lefevre Fine Art; Simon Stock, Senior International Specialist, Sotheby's; Paul Williams and André Baugh.

I also want to offer our gratitude to our exhibition sponsor, Bank of America Merrill Lynch, whom we welcome back after our very successful partnerships with them for the exhibitions *Irving Penn Portraits* in 2010 and *Lucian Freud Portraits* in 2012, and in particular to Simon Mackenzie Smith, Chairman of UK and Ireland Corporate and Investment Banking, and Andrea Sullivan, Head of Corporate Social Responsibility. I would also like to express our thanks to the exhibition's supporters, Pro Helvetia and The Henry Moore Foundation as well as the *Giacometti: Pure Presence* Exhibition Supporters Group.

To all of these people, for making our appreciation of Giacometti's portraits possible, my sincere thanks.

Nicholas Cullinan
Director, National Portrait Gallery, London

SPONSOR'S FOREWORD

Bank of America Merrill Lynch is delighted to sponsor *Giacometti: Pure Presence* at the National Portrait Gallery in London. Our long-standing partnership with this world-renowned institution has already included our collaboration on *Irving Penn Portraits* and *Lucian Freud Portraits*, and now continues with this innovative exhibition, the first to focus on Giacometti's engagement with the human figure.

The arts are crucial to the success of thriving economies and creative societies, and public-private partnerships are vital to maintaining their vibrancy. With that in mind, our programme of support is therefore diverse and global: partnering with not-for-profit arts organisations through loans from our collection, providing grants for arts education and outreach initiatives, and helping to preserve cultural treasures worldwide through our unique Art Conservation Project.

We trust that you will enjoy *Giacometti: Pure Presence*.

Alex Wilmot-Sitwell
President, Europe, Middle East & Africa
Bank of America Merrill Lynch

CURATOR'S FOREWORD

Alberto Giacometti is rightly regarded as one of the most important and distinctive artists of the twentieth century. Like Pablo Picasso, that other giant of modernism, Giacometti's art spans painting, sculpture, drawing and printmaking. And, in common with the older artist, he created works of art that are immediately recognisable, the unmistakable manifestations of a unique artistic vision. But, again like Picasso, Giacometti was a restless innovator. Eschewing a single line of development, his oeuvre spans a range of different styles and ways of working, some apparently contradictory. With both artists, it is the singularity and the diversity of their respective achievements that underpins the accolade of greatness. There, however, the similarity ends. Whereas the extraordinary breadth and richness of Picasso's achievement are well known and celebrated, certain important aspects of Giacometti's art remain relatively unexplored and underestimated. Such considerations were responsible for the genesis of the present exhibition, which focuses on Giacometti's portraits.

Perhaps sensing the emergence of another unique artistic identity, Picasso was among the first to attend the opening of Giacometti's first one-man exhibition in Paris in 1932. At that time, Giacometti was linked with the Surrealist group, then the focus of avant-garde activity in the city. His fantastic, violent and perplexing sculptures were the outcome of a period when he had felt it necessary to 'abandon the real'. Those works, some of which were placed directly on the floor, announced a compelling, if disturbing, imagination. But within two years, Giacometti would break with Surrealism's founder André Breton and his followers. Too individualistic to be constrained for long, the work he made from 1935 until the outbreak of war seemed to proceed in the opposite direction. His pre-war activity was rooted in observed reality and subjected a limited number of sitters to relentless scrutiny. Working from life, his aim was to copy the appearance of the human head, only to discover that this task seemed impossible: '… the more I looked at the model, the more the screen between reality and myself thickened'.

Giacometti spent part of the Second World War in Geneva. During his exile, he made tiny sculptures of the human figure. Those works are said to have been brought to Paris in matchboxes. They were the basis for the tall, thin and impossibly elongated figures that ensued. As the progeny of an anxious age, a period when man questioned his place and purpose within an absurd, apparently meaningless world, they have been taken to define that wider historical and philosophical context. Those remarkable sculptures seem enveloped by the space that surrounds them, almost to make tangible the void that they inhabit. No other artist had tested the boundaries of the visible in this way. For that reason, such sculptures are among the most celebrated images of the post-war period. They are a central presence within the numerous exhibitions devoted to Giacometti since his death in 1966, inescapably identified with his stature, and presented as fundamental to our understanding of his work.

Giacometti drawing in his studio photographed by Sabine Weiss, July 1954.

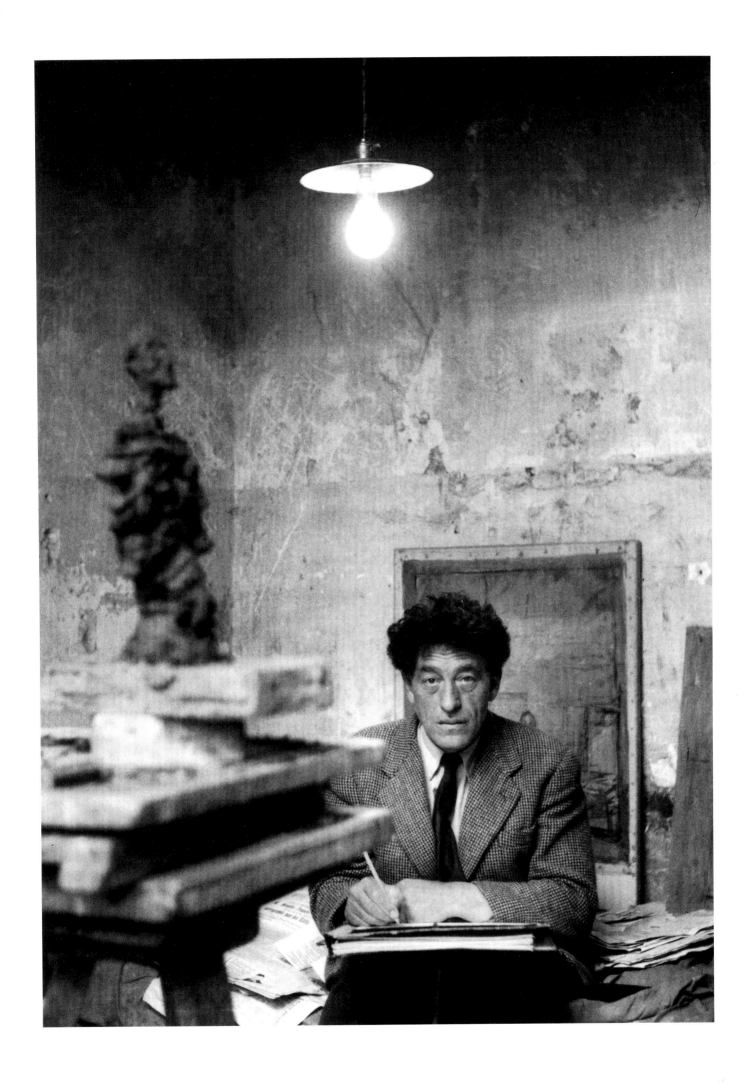

While acknowledging the importance accorded to those familiar aspects of Giacometti's art, this exhibition ploughs a different furrow. A single figure sculpture dating from 1956 is included as an exemplar of that wider, well-known aspect of his work. But in other respects it deliberately avoids the well-trodden path that leads from Giacometti's Surrealist sculpture to the 'existentialist' evocations of an anonymous human form. Instead, taking an overview from 1914 to the work preceding his death in 1966, it focuses on Giacometti's unbroken involvement with portraiture, and it specifically explores his close relationships with particular sitters. In tracing a continuous line of development in portraiture, it inevitably and unapologetically contradicts Giacometti's own claim to have abandoned working from observation in 1925 and to have resumed that approach only ten years later. It explores the parallel, portrait-based trajectory that was sustained during his regular visits to Switzerland and that coexisted with his Paris-based experiments of the 1920s and early 1930s. In so doing, it intimates the dual nature of Giacometti's art during the pre-war period. While previous exhibitions have justly demonstrated the avant-garde and imaginative nature of his early work in Paris, the present survey shifts the focus to his concurrent commitment throughout that period to portraiture and observation. As a whole, it affirms the central position that working from life occupied throughout Giacometti's development.

Indeed, the preoccupation with 'copying' stands at the centre of Giacometti's art. Despite the abstract and Surrealist work that engaged him for lengthy periods, the principle of representing the appearance of the external world was a persistent obsession. To that end his visual experience – the 'sensation' he had of reality – was his raw material. Nor was this simply an aesthetic matter. Giacometti was at pains to point out that truth, not beauty, was his aim. Copying was vital 'in order to begin to realise what we are seeing'. The experience of seeing was identified with an ongoing attempt 'to understand the world'. He was, however, profoundly aware that 'All that remains of reality is an appearance'. Looking was a vital means of interrogating appearance, a constant questioning of what is seen, and an endless endeavour to penetrate to the reality that he sensed behind the apparent. By connecting with the world visually and testing his responses, he came to a deeper understanding of his existence.

Viewed in this way, it is possible to grasp the unusual significance that Giacometti attached to portraiture, and to his relationships with his models. In confronting a sitter in the confined space of his studio, he was in direct contact not only with the appearance of the external world, but also with its most vital manifestation – another human being. As Giacometti discovered around the age of nineteen, that relationship was highly charged. The model's appearance was animated. Depending on his physical proximity, his visual sensations changed constantly and proliferated. Questions of size, relative distance and the connections between different elements became progressively unfathomable. Conventionally, artists cope with these difficulties by resorting to what is known about the subject. They draw upon previous experiences, which are amalgamated into a realistic image. Giacometti recoiled from that conceptualising process. To an extent that few other artists have manifested in their work, Giacometti's depiction of a model is essentially connected with the internal process of seeing that person. His portraits thus stop short of evoking his sitters' psychology, character or what is known about them. Rather, they are an intense record of numerous attempts to give objective reality to that which is forever appearing and disappearing: his subjective sensations of a living presence.

Portraiture for Giacometti was therefore a means of engaging with what he described as the 'core of life'. The process of representation drew him closer to reality, and the bridge was, in effect, the sitter. Given the formidable complexities of that transaction, Giacometti's approach to portraiture was exacting. He recognised that his impressions

constantly changed, each calling for a fresh response. Consequently, the modelling sessions tended to be protracted and characterised by constant revision. By his own admission, he thought nothing of beginning each session by completely undoing his previous work. As a result, the process of creating a portrait could go on indefinitely before reaching a provisional conclusion. When repeated sittings for the portrait of his biographer James Lord finally ended, he regretted that time had run out, claiming 'we could have gone on'. The reality was that, for Giacometti, the process of making a portrait never really reached a terminus. Life unfolded continuously, revealed in the pageant of endless change. As a representation of life, and of the process of recording it, a portrait could never be something fixed or definitive. It is this that accounts for the apparently unfinished nature of Giacometti's portraits, a characteristic that deepened with time.

Responding to the difficulties of that process and the concomitant need for constant revision, Giacometti tended to work with relatively few sitters. Most were close to him and thus readily available to sit and to endure lengthy modelling sessions. The structure of this book and the exhibition it accompanies reflects that situation. Arranged chronologically, it also traces his progressive involvement with particular sitters. It begins with the portraits of his family that were created in Switzerland before he moved to Paris in 1922. The section following that is devoted to the portraits he continued to make throughout the 1920s and 1930s. Covering the remaining period of his life, there are rooms focusing on portraits of his mother Annetta, his wife Annette, his brother Diego, his wider circle in Paris, and his final model, Caroline.

Arranged in this way, the exhibition explores Giacometti's response in sculpture, painting and drawing to his various models, and it illuminates the dialogue he created between these various media. Presenting this material by sitter also deliberately exposes the enduring paradox of Giacometti's portraits. Necessarily, they were the outcome of an intense, repeated scrutiny of specific people, but in each resulting image the individual identity of the sitter is not a prime concern. Specific, circumstantial characterisation has been subsumed within the creation of something more profound and universal. Connecting with his celebrated sculptures of anonymous figures, Giacometti's portraits are an evocation of what Jean-Paul Sartre described as the 'pure presence' of a human being.

Paul Moorhouse
Curator of Twentieth-Century Portraits
National Portrait Gallery, London

GIACOMETTI
PURE PRESENCE

PAUL MOORHOUSE

One evening in late 1945, Alberto Giacometti emerged from a cinema on the Boulevard Montparnasse in Paris. The 44-year-old artist had recently returned to the French capital following a period of almost four years spent living as a virtual exile in Geneva while Paris was under German occupation. With the war over, he had made his way back and was relieved to find his ramshackle studio on the nearby rue Hippolyte-Maindron unchanged (fig. 1). Throughout Giacometti's absence, his younger brother Diego had carefully preserved the studio's contents. By contrast, Paris had been profoundly affected by recent events, its artistic and intellectual life shaken to the roots. Even so, that the studio had survived no doubt created an expectation in Alberto that his life and work could now resume their previous pattern. This, however, was not to be. As he later recorded, at the moment of stepping into the street he became aware that 'Everything was different.'[1] Nor was this simply a sense of the altered post-war atmosphere. Rather, he registered 'a complete change in reality'.[2] His surroundings appeared transformed, 'marvellous, totally strange, and the boulevard had the beauty of the Arabian Nights.'[3] For an individual given to flashes of epiphany, this singular insight ranks as the most profound he had experienced. He recollected, 'It was a beginning.'[4]

In order to understand the significance of this occurrence, it is necessary to place it in the wider context of Giacometti's personal and artistic development. One of his earliest works was a bust of Diego, a small head he had created in 1914 at the age of thirteen. That remarkably precocious sculpture contains, in essence, the hallmarks of all that would follow. The younger boy's appearance has migrated into the sculptor's materials, inhabiting them and conveying an impressive semblance of a living presence. Eschewing slavish imitation, the features are rendered summarily and evocatively, suggesting rather than describing. Even at this incipient stage, the head that confronts us intimates the way it has been seen. In everyday life and in our encounters with others we tend to grasp the unfamiliar immediately and then modify that initial impression by analysing its constituents. Giacometti's head of Diego preserves the fresh, unadulterated vitality of a first glimpse.

Encouraged by this success, the youthful artist turned to other members of his family as subjects for portraits. These included his mother Annetta, his father Giovanni, his sister Ottilia, and his youngest brother Bruno. Landscape and still-life motifs also figured in the numerous drawings, watercolours and paintings in oils that he produced. Looking back on such early essays in rendering appearance, Giacometti commented, 'I had the feeling that there was no obstruction between seeing and doing … it was paradise.'[5] Indeed, with that initial body of work, Giacometti found and established what would be the central, abiding preoccupation of his art until his death over fifty years later, in 1966. In the latter part of his life, Giacometti articulated that driving force with undiminished vigour and precision, 'To copy exactly, as in 1914, appearance. Exactly the same concern.'[6]

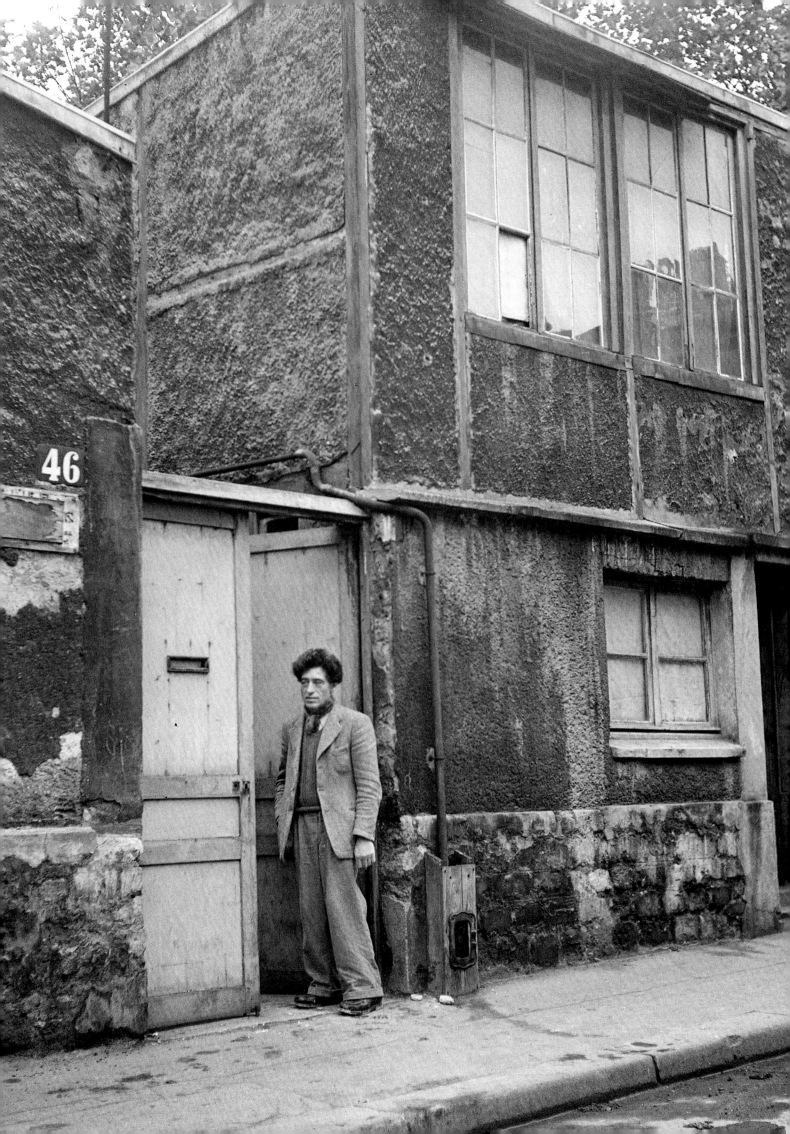

The endeavour to engage with the perceived reality of the external world stands at the heart of Giacometti's entire output. Driven by that aim, and comprising sculpture, painting, drawings and prints, his oeuvre went through numerous stylistic changes. It proceeded from a post-Cubist analysis of form in the early 1920s, through a Surrealist phase that ensued at the end of that decade, to his re-engagement with art which emerged from direct observation after the death of his father in 1933. Thereafter, and in particular following his transformative experience on the Boulevard Montparnasse in 1945, Giacometti concentrated on reproducing with absolute fidelity his optical experiences, which he characterised simply as 'what I see.'[7]

During the course of those changes and developments, his subject-matter nevertheless remained remarkably steadfast. Even when working from memory and imagination, notably while making the abstracted and fantastical sculptures that established his reputation within the Surrealist group, Giacometti's ongoing source of inspiration was a human presence. Whether the outcome of observation or recollection, figures and faces are a recurrent, practically continuous theme that carries the insistent force of obsession. This was something the artist repeatedly acknowledged, noting that 'The human figure has always interested me above all.'[8] At the same time, the reasons for that preoccupation were mysterious, even to Giacometti himself. 'Why do I feel the need, yes, the need, to paint faces? Why am I … how could I put it … almost astonished by people's faces, and why have I always been? Like an unknown sign, as if there were something to see which at first glance is invisible? Why?'[9]

The depth, intensity and extent of Giacometti's engagement with the depiction of people have few parallels in twentieth-century art. Long after his arrival in Paris in January 1922, he continued to paint his parents and siblings during summer holidays spent in the family homes in Stampa and Maloja, Switzerland. From 1922 onwards he also turned to a range of individuals – family, friends or models – with whom he had a close relationship. After joining Giacometti in Paris, Diego became one of his principal sitters. Others who subsequently endured many hours of prolonged scrutiny included Rita, a professional model; Isabel, with whom he had an affair; Annette, who became his wife in 1949; the writer Jean Genet, the philosopher Isaku Yanaihara (fig. 2) and the photographer Eli Lotar, who were part of Giacometti's circle in post-war Paris; and, not least, Caroline, the young woman who became his final muse. Despite the artist's own inability to account for his obsession with representing the human form and the appearance of certain individuals, there is no doubt of his commitment to portraiture.

That said, the nature of his engagement with portraiture was far from conventional. One of the paradoxes of Giacometti's art is that, although intimately involved with people as its subject, characterisation, psychology and individual identity are unusually absent. As the artist confirmed, probing the sitter's inner landscape was not a concern: 'I have enough trouble with the outside without bothering with the inside.'[10] Moreover, in working from observation and memory, there was a tendency for the identity of particular models to migrate: '… when I draw or sculpt or paint a head from memory it always turns out to be more or less Diego's head, because Diego's is the head I've done most often from life. And women's heads tend to become Annette's head for the same reason.'[11] Thus, while the artist could claim that the reasons for his immersion in portraiture were obscure, an even more pressing question remains regarding its significance. If Giacometti's portraits are not primarily about the sitters themselves, what do they represent?

This question brings us back to Giacometti's artistic imperative to render the appearance of reality. Throughout his extensive commentaries on the purpose and nature of his art, this is a recurrent theme, and one on which he is explicit.

A sophisticated and articulate thinker, Giacometti was well able to hold his own in the company of André Breton, Jean-Paul Sartre, Simone de Beavoir, Jean Genet and Samuel Beckett, to name but a few of the many intellectuals with whom he associated. His views on the complex relation of reality, appearance and representation are compelling and illuminating. In the first instance, he was in no doubt as to the ineffable nature of reality itself: 'All that remains of reality is an appearance'.[12] Confronted with a world perceived indirectly and subjectively via the senses, the artist must therefore turn his attention to that of which he is directly, if imperfectly, aware – his visual sensations. In that context, Giacometti's stated commitment to copying appearance now assumes a deeper significance:

> I do not work to create beautiful paintings or sculpture. Art is only a means of seeing. No matter what I look at, it all surprises and eludes me, and I am not too sure of what I see. It is too complex. So, we must try to copy simply in order to begin to realise what we are seeing. It's as if reality were continually behind curtains that one tears away … but there is always another … always one more.[13]

Viewed in this light, the artist's constant recourse to recording his visual response to a sitter in the studio reveals its deeper purpose. Portraiture for Giacometti was less concerned with evoking the personality of the sitter than with providing a means of engaging with – in the most intimate way conceivable – what he described as 'the core of life'.[14] In Giacometti's images of people, there is a profound sense of the artist's involvement with his own subjective responses, his compulsion to test the processes of perception, in order to understand his relationship both with the external world and

Fig. 2 Isaku Yanaihara sitting for Giacometti photographed by Mac Domag, 1960.

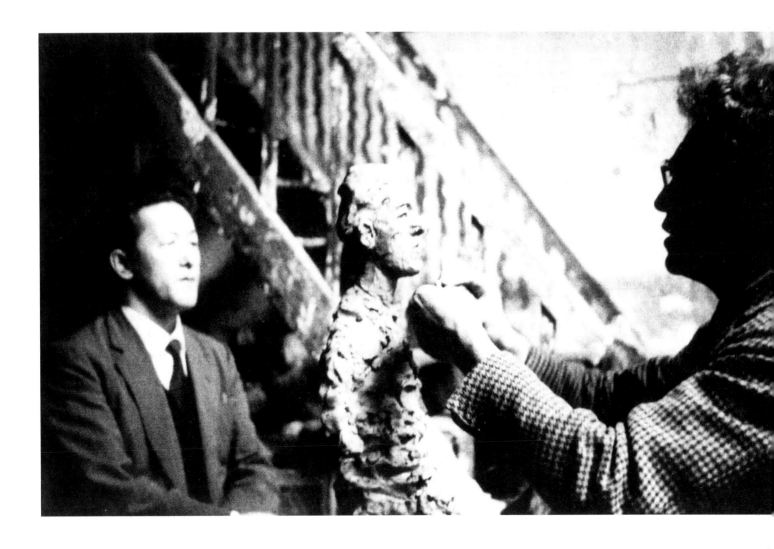

with its most vital manifestation: another living being. But, as he continually acknowledged, the process of visually recording that relationship was fraught with difficulty: 'The distance between myself and the model tends to increase continually; the closer I get, the further away it moves.'[15] To an extreme degree, Giacometti's art lays bare the complexities and ambiguities of perception, relentlessly exposing the fugitive and elusive nature of visual experience. His portraits are in that sense not simply depictions of individuals. Rather, they are sites that bear the evidence of the artist's struggle to comprehend and express an unfathomable human presence.

Giacometti's experience of 'a complete change in reality' on the Boulevard Montparnasse occurred over thirty years after creating his first portrait. In the interim, he had grappled with a process that he had come to feel was impossible. By the age of nineteen, initial confidence had given way to frustration and, beyond that, despair. 'Gradually things deteriorated. Reality escaped me.'[16] Making portraits became instead a way 'to find out why I can't simply reproduce what I see'.[17] The insight he gained in 1945 brought to perception a new dimension, 'a moment in which reality astonished me as it had never done'.[18] From that point his work called for a new response. The portraits made prior to that experience, and in the maturity of its aftermath, are encounters made during a remarkable journey of discovery, described by Giacometti as his 'endless search'.[19]

FAMILY PORTRAITS

Alberto Giacometti was born on 10 October 1901, the first child of the painter Giovanni Giacometti and his wife Annetta. His godfather was Cuno Amiet, the Fauve painter. Alberto's birthplace was the village of Borgonovo. Situated in the Bregaglia valley, the so-called 'new village' was enclosed within a mountainous region that separates south-eastern Switzerland from Italy. His mother had been born and brought up there. Indeed, her maiden name was Stampa, which derives from the nearby village where Giovanni was born. Following their marriage in 1900, they had settled in lodgings in Borgonovo. Their second child, Diego, was born just over a year after Alberto, and the family remained in Borgonovo until 1904, when the birth of a third child, their daughter Ottilia, called for a move to larger accommodation. Accordingly, they moved to Stampa in the late autumn of that year. There, three years later, the family was completed with the arrival of a fourth child, Bruno (fig. 3). Here close family ties were forged, and together their lives unfolded within the huge expanse of space contained by the distant, snow-topped skyline that formed a backdrop for Alberto's childhood.

By his own account, Giacometti's first years were both carefree and happy. He recalled, 'Between the ages of four and seven, I saw only those things that could be useful to my pleasure.'[20] Nature, as revealed in its geology and organic growth, was a prime source of fascination. He also began to discover a new, parallel source of satisfaction in art. No doubt inherited from his father Giovanni, and certainly encouraged by him, this early affinity with making images took the form of drawings created to accompany the books he was reading. The story of 'Snow White and the Seven Dwarves' was one such subject, and the memory of the illustrations he invented remained throughout his adult years. These developments were accompanied by the intense pleasure he discovered in occupying his father's studio. In 1909 his mother had inherited from her uncle a large house at Maloja, at the top of the valley. As well as becoming a second residence that they used for summer holidays, a converted barn there also provided additional studio space for use by Giovanni and his youthful acolyte. Giacometti recalled, 'There was no greater joy for me than to run to the studio as soon as school was out and sit in my corner …'[21] As it would in later life, the experience of occupying a studio came to assume great importance.

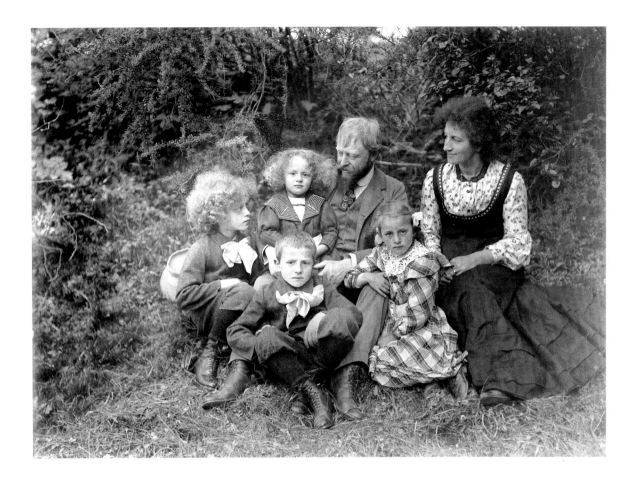

Fig. 3 The Giacometti family. From left: Alberto, Diego (front, seated), Bruno (on his father's knee), Giovanni, Ottilia and Annetta photographed by Andrea Garbald, 1909.

By the age of ten, nature and art had begun to coalesce for Giacometti. Turning to drawing from life, he formed 'the impression that I held such a command of the subject that I could do exactly as I pleased. I was terribly conceited when I was ten. I admired myself, felt I could do everything with this wonderful weapon, drawing – that I could draw no matter what.'[22] Significantly, he added that this impression extended to the belief 'that I saw more clearly than anyone'.[23] Even at this early stage, there is the implication that seeing is not simply a common facility but, rather, an instinct or ability, a unique way of perceiving the world, and one that defines the individual. In addition to studies of the landscape and still-life subjects, he now began to make portraits of members of his family. One of these, a pencil drawing done around the age of fourteen depicting his mother, (fig. 4) demonstrates a sensitive talent. With a sure feeling for line, the young artist has captured the essence of his sitter's features. Tellingly, Giacometti has confronted his model frontally, an aspect that would be one of the principal characteristics of the mature portraits made towards the end of his life. The clarity that he sensed in his own vision of things would, from the outset, be connected with the will to face them directly.

Giacometti progressed from drawing to painting in watercolour and oils, and in those media the influence of his father is apparent. Giovanni's bold use of colour, which betrays his affinity with Post-Impressionism, is the model for *Still Life with Apples* (c.1915, fig. 5), with its vibrant palette of blues, ochres, umbers and lemon-yellows. Perhaps a desire to find his own way underlay Giacometti's decision to try his hand at sculpture. *Portrait of Diego* (1914) was, as we have seen, a confident step forward. Modelled from life in Plasticine, the head marks the future sculptor's first engagement with producing a three-dimensional equivalent for a perceived human presence. In addition to achieving a credible likeness, one other characteristic is noteworthy: its size. While the head is correct in terms of its relative, internal proportions and is fully realised in the round, it is smaller than life-size. This intriguing feature does not detract. Indeed, it suggests

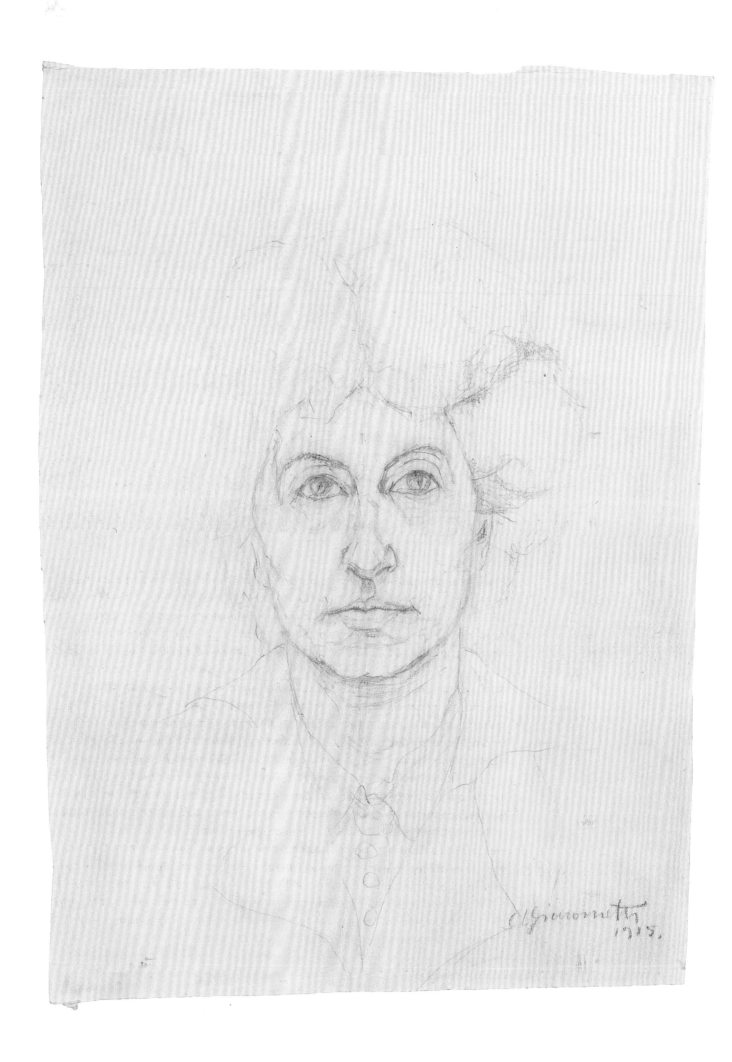

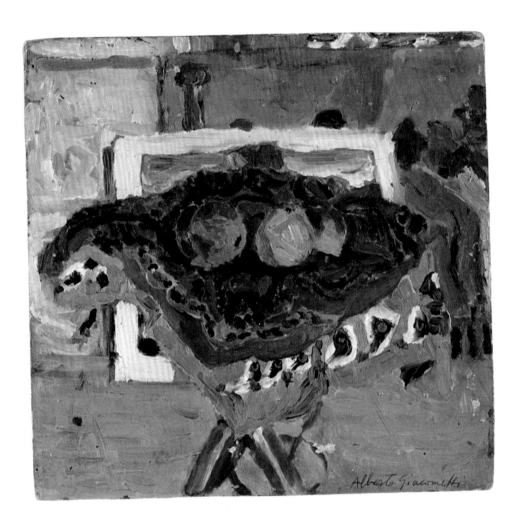

a way of seeing and reproducing appearances that, like the abstracted features, is not governed by convention but, rather, by something more idiosyncratic. It retains a sense of the sitter seen as if at a distance, its reduced size compressed by that perception. As such, it exists in the viewer's domain, and also suggests the cognitive space in which the image was formed. In later life Giacometti would explain, 'I see things small.'[24]

At this stage, that tendency to distort the human form was no cause for disquiet. Indeed, after enrolling as a boarder at the Evangelical Secondary School at Schiers, an hour's journey by train north of Stampa, his artistic gifts attracted admiration, thus adding to his growing confidence. It was not until he reached the age of eighteen or so that things began to change. In the autumn of 1919 he moved to Geneva to attend a course in painting and drawing at the School of Fine Arts. His time there was marked by the onset of problems that would later come to dog him. In drawing from life, he refused to attempt an image of the entire figure, feeling able to concentrate instead only on discrete details. In May 1920 he accompanied his father to Venice, where he first encountered the powerful example of Tintoretto. On a subsequent visit to Padua he formed an even greater admiration for Giotto's art. He spent the summer in Switzerland, and returned to Italy in mid-November. The ancient Egyptian art he saw in the Museo Archeologico, Florence, made a profound impression on him. In December 1920 he moved on to Rome, where he stayed with cousins of his parents. It was during this time that he experienced a disturbing setback.

Attempting a bust of Bianca, his hosts' eldest daughter, he now found himself incapable of producing anything satisfactory. Of this abortive episode, Giacometti later explained that he had the sitter 'pose the entire winter, for six months perhaps, following which I disposed of the head, throwing it in the dustbin when I left. Total

impossibility of capturing the entirety of a head.'[25] In contrast to the earlier experience of modelling the bust of Diego, it appears that the artist now encountered a complete fracture between what he was seeing and his ability to produce a visual equivalent. In part this seems to have been engendered by the issues of size and detail that now took on a problematic aspect. In focusing intensely on the individual elements of his sitter's appearance, he found himself at sea when attempting to create a unified whole. Size and volume, those elements intrinsic to sculpture, eluded him and he lost heart. Over forty years later, Giacometti still claimed 'from that time on I have never again been able to make a head just as I see it'.[26]

The portraits he had made in two dimensions slightly earlier had given no intimation of this looming crisis. Around 1920 he completed paintings of Diego, Ottilia and Bruno, which, in terms of colour, likeness and expressive depth, are utterly convincing. In each, the sitter is evoked with sympathy and penetration. *Bruno Asleep in Bed* (1920, cat. 3), for example, is an affecting portrait of his youngest brother in which observation is underpinned by tenderness. Even afterwards, his paintings were seemingly unaffected by the problems that beset his sculpture. In 1921 he created two remarkable self-portraits. The larger painting, *Self-Portrait*, is an accomplished work in which he depicts himself in the act of painting (fig. 6). The other, *Small Self-Portrait* (cat. 8), is a forthright engagement with his own features, at once searching and

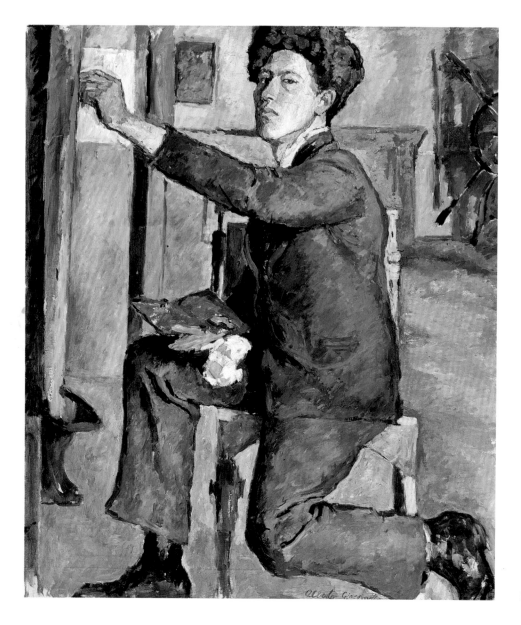

Fig. 6 *Self-Portrait*, 1921

confident. However, a fracture had been opened up, one that would continue, to a greater or lesser extent, for the remainder of Giacometti's working life. As he later explained, 'the main impossibility is that of grasping the whole as well as what we would call the details'.[27] As we shall see, this was only one aspect of the larger question of how to render visual experience exactly: a profound question involving perception, representation and the complex relation of the two.

STRUCTURE AND FORM

Torn between a continuing desire to make sculpture and a growing sense of inability to translate visual experience into an equivalent three-dimensional structure, Giacometti consulted his father. Giovanni's advice was that his son should go to Paris to study with Antoine Bourdelle, then regarded as France's most distinguished living sculptor. In late December 1921, Giacometti left Stampa. He arrived in Paris in early January to begin attending classes with Bourdelle at the Académie de la Grande Chaumière. The street on which the school was located intersects with the boulevard Montparnasse, which, over twenty years later, would assume a singular significance in the artist's development. In contrast to that later epiphany, Giacometti came to feel that his time with Bourdelle yielded little, and even led to a deepening sense of frustration and confusion. Although renowned as an excellent teacher, Bourdelle's contact with his students was limited to a day a week. For the rest of the time, Giacometti's classes comprised a regime of sculpture in the mornings, followed by drawing from life in the afternoons.

Despite his later claim that this period of study was of limited value, the drawings that survive provide an impressive record of Giacometti's immersion in the discipline of life drawing. Combining close observation with rigorous analysis, his studies of the figure standing, crouching and sitting demonstrate a feeling for mass and weight conveyed with authority (fig. 7). This facility attracted admiration from his peers, but that response did little to assuage Giacometti's own misgivings. Confronted with the nude form, he sensed an inability to cope with its endless complexities. As experienced previously with the head of Bianca, the principal problem appears to have been a sense of conflict between the need to render the detailed appearance of the model and the corresponding difficulty of attaining a unified whole. Compounding that problem, he began to feel that his proximity to the model was a source of uncertainty. Situated too close, the relation of individual features and parts became an overwhelming preoccupation, and it was impossible to see the entirety of the figure. Placed too far away, details receded and 'I saw the figure as a blob'.[28] Either way, the model would be gone before these contradictions could be resolved. Each day, he would approach the subject differently, only to find that his 'vision changed daily'.[29]

Giacometti experienced a profound gap between the fugitive and contingent nature of what he saw and his ability to capture his impressions. Perhaps to mitigate the complexities of depicting an entire human body, Giacometti resorted to his own head as a subject. The self-portrait drawings made during his time at the Académie are, in common with his studies of the nude, analytical (cat. 10). Employing a visual language derived from Cubism, they depict an anatomical form broken down into individual faceted planes. However, even when addressing a smaller subject in this highly focused way, there is an implication of Giacometti's struggle to unify his discrete perceptions. The intense nature of this activity is evident in his summation of the difficulties presented: '… the distance between one wing of the nose and the other is like the Sahara, it has no limits, nothing to be fixed, everything escapes.'[30]

It would be a misunderstanding to interpret the problems that Giacometti now confronted as being simply technical in nature. Transcending the facility of draughtsmanship, they address a more profound issue: that of putting aside what is known about the observed subject and, instead, concentrating solely on reproducing what is seen. In pursuing that objective, stylistic conventions were worse than useless in that they imposed ways of seeing and describing observation. As Giacometti would comment later, 'one must create a vision and not merely something that one knows to exist'.[31] At its root, the mystery he identified was that of perception itself, stating, 'I am not too sure of what I see. It is too complex.'[32] By 1925 he reached a point when reproducing his visual experiences exactly appeared impossible. Coinciding with that realisation, his regular attendance at Bourdelle's classes came to an end, although he continued on a more occasional basis for a further two years.

Throughout the period when Giacometti frequented the Académie, he had a somewhat peripatetic existence, living in various hotels and occupying a succession of studios. In the spring of 1927 he moved into a new studio at 46 rue Hippolyte-Maindron, a building that formed part of a larger complex. The space was tiny and devoid of material comforts. At the outset he both worked and slept there, and it remained his sole workplace in Paris for the rest of his life. Diego had joined his brother in February 1925, and initially they shared the studio at rue Hippolyte-Maindron. The course of the artist's work in Paris after the impasse he reached in 1925 is well known. Faced with uncertainty both about the nature of his perceptions and his capacity to copy them with any degree of precision, he now resorted increasingly to working from memory and, subsequently, from imagination. From 1926 he embarked on a series of sculptures that proceeded in a new direction, free from the previous inhibiting need for copying. Having digested a range of influences, from Cubism to the art of New Guinea, Giacometti now drew upon these disparate sources, producing a diverse body of work. The degree of abstraction that these examples incorporated led inexorably to work of a more freely inventive kind. By 1929 it had begun to attract the attention of André Breton the founder of the Surrealist group, then the focus of avant-garde artistic activity in Paris. During the course of the next three years, Giacometti gradually attained prominence as one of the group's leading figures.

The rue Hippolyte-Maindron was not, however, the only site for Giacometti's creative output. Nor was the work produced in Paris his only line of development. Prior to 1925, Giacometti had continued to return to Stampa for extended periods; and, after taking over the studio in Montparnasse, he continued to return to the family home each summer. This parallel existence was characterised by two contrasting lifestyles. While his life in Paris was frugal and austere, the time spent in Stampa and Maloja at his father's studio and his parents' houses was more salubrious and comfortable. In a similar vein, his work now also flowed in two directions. In France his output tended towards a radical kind of sculpture in which themes of sexual violence increasingly played a part. *Woman with Her Throat Cut* (1932) exemplifies that darker aspect (fig. 8). In Switzerland, on the other hand, Giacometti's work ploughed a different furrow and continued to be based on observation.

Maintaining an unbroken connection with his earliest work, portraits of his family continued unabated. In 1924 he returned to his earliest sculptural motif with a head of Diego (cat. 11). In common with the earlier work, the features are abstracted and unified, conveying an impression of an appearance grasped entirely. In that respect, it preserves the artist's earlier confidence, notwithstanding his claims regarding the difficulties he was then experiencing in Bourdelle's Académie. Giacometti's subsequent portraits are no less resolved, but their stylistic diversity is evidence of an unsettled outlook, as if a succession of different approaches and solutions were being investigated.

Fig. 8 *Woman with Her Throat Cut,* 1932

The head of Giovanni that Giacometti made in the second half of the decade is highly focused, the features rendered with exactitude (cat. 15). However, two related heads subjected the same motif to an astonishing process of simplification. As a result, the features were reduced, first to essential facets (fig. 9), and finally to inscribed lines (cat. 17). A connected work, a head of his mother, proceeded similarly (cat. 14). In that arresting sculpture, the face has been flattened and the features gently etched. Despite that degree of abstraction, a head of Bruno, completed around 1929–30 reverted to a more naturalistic mode of representation (fig. 10).

Rooted in portraiture, Giacometti's investigations of appearance and its representation continued alongside his Surrealist works and beyond his eventual break with Breton and his followers in late 1934. Although apparently distinct, it would be misleading to regard these parallel developments as unrelated. In the highly abstracted and imaginative works produced after 1926, Giacometti evoked his subject matter without recourse to copying. These works have an independent and self-contained identity, a reality that exists on its own terms. Such considerations are germane to an appreciation of the progressively abstracted portraits produced at the same time. The portraits of his father and mother are not likenesses in a literal sense; but, in suspending verisimilitude, they seek to evoke the presence of their subjects through the equivalent, assertive reality of an abstracted work of art. Rather than merely copying the appearance of the sitter, they convey a powerful sense of the otherness, the elusive strangeness of visual experience. They probe the unknowability of the seen, and present that uncertainty as a material fact. That in itself was a compelling insight. With his involvement with Surrealism at an end, the path ahead would now return him – more exclusively – to the mysteries of looking.

A DEATH AND THE RETURN TO LIFE

Shortly before his breach with the Surrealist group, Giacometti experienced a personal catastrophe that marked his artistic development no less decisively. In late June 1933 his father suffered a stroke and fell into a coma. On hearing the news of his illness, Bruno and Ottilia returned immediately to Switzerland to join their mother at the sanatorium where Giovanni was being cared for. Alberto and Diego set out from Paris but failed to arrive in time. Without recovering consciousness, on 25 June Giovanni died. Alberto was distraught and himself suffered an immobilising illness that confined him to bed for several days. His father, who was by then an artist of repute, had been the source of his eldest son's commitment to art, an inspiration, a model, a confidant and an early adviser. Alberto felt this loss keenly and, long after Giovanni's death, he continued to occupy the older man's studio. However, an immediate effect seems to have been to provoke a re-evaluation of his own work. In Switzerland his portraits had suggested a continuing affinity – if not conformity – with the traditional values espoused by his father. The same could not be said of his recent Surrealist work in Paris. With Giovanni gone, the way was open to pursue a fuller artistic independence. Instead, Alberto now reverted to those original, shared principles of observation that had inspired his work at the outset.

Giacometti later explained that for ten years the difficulties he had experienced had compelled him to 'abandon the real'.[33] It is clear that such remarks need to be treated with a degree of caution, applying as they do with greater veracity to his work in Paris than with that produced in Switzerland. However, he added that throughout that decade, he had known 'that whatever I may do, whatever I may desire, one day I would feel

Below
Fig. 9 *Head of The Artist's Father I*, 1927

Right
Fig. 10 *Head of Bruno*, 1929–30

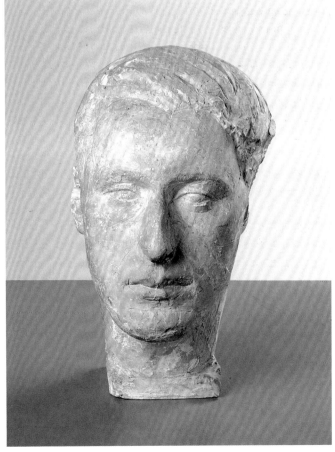

obliged to sit on a stool facing the model, endeavouring to copy what I saw'.[34] In the wake of his fading involvement with Surrealism – itself prompted, perhaps, by feelings associated with his father's death – that day of confrontation with a model now loomed. As we have seen, the purported break with observed reality was less absolute than Giacometti claimed. Made concurrently with his Surrealist work, the portraits of Giovanni, Annetta, Diego and Bruno testify to an unbroken engagement with depiction. However, from 1934 portraiture from life increasingly preoccupied him.

As had been the case previously, Giacometti turned to members of his own family as models. A painted portrait of Ottilia, undertaken in Switzerland, stands at the beginning of his new, more exclusive focus on reproducing appearance (cat. 19). No less than before, Giacometti's endeavour was to represent his visual experience as faithfully as possible. But, as this work suggests, the old issues had not receded. The complexity of relating individual, constituent details remains a preoccupation. As if returning to the analytic studies he had made from life prior to 1925, the language employed again derives from Cubism. The sitter confronts the artist directly, her head and upper torso filling the picture space, and Giacometti has described its form and volume in terms of faceted planes. A remarkable self-portrait drawing made around the same time continues that approach (cat. 20). Concentrating on his own head, he reduces the features to essentials. In both portraits, the endeavour to describe appearance directly is imperative. The resulting images depict the sitter, not as known, but rather with the raw force of individual visual sensations, captured discretely and then, somehow, combined into a whole. In this way, earlier preoccupations are reasserted. At the same time, there is the evidence of something else: an intensified engagement with the elusive nature of appearance in order to probe the mysterious fact of a human presence.

Back in Paris, Giacometti intended a return to making sculpture from life. To that end he engaged a professional model, Rita Gueyfier, who began frequenting the studio for sittings in 1935. He expected a fortnight would be sufficient time to reacquaint him with depicting a figure. After eight days, though, he realised that representing the entire human form was too complex and, instead, resolved to focus on studies of his sitter's head. This established a pattern that would continue for the next five years. At the beginning of each session he would begin afresh, only to find that the more he scrutinised Rita's appearance, the more impossible it became to reproduce what he saw. The difficulties of perception that had led him to abandon sculpture from life ten years earlier now appeared as irresolvable as ever. The competing demands of describing detail yet also conveying a unified whole continued to perplex. In addition to that impasse, he now sensed a further obstacle. By refusing to illustrate his prior knowledge of the subject's features and choosing instead to attempt to record only what he saw, the overwhelming difficulty was that of his proliferating impressions. Every time he looked, a new and different visual experience presented itself, each calling for an alternative response in the form of sculpture. Depending on his own relative position, the size, shape and appearance of his sitter's head appeared constantly to change. Which of these sensations corresponded to the reality of things?

Two small heads of Rita, made three years into this process, manifest the same extraordinary outcome. In similar ways both depict a short-haired, somewhat sharp-featured young woman, and both employ a degree of abstraction, suggesting the features of an individual seen with the imprecision of distance. Underpinning that sense, the unusual size of these portrait heads is arresting. One is small (cat. 23), the other tiny (cat. 24). We read this progressive diminution as an effect of remoteness. A living person is evoked, but in a way that preserves the artist's own physical relationship with the sitter, whom he regarded from afar. Incorporating a recessive perspective within the language of sculpture would be a characteristic of Giacometti's

Fig. 11 Giacometti's studio by an
unknown photographer, 1938. *Rita*
(*c.*1938, cat. 23) can be seen on the left
and *Head of Isabel* (*c.*1938–9, cat. 22)
on the right.

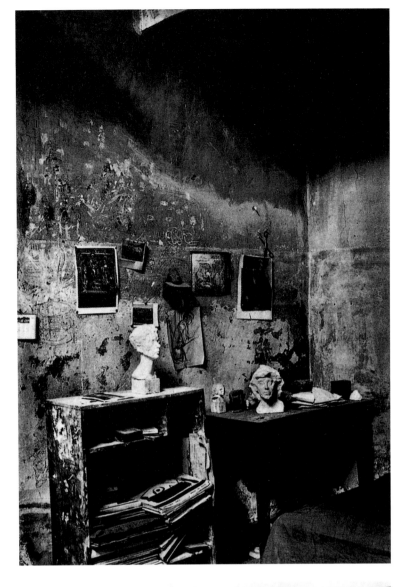

Fig. 12 Entrance to Giacometti's studio
at 46 rue Hippolyte-Maindron, Paris,
photographed by Sabine Weiss, 1938

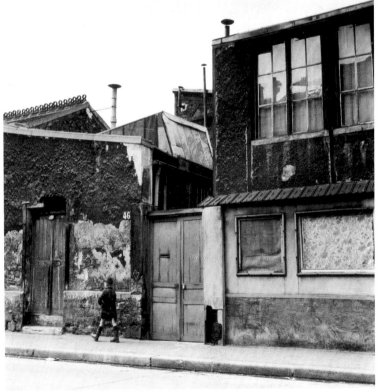

subsequent work and is one of his most remarkable innovations. However, this tendency was, for the artist, alarming: 'The further back it drew, the smaller became the head, and that terrified me. The danger of the disappearance of things.'[35]

Giacometti's other main female model at this time was the young English woman Isabel Nicholas. An aspiring artist, she arrived in Paris in September 1934 and became an increasingly visible figure within Montparnasse's artistic circles and café society. In common with many others, Giacometti was intrigued by her striking looks and vivacious personality. She began sitting for him later that year and he produced his first head of Isabel in 1936 (cat. 21). In contrast to his earlier busts of Diego, his father, mother and Rita, his depiction of Isabel seems idealised. Her flawless, rounded features seem not only unrelated to the tactile handling reserved for Rita, but have a somewhat transcendent quality. The early Egyptian art that impressed the young Giacometti had continued to provide him with a benchmark of excellence and truth. In the hieratic portraits produced by that earlier civilisation, he seems to have perceived a numinous quality, a harmonious order behind the flux of appearances. At this early stage in their relationship, which later became intimate, Giacometti's view of his sitter conveys physical distance but, more importantly, the remoteness conferred by an individual who became an object of fascination. A later head of Isabel, made at the end of the 1930s, could hardly be more different. In its roughly hewn appearance, a startling physical tactility has entered the equation of art and life (cat. 22).

In that respect, the remarkable portrait of his mother that Giacometti made in 1937 (cat. 25) marks a turning point. In that painting he turned to the individual to whom he had been closest, both physically and emotionally, and who would continue to exercise a profound psychological influence until her death only two years before his own demise in 1966. Yet the portrait he made expunges sentiment. Confronting this central figure in his own life, he stops at the carapace of her physical appearance. She is depicted without sentiment or speculation. Instead the artist has responded to her tactile presence, treating it almost as a landscape over which his gaze passes. Like a geological expanse, the appearance of the sitter is ever-changing, and, as a result, unfamiliar – qualities he has sought to contain within a matrix of probing brushstrokes. The real seems both immediate yet remote. In his exploration of representation, Giacometti now admitted a new dimension: a sense of wonder.

BEGINNING TO SEE

Giacometti's return to working exclusively from an observed model persisted for five years, from 1935 until 1940. During that time Rita and Isabel were his principal sitters. Both were subjected to the same relentless scrutiny, and in his response to these individuals there was the same growing sense of the impossibility of his task. Of the difficulties experienced he later commented:

> You begin by seeing the person who is posing, but gradually every possible sculpture interposes itself between the sitter and you. The less clearly you actually see the model, the more unknown the head becomes. We are no longer sure of its appearance, its size or anything at all![36]

These words encapsulate the dilemma that Giacometti had set himself and that would haunt the rest of his work, both inspiring his efforts and conspiring against them. As we have seen, his obsessive fascination with a human presence was, in part at least, the outcome of his desire to penetrate to the reality he sensed beneath the surface of appearance. This imperative to see that 'which at first glance is invisible'[37] resulted in

an open-ended engagement, a pattern of repetitive scrutiny that yielded a multitude of different impressions. However, as he now found, that accretion of sensory information itself posed what appeared to be an insuperable problem. The more he looked, the less able he was to see the sitter afresh. Each visual impression obscured the preceding one, prompting a new response and another 'possible sculpture'.[38] Faced with that mass of alternatives, the tendency was to destroy the work in progress and constantly start again.

For this reason, his output during the years immediately preceding the outbreak of the Second World War was relatively sparse. As he himself recognised, the obsessive nature of this engagement seemed abnormal:

> It is hardly normal, instead of living, to spend one's life just trying to copy a head, keeping the same person immobilised in a chair for five years, trying to copy their face without succeeding.[39]

Around 1940 he seems to have reached an impasse. Faced with the growing impossibility of completing anything, Giacometti now abandoned the sittings and returned to working from memory. This break in his practice was, however, not only brought about by the frustration he was experiencing. Following the invasion of France by German forces in May 1940, the eventual occupation of Paris became a growing anxiety. Faced with that prospect, Isabel decided to return to London. For his part, Giacometti took the precaution of secreting his recent work beneath the floor of his studio. After the Armistice of 22 June was signed, he remained in Paris for over a year. But, having lost his main sitter, and with his routine disrupted, working from life became more than ever an impossibility.

In December 1941 Giacometti resolved to visit his mother, who was then living in Geneva. Four years earlier Ottilia had died in childbirth. Silvio, the infant who had been delivered, was by then a young boy living with his father, Francis Berthoud, in Geneva, and Annetta was helping to raise her grandson. On his arrival, Giacometti found a room in the Hôtel de Rive, a rather run-down establishment that nevertheless suited his purpose (fig. 13). He immediately set about creating a place in which he could work. Geneva would be his home and the site of his artistic endeavours until his eventual return to Paris in September 1945. This period ranks among the strangest in terms of his development. Working now entirely from memory, he concentrated on modelling the human figure.

One evening in 1937, while still in Paris, he had seen Isabel from afar, standing on the Boulevard Saint-Michel. To some extent that recollection became the source of this new, displaced activity in Geneva. On the earlier night in question, the distant figure had seemed engulfed by the surrounding space. That perception now informed the sculptures he commenced. However, to his mounting consternation, his previous tendency to represent distance by reducing the image size now appeared beyond his control. In spite of his repeated efforts to resist this compulsion, each sculpture shrank to minuscule proportions. Although he recoiled from this phenomenon, he was nevertheless in thrall to it, believing that the figures 'only seemed to me to be slightly real if they were minute'.[40]

It was while in the midst of this crisis that Giacometti met the woman who would eventually become his wife and one of his most important models. In October 1943 he was introduced to Annette Arm. A 20-year-old who lived locally, she was a schoolmaster's daughter. Giacometti was immediately captivated, not least by her frank gaze and open, unaffected demeanour. Those who knew Annette commented

upon her charm, capacity for laughter and carefree manner. The two quickly formed a close relationship and began living together at the Hôtel de Rive. Despite that proximity, Annette was not asked to pose. Evidently, Giacometti remained committed to the small figures that continued to preoccupy him and on which he worked until he eventually left Geneva. He subsequently returned to Paris carrying the work he had completed, which comprised several tiny figures, in matchboxes. It was not until July 1946, when Annette joined Giacometti and began living with him in the rue Hippolyte-Maindron studio, that her central presence in his art began to take shape.

By then, Giacometti's art had already taken a new direction. His experience on the boulevard Montparnasse had been revelatory, suggesting not only a different view of the world, but an alternative approach to representing his visual life. As a result, Giacometti now grasped that, in common with most other individuals, his way of looking at things was conditioned by convention. Familiar habits and established artistic styles shape our way of looking. We perceive reality according to certain expectations. As Giacometti explained, 'My view of the world was a photographic view, as I think almost everyone's is, near enough. We never see things, we always see them through a screen ...'[41] Emerging from the cinema, he now saw his surroundings afresh. In contrast to the projected cinematic images he had been observing, the real world now appeared in an unfamiliar light: alive, elusive, strange and entrancing.

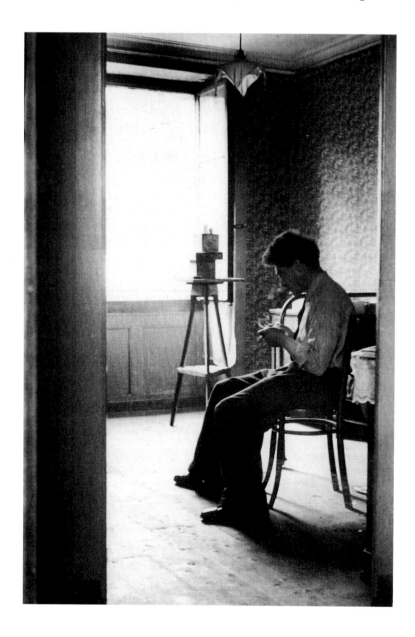

Fig. 13 Giacometti working in his room at the Hôtel de Rive in Geneva photographed by Eli Lotar, 1944.

With this perception, there followed a recognition that previous modes of artistic representation presented only a partial account and had therefore failed. His realisation that the art of the past was deficient dates from this moment, which he characterised as 'the day I began to see'.[42] Verisimilitude fell short. The world was in reality 'dazzling, and at the same time impossible to render'.[43] This insight meant that even to suggest a likeness, it would be necessary to abandon conventional approaches to depiction. Now, with the same single-mindedness that he had brought to his original aim of copying appearance exactly, he concentrated on giving objective reality to the subjective experience of seeing. Beginning with Annette and Diego, this ethos would be the basis of Giacometti's renewed engagement with portraiture, which from 1950 would be his principal concern (fig. 14).

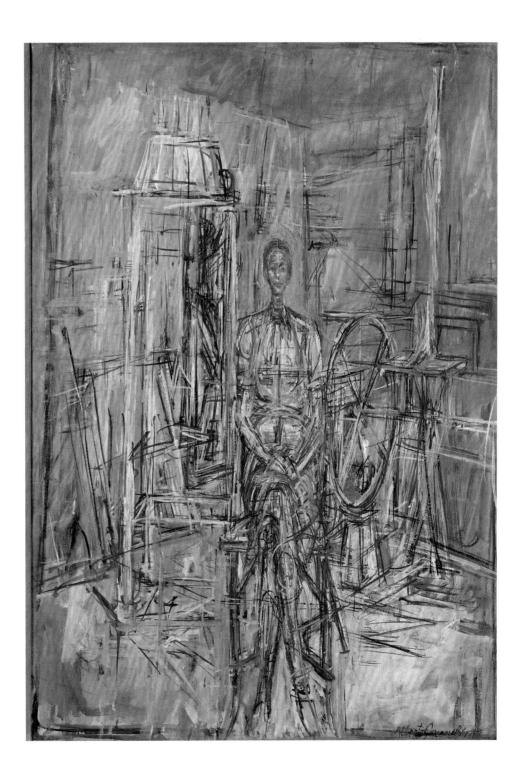

Fig. 14 *Annette au Chariot*, 1950

ANNETTE AND DIEGO

Giacometti's moment of revelation on the Boulevard Montparnasse was a turning point in more ways than one. From that time onwards he ceased to equate his achievement of likeness with a 'photographic' view of the world. Previously, there had been no difference between photographic images and the way he saw the world. Now he was conscious of a deep split between the kind of representation yielded by a camera – a so-called literal appearance – and his own, subjective apprehension of reality.

The first of these modes of representation preserved an appearance that was still and inert, almost fossil-like. By contrast, his view of his surroundings was inseparable from the experience of seeing, which he characterised as a succession of constantly changing sensations each contradicting the preceding ones. In copying a glass, for example, he explained:

> Each time I look at the glass, it has an air of re-making itself, that is, its reality becomes doubtful because its projection in my brain is doubtful, or partial. I see it as if it disappeared … reappeared … disappeared … reappeared … In other words it really always is in between being and not being. And this is what we want to copy …[44]

That realisation was both a source of wonder and a call for a new way of expressing his visual experiences. At the same time, it plunged Giacometti into a new situation of uncertainty and anxiety. The position and relation of objects in space now seemed disconnected and disorientating. The perception of movement was almost a series of still apparitions. This induced, as he recalled, 'almost a chill down my spine'.[45]

Despite these conflicting emotions, the ensuing period was a productive one. Having been reunited with Isabel in Paris in the autumn of 1945, by Christmas their affair had run its course. Even so, he continued to work from memory on busts of his former lover. From 1947 his attention turned increasingly to the production of sculpted figures, which now assumed a tall, elongated appearance. No longer compressed by distance into minuscule proportions, his sensation of remoteness took a different form. The figures were presented as if consumed by an enveloping space. 'I have often felt,' Giacometti commented, 'in front of living beings … the sense of a space-atmosphere which immediately surrounds these beings, penetrates them, is already the being itself …'[46] The figures he now made tended to fall into two types – evocations of a woman standing and a walking man – and they mark an important breakthrough. They define a new aesthetic in which the relation of a figure to a surrounding void is a recurrent theme. At the same time, he now began again to exhibit regularly and to attain growing recognition. In 1948 and 1951 he held exhibitions of recent work in New York and Paris, and these marked the beginning of numerous solo and group shows that would continue in both these cities, as well as elsewhere in Europe and America.

Coinciding with that progress, two other important advances occurred. In 1946 Giacometti resumed painting. His sojourn in Geneva had extinguished that activity and, beginning with drawing, he now found his way back to making two-dimensional images. The impetus for that resumption was a second, related step forward. With Diego already at his side in the rue Hippolyte-Maindron, Annette's arrival in July 1946 provided a second close human presence. From this point onwards, Giacometti's brother and wife, as Annette became after their marriage in 1949, were his principal models (fig. 16). As if shadowing the sculpted figures, both these individuals assumed an archetypal significance in Giacometti's iconography as portraiture gradually became a preoccupation. Indeed, the two activities – sculpture created from memory and

portraiture made from life – now cross-fertilised. The central concern explored in the sculpted figure, that of evoking the presence of a figure in space, informed the portraits. Conversely, his response to an individual sitter in the studio progressively underpinned the creation of figures that shed a specific identity.

Of the two sitters, Diego was, as Giacometti told his biographer James Lord in 1964, 'the one I know best. He's posed for me over a longer period of time than anyone else. From 1935 to 1940 he posed for me every day and again after the war for years.'[47] As his drawings of Diego from that time show, a radical rethinking of his approach to recording appearance was under way. In one such drawing, made in 1948, the features of this familiar sitter have been rendered indistinctly, almost as a web of lines (cat. 40). The face seems almost transparent, as if infiltrated by the surrounding space. In one of the paintings of Diego made at the same time, *Portrait of the Artist's Brother Diego*, the model confronts the artist directly (cat. 38). He is shown seated, his arms cradled on splayed knees. As would be characteristic of Giacometti's portraits of this sitter, the pose is informal, almost matter-of-fact. In later paintings, notably *Man Seated on the Divan while Reading the Newspaper* (1952–3, cat. 42), there are allusions to the studio context, the figure presented amid a jumble of stacked canvases and furniture.

However, the mode of representation has moved on. Supplanting the relative stasis of Giacometti's earlier portraits, such images are now formed from a plethora of agitated brushstrokes. In *Diego* (1950) the entire paint surface has been activated, the sitter and his context apparently vibrating with a nervous energy that fills the canvas as a whole (cat. 41). In a number of these paintings the figure appears within a painted frame, a device that became evident at an early stage, notably in *Diego Seated* (1948, cat. 39). The effect is to emphasise and delineate the space occupied by the sitter. Giacometti had previously sought a unity of detail. Now the visual field contained by the frame

Fig. 15 Plaster busts and figurines of Giacometti's studio on rue Hippolyte-Maindron photographed by Brassaï, January 1948.

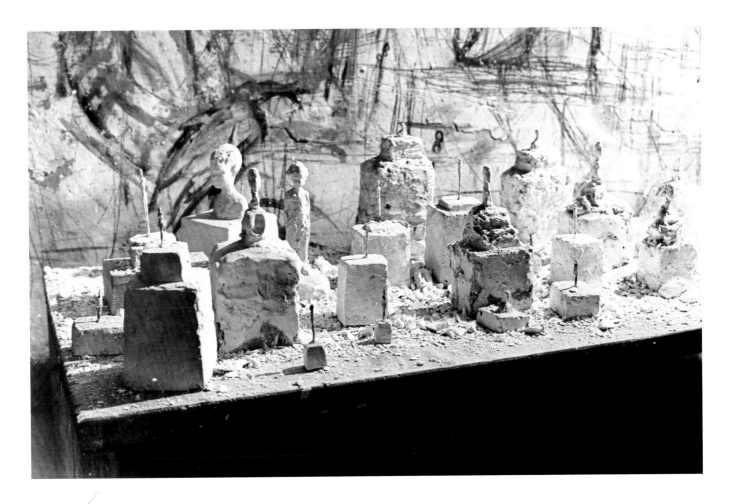

seems continuous with the human presence at its centre. Being and non-being are rendered equally: fugitive counterparts in a personal vision of reality, whose fabric, as we have seen, comprises appearance and disappearance.

Giacometti's portraits of Diego, in common with those of Annette, which evolved concurrently, demonstrate a shared, surprising characteristic. Both were rooted in the immediacy of the enclosed studio situation, the artist confronting the sitter from a distance of around 3 metres (9 feet). In that intense, fixed proximity the model was subjected to repeated and prolonged scrutiny, the features examined and re-examined, committed to memory and paint. Yet from that face-to-face relationship with known individuals there emerged likenesses that are not in any way specific or psychological. Indeed, as the portraits took shape, there is a sense that they moved further and further away from incidental appearance. Instead, Giacometti's quarry was something more fundamental, existing beyond the play of light across an individual's features or the intimation of personality. As his art now developed, a deeper subject was revealed – that of creating an equivalent for the human presence he encountered. In this sense, his portraits of Diego and Annette are that in name alone. Their character is more universal and ontological. In essence, they express the perceived awareness of another being.

The paintings of Annette, like those of Diego, suggest the sitter's presence in a flurry of lines and abbreviating brushmarks, drawing providing the foundation of both. In the tiny portrait *Bust of Annette* (1954, cat. 32), for example, the sitter is revealed through a complex network of marks, each providing the trace of a fleeting sensation. Collectively, these marks record an accretion of impressions. Proceeding from the flux of Annette's ever-changing appearance, the resulting image seeks an encapsulation of the presence to which the artist bore witness. Until 1956, Giacometti's portraits of his wife were mainly paintings. After that date the sculptures that he made of both sitters extended his concern with creating a material equivalent for a living being. In confronting both models, the busts that resulted can be regarded in the light of his illuminating statement, 'the closer you are to something, the more condensed your perception of it. In this case, what was condensed for me was width.'[48]

As in the framing device used in the paintings, the sitters appear compressed by the surrounding space. While the sculptures' lumpen appearance evokes the poignancy of flesh, their silhouettes seem eaten away by the space they occupy. In the case of the busts of Annette made in 1962, their outlines seem corroded (cat. 35). Also manifesting that reductiveness, the *Bust of Diego* (1955) has been reduced to a blade-like thinness (cat. 45). In one way, these are phenomenological aspects. A head is forever competing with the void into which it constantly moves; a figure seen in profile has no apparent depth. At the same time, however, in these works' relationship with space there is an intimation of something else and even more fundamental: the predicament of existence. Giacometti's depictions of Annette and Diego have an elusive quality that suggests the fragility of being. In exploring that condition further, his later portraits would attain an expressive depth that transcends the complexities of perception.

THE IMAGE OF MAN

Giacometti's first solo show in New York in 1948 was held at the Pierre Matisse Gallery and the accompanying catalogue contained an essay by Jean-Paul Sartre. Titled *The Quest for the Absolute*, Sartre's text exercised a profound influence on the way Giacometti's work was perceived by an American audience. Subsequently, it informed the responses of a range of commentators. The two men had first met in Paris in 1939. Giacometti was sitting alone in the Café de Flore when the younger man approached him with a request that the artist pay his bill. The ensuing conversation marked the beginning of an enduring relationship.

At the time of their meeting Sartre was engaged in writing *Being and Nothingness*. Published in 1943, that seminal text defined Sartre as one of the leading intellectuals associated with existentialism, the philosophical movement that dominated Paris in the 1940s. It was followed in 1946 by *Existentialism and Humanism*, Sartre's statement of doctrine that disseminated his ideas more widely. The essay was reprinted in 1957

Fig. 16 Alberto, Annette and Diego in the studio on rue Hippolyte-Maindron photographed by Alexander Liberman, 1952.

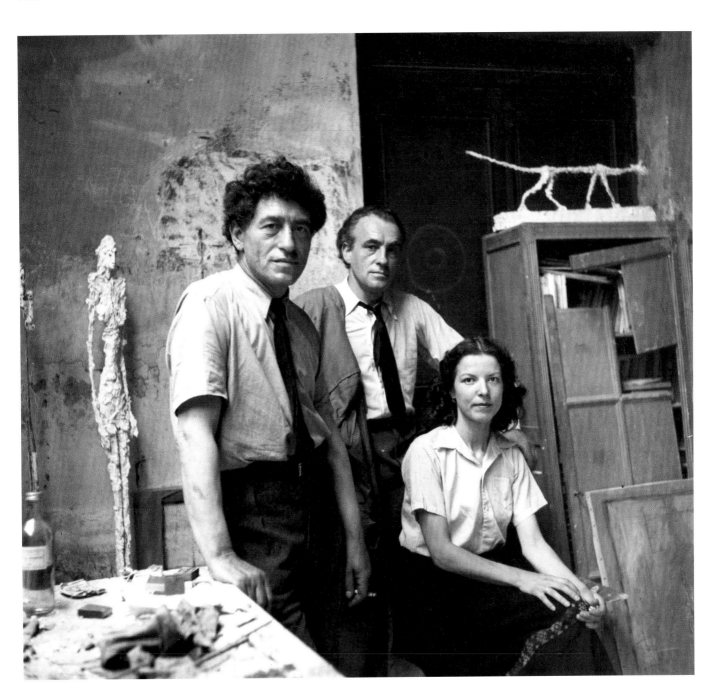

under the title *Existentialism and Human Emotions*. In that context, Sartre was able to state with justification that existentialism 'is all the rage'.[49] In essence, the philosophy he outlined in those key texts addressed the position of man in a godless universe. Without purpose or destiny, as Sartre saw it, 'man exists, appears on the scene, and only afterwards defines himself'.[50] Significantly he added, 'at first he is nothing'.[51] Sartre was at pains, however, to emphasise that his ideas opposed any intimation of passivity. Declaring that 'there is no reality except in action',[52] his central position was that man defined his place in the world through 'the ensemble of his acts'.[53] With subjectivity as the 'starting point',[54] through his existence man forged his essential nature.

In *The Quest for the Absolute*, Sartre drew on these ideas in erecting a framework for understanding Giacometti's art. Drawing a contrast with those earlier sculptors who had created an immobile, inert representation of man, he cited Giacometti's attempt to work without recourse to previous models as an approach in which it was 'necessary to start again from zero'.[55] Sartre's admiration for a way of working that involved coming to the model without prior knowledge is tangible in his observation, 'Giacometti himself is forever beginning anew.'[56] To reinforce the point of connection, Sartre's estimation of the sculptor's achievement referred to his own, earlier text: Giacometti's images of man were in his view 'impressive works, always mediating between nothingness and being'.[57] His endorsement was underpinned by an allusion to a paradigm of the new philosophy, namely the centrality of man's active, subjective existence. Giacometti's endeavour was, he affirmed, 'To give perceptible expression to pure presence.'[58]

In 1954 Sartre wrote a second appreciation of Giacometti's work. This appeared in the publication that accompanied the artist's exhibition at the Galerie Maeght in Paris and, like his first essay, it focused on the notion of presence. 'Giacometti,' he stated, 'becomes objective when he paints. He tries to capture the features of Annette or of Diego just as they appear in an empty room or in his deserted studio.'[59] Referring to his sculpture, he added, 'He confers on his statuettes a fixed, imaginary distance.'[60] Space – or the 'void', as Sartre called it – is his underlying theme. Crucially, the question addressed by Giacometti is presented as an existential one: 'Why is there something rather than nothing?'[61] Reinforced in this way, Sartre's reading of the artist's work gained currency. Published in *Arts Digest* in October 1954, Michel Seuphor's review of the Galerie Maeght exhibition observed, 'One wonders, after such a dialogue with Sartre, if Giacometti will ever be anything but the artist of existentialism.' He added, 'Whoever sees Giacometti's sculpture finds an eloquent illustration of Sartrian thought; whoever reads Sartre finds an exhaustive exegesis of Giacometti.'[62] That equation has recurred in numerous assessments of the artist's work ever since.

The year 1956 crowned a decade of progress. Following a series of successful exhibitions held in New York, London and Basel, Giacometti exhibited a major group of sculptures, *The Women for Venice*, at the French Pavilion at the Venice Biennale. His international reputation was consolidated. However, by the end of that year he had again succumbed to a sense of failure. He had begun a portrait of a new sitter, a Japanese professor of philosophy named Isaku Yanaihara (fig. 17). The two men met originally when Yanaihara had sought an interview with Giacometti. From the outset the sittings went badly, and Giacometti felt defeated. He later recalled, 'It had seemed to me that I'd made some progress, a little progress, until the time when I started working with Yanaihara. Since then, things have been going from bad to worse.' Artistic impotence now again threatened: 'I'm right back where I was in '25!'[63]

Yanaihara's first visit to the studio was in September 1956 and, with the exception of 1958, he visited Paris for sittings every year until 1961. Throughout that period Giacometti persisted with a task that he felt to be hopeless. As before, the gap

opened up between what he saw and his ability to reproduce that visual experience. In part, this may be attributed to the developments that had occurred in the interim. Giacometti now sought an equivalent for what was seen and, also, his experience of seeing. The portraits of Yanaihara that resulted are remarkable evocations of that struggle. Yanaihara is presented almost as an apparition. In each the figure is as substantial – or not – as the enveloping space. As we have seen, Giacometti had referred to a reality that becomes 'doubtful because its projection in my brain is doubtful, or partial'. In the paintings of Yanaihara, the intangible and uncertain nature of subject experience was conveyed with an extraordinary immediacy.

Around the same time, Giacometti continued to make portraits of a range of sitters. In addition to Annette, Diego and Yanaihara, there were paintings and sculptures of Annetta, the playwright Jean Genet (cat. 51), the collector David Thompson (cat. 52), the photographer Eli Lotar and Giacometti's biographer James Lord (cat. 54). The last of these left a valuable account of the artist's life and also an illuminating record of sitting for his portrait. During the course of eighteen sessions that took place in 1964, Lord was subjected to the artist's persistent visual interrogation. As with Yanaihara, Giacometti experienced a constant sense of the impossibility of the task and his

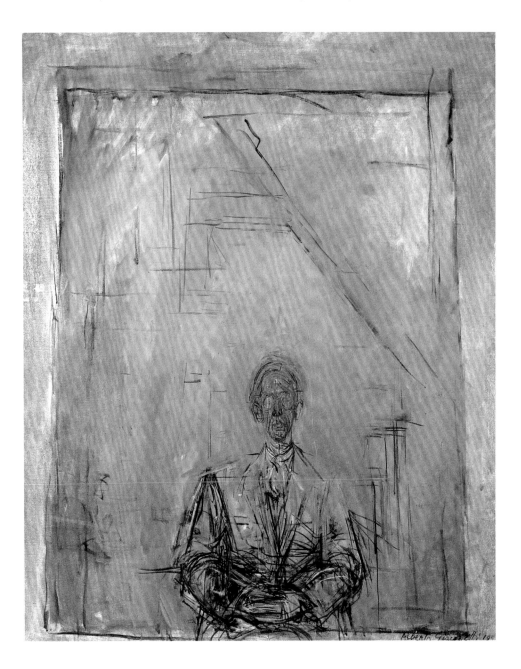

Fig. 17 *Isaku Yanaihara*, 1958

inability to undertake it. At the outset he declared, 'the more one works on a picture, the more impossible it becomes to finish it'.[64] After repeated protestations of difficulty, during which the image came and went, in the thirteenth sitting he admitted, 'It's abominable. It's hopeless.'[65] The final sitting began with the statement, 'I'm giving up painting for good. It's horrible.'[66]

These despondent remarks hardly accord with the photographic record of the progress of the portrait that has survived, nor with the finished work. However, they provide a telling insight into Giacometti's thinking. The connections with existentialist theorising are apparent. Sartre's philosophy placed a huge burden of responsibility on the individual: 'Man is nothing else but what he makes of himself. Such is the first principle of existentialism. It is also what is called subjectivity.'[67] In depicting his sitters – alone, as if enveloped by a void – Giacometti was keenly aware of the isolation enforced by individual experience. There were other links too. The responsibility for action identified by Sartre necessarily entailed a consequent sense of anguish, which has also been taken as a characteristic of existentialist thought: 'A man chooses and makes himself'.[68] Giacometti's own dogged, single-minded imperative to fulfil his stated aims can be seen in the context of the premium placed by Sartre on solitary effort.

With anguish there was also the constant anticipation of failure. Samuel Beckett, with whom the artist was closely associated in post-war Paris, later encapsulated this predicament in his 1983 prose work *Worstward Ho*: 'All before. Nothing else ever. Ever tried. Ever failed. No matter. Try again. Fail again. Fail better.'[69]

In that respect too, Giacometti's activity has affinities with existentialist writers such as Beckett (fig. 18). At every step the artist was aware of his own fallibility, the prospect of failure ever present. Interviewed in 1961, he stated, 'I try to do the same thing that I found impossible to do thirty years ago. It seems as impossible to me now as it was then, totally impossible even, all it can lead to is failure.'[70]

It is tempting therefore to see Giacometti's work in the light of existentialism. However, that would, in the final analysis, be a simplification. As we have seen, at the outset his concerns were focused on making art as 'a means of seeing'.[71] The intellectual atmosphere of post-war Paris undoubtedly informed his progress, and his ideas and opinions certainly coloured the debates that grew up around him. But, in the midst of that milieu, Giacometti remained an individual, an artist centred on an obsessive agenda that remained free of philosophical theorising and, ultimately, his. The primacy of his own experience, the ethos of persistent effort, and his ongoing struggle with a seemingly hopeless activity were deeply ingrained at a deeper, personal level. Four years before his death, he could express his self-contained aims succinctly: 'Basically I now only work for the sensation I get during the process. And if I am able to see better, if as I leave I see reality slightly differently, deep down, even if the picture doesn't make much sense or is ruined, in any event I have won. I have won a new sensation, a sensation I had never experienced before.'[72]

Fig. 18 Giacometti with Samuel Beckett in Paris, photographed by Georges Pierre, 1961. At this time Giacometti was working on a set design for a production of *Waiting for Godot* at the Théâtre de l'Odéon.

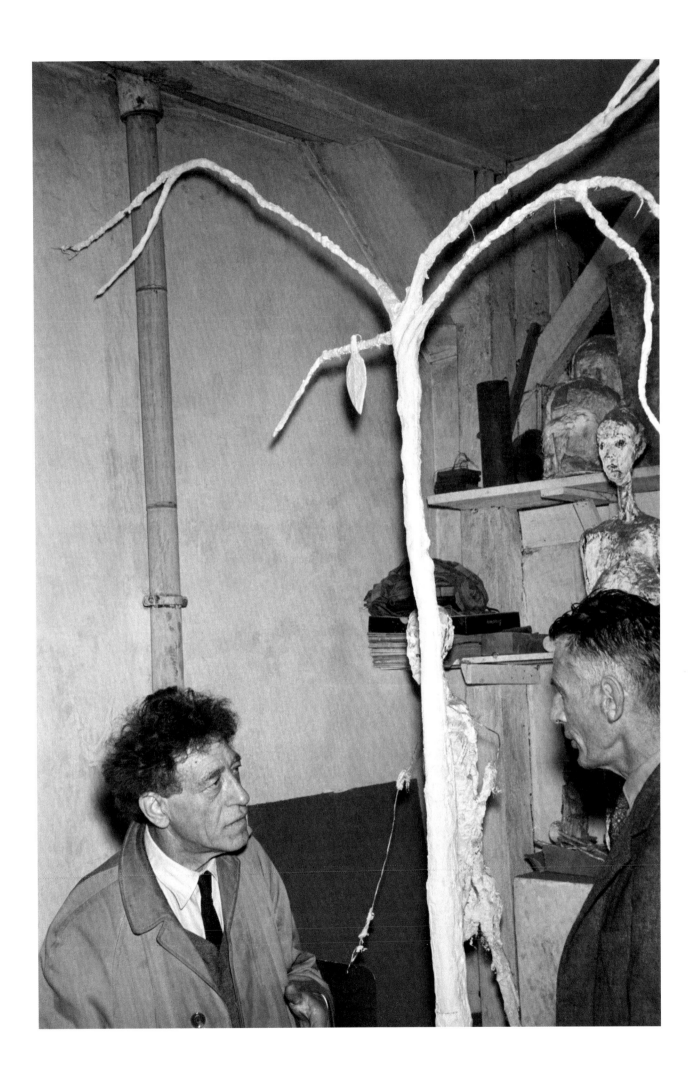

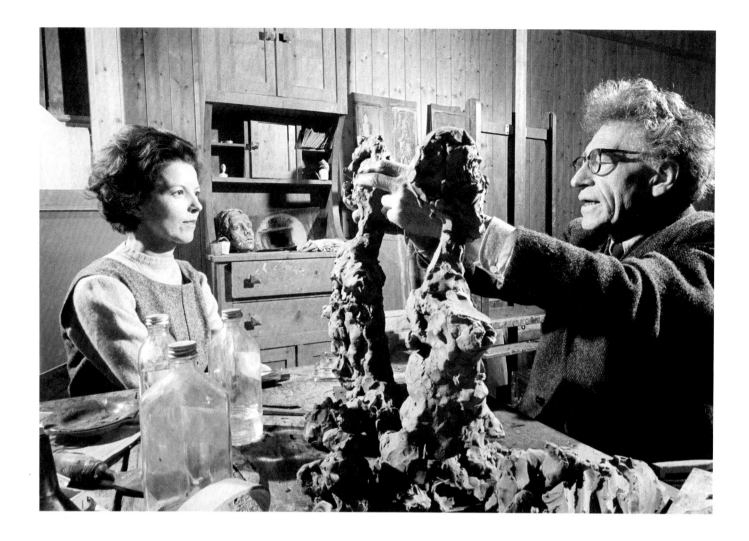

LAST PORTRAITS

The sittings with Yanaihara finally came to an end in September 1961. During the preceding five years Giacometti had come to believe that the difficulties he had experienced had taken him back to the impasse he had first reached in 1925. In the preface to *Paris Without End*, the series of lithographs that he published in 1963, he wrote: 'I do not know who I am, nor what I am doing, nor what I want.'[73] Even so, and in spite of his failing health, Giacometti's final years saw an undiminished appetite for work, a central part of which continued to be his engagement with portraiture.

Between 1962 and 1965 he created a magnificent series of ten portrait busts of his wife (fig. 19). These portraits of Annette were a renewed and sustained attempt to accomplish his long-standing ambition 'to succeed, just for once, in making a head like the head I see'.[74] Yet, as these remarkable sculptures show, the likeness he achieved was one now filtered through the subjective lens of memory and compassion. Echoing his early fascination with Egyptian portraiture, they have a closely observed presence that is at once imperious yet fragile. Alongside that activity, Diego continued to be a regular sitter although, with his well-known features long impressed on the artist's inner store of images, the portraits that Giacometti created arose from a combination of observation and recollection. Indeed, as well as drawing on both these different sources of visual information in creating portraits of Annette and Diego, Giacometti moved freely between painting and sculpture.

To some extent this had always been the case. Earlier, he had commented, 'There is no difference between painting and sculpture. I have been practising them both indifferently,

Fig. 19 Giacometti working on a bust of his wife, Annette, by an unknown photographer, *c*.1962.

each helping me to do the other.'[75] Now, however, the two ways of working seemed not only complementary but interlinked and mutually reinforcing. The insights gained in either one of these media migrated to the other. For example, the modelling of *Annette IV* (1962) has a lively, plastic quality that echoes the sensuous movement of paint (cat. 34). Similarly, the late bust of Diego, *Chiavenna Bust I* (1964) has a tactile quality, an assertive expressiveness in the handling of the original clay that preserves the artist's hand movements (cat. 62). Most striking in these sculptures is the tension sustained between looking and feeling. It is as if the sculptor were probing an appearance not only visually but also with his hands. In the paintings of Annette and Diego, the rendering of the heads conveys a feeling of mass that transcends their expression in two dimensions. This is not true of the figures as a whole. The torsos tend to be suggested in a hatched network of brushmarks. But in concentrating on the head – always the site of Giacometti's most intense scrutiny – this part of his sitters' anatomy has startling immediacy and a vital intensity.

While the depiction of the human head had always been his principal preoccupation, the head itself contained a focal point that exercised an even greater fascination. For Giacometti, the gaze – the look that returned his own penetrating stare – was invested with primary importance. 'If I can hold the look in the eyes,' he observed, 'everything else follows.'[76] Towards the end of the sittings with Yanaihara, the artist found a new model, a young woman, who, among all his other sitters, he particularly associated with the quality of her gaze. The two met in a bar, Chez Adrien, on the rue Vavin in Montparnasse in 1958. Caroline was the name she used, although her real name was Yvonne Poiraudeau. Born in 1938 in western France, she had moved to Paris and taken up a shady existence that involved her with drug dealers, thieves and prostitutes. Although she claimed not to be a prostitute herself, her lifestyle seems to have attracted the artist, as did her appearance. At the time of their meeting, she had short brown hair and brown eyes that the much older man admired. Within a short period his admiration had deepened.

The two began spending more time together in 1959. The extent of the artist's commitment can be surmised from the events that ensued. Following a period when she disappeared, it emerged that Caroline had been arrested and imprisoned, having been involved with a gang of thieves. Giacometti then attempted to assist with her release by negotiating with the judicial authorities. Her liberty restored, Caroline's rehabilitation was further supported with Giacometti's financial help and the gift of a well-appointed apartment. The artist himself remained living in the impoverished surroundings of his studio. However, the episode had set a seal on their relationship. From October 1960 Caroline began sitting regularly, becoming, in this final phase of the artist's life, his main model. During the course of the next five years, when Caroline willingly participated in the long, exacting sessions that he required, Giacometti painted no fewer than thirty portraits of her.

The sittings were held at night. Usually they commenced at nine, following straight after the preceding sessions with Annette, and continued beyond midnight. By this stage, Giacometti's nocturnal activity had become established, and it was his practice to work later and later. This meant that artificial light became part of the process of looking. As a result, the Caroline that emerges from the extraordinary odyssey they shared has an uncanny presence. To an unusual degree the sitter seems bathed in a light that progressively dissolves her surroundings. Always seated, a range of different appearances is revealed. Certain portraits convey her facial expression. Others seem to penetrate beneath the skin, almost exposing the skull. It seems as if the artist were peeling back a succession of layers only to find, each time, another veil, another semblance to penetrate. But within that process of attrition, gradually there emerged

a tightening focus, as if the artist were drawing closer to his quarry. In the two later portraits painted in 1965, both now in the Tate's collection, the artist seemingly abandons description of the figure, which is sketched summarily (cats 60 and 61). Instead, the main focus is on the sitter's head, face and, ultimately, the eyes. In the artist's own words, Caroline had 'eyes like a bird's cry'.[77]

Among Giacometti's last portraits were busts of Diego and Lotar. In addition to the so-called *Chiavenna Bust I* mentioned earlier, the large sculpture *Diego Seated* (1964–5) took an assertive material quality to an unprecedented extent (cat. 65). In that work, the clay seems almost piled, describing the sitter's flesh with an affecting resignation. At the same time, Giacometti worked on three busts of Lotar. By this time, the artist's health was poor. Following an operation for stomach cancer on 1 February 1963, he had rallied, but his energy was depleted. He lived just three more years, dying on 11 January 1966 at the age of sixty-four, the same age at which his father Giovanni had died. *Bust of Lotar II*, like *Diego Seated*, has a strange, earthy quality (cat. 64). In both works, the head of the sitter seems to emerge from a conglomeration of inchoate matter. Also disarming is the degree of resemblance between his depiction of these two sitters. In some uncanny way, their features have migrated, as if having shed the specifics of identity. In that respect, Giacometti's portraiture embraced its underlying subject. Rooted in the particulars of its individual subject matter, it attained the universality that lies beyond appearance. Yet, to the end, his entire endeavour remained as it was at the outset: 'just to reproduce on canvas or in clay what I see'.[78]

Fig. 20 A cabinet in Stampa, painted by Giovanni. *Portrait of the Artist's Father* (c.1932, cat. 18) is on the shelf above, second from right. *Portrait of Diego* (1914, cat. 1) is third from right.

NOTES

1 Quoted in James Lord, *Giacometti: A Biography* (Farrar Strauss Giroux, New York, 1985), p.258.

2 'My Long March: An Interview with Pierre Schneider', originally published in *L'Express*, no. 521, 8 June 1961, p.48, reprinted in Ángel González, *Alberto Giacometti: Works, Writings, Interviews* (Ediciones Polígrafa, Barcelona, 2006), p.141.

3 Quoted in Lord, op. cit., p.258.

4 Ibid., p.258.

5 González, op. cit., p.139.

6 'Why Am I a Sculptor? An Interview by André Parinaud', first published in *Arts*, no. 873, 13–19 June 1962, p.1, reprinted in González, op. cit., p.146.

7 Ibid., p.151.

8 Interview with Jean-Marie Drôt, quoted in Yves Bonnefoy, *Alberto Giacometti: A Biography of His Work* (Flammarion, Paris, 1991), p.118.

9 González, op. cit., p.139.

10 Quoted in James Lord, *A Giacometti Portrait* (Faber & Faber, London, 1981), p.38.

11 Ibid., p.39.

12 González, op. cit., p.150.

13 Ibid., p.151.

14 Ibid.

15 Ibid.

16 González, op. cit., p.139.

17 Quoted in Lord, op. cit., *A Giacometti Portrait*, p.77.

18 González, op. cit., p.152.

19 Ibid., p.151.

20 Alberto Giacometti, 'Yesterday, Quicksand' ('Hier, sables mouvants'), *Le Surréalisme au service de la révolution*, no. 5, May 1933, pp.44–5, quoted in Lord, op. cit., *Giacometti: A Biography*, p.9.

21 Ibid., p.19.

22 González, op. cit., p.139.

23 Ibid.

24 Quoted in Bonnefoy, op. cit., p.393.

25 González, op. cit., p.146.

26 Ibid.

27 Ibid.

28 Ibid., p.147.

29 Ibid.

30 Letter from Giacometti to Pierre Matisse on the occasion of his exhibition at the Pierre Matisse Gallery, New York, 19 January –14 February 1948, reprinted in González, op. cit., p.132.

31 Quoted in Alexander Watt, 'Alberto Giacometti: pursuit of the unapproachable', *Studio International*, vol. 167, no. 849, p.23.

32 González, op. cit., p.151.

33 Ibid., p.147.

34 Ibid., p.140.

35 Ibid., p.148.

36 Ibid.

37 Ibid., p.139.

38 Ibid., p.148.

39 Quoted in Bonnefoy, op. cit., p.254.

40 Letter from Giacometti to Pierre Matisse, González, op. cit., p.133.

41 González, op. cit., pp.140–1.

42 Ibid., p.143.

43 Ibid.

44 Ibid., p.150.

45 Ibid., p.141.

46 Quoted in David Sylvester, 'The residue of a vision', *Alberto Giacometti: Sculpture Paintings Drawings 1913–65*, exhibition catalogue (Arts Council of Great Britain, 1965), not paginated.

47 Quoted in Lord, op. cit., *A Giacometti Portrait*, p.39.

48 Quoted in Véronique Wiesinger, *Isabel and Other Intimate Strangers: Portraits by Alberto Giacometti and Francis Bacon*, exhibition catalogue (Gagosian Gallery, New York, 2008), p.234.

49 Jean-Paul Sartre, 'Existentialism', excerpted from 'Existentialism and Human Emotions' (1957), reprinted in *Basic Writings of Existentialism*, ed. Gordon Marino (The Modern Library, New York, 2004), p.343.

50 Ibid., p.345.

51 Ibid.

52 Ibid., p.355.

53 Ibid.

54 Ibid, p.344.

55 Jean-Paul Sartre, 'The Quest for the Absolute', reprinted in *Sartre: Essays in Aesthetics*, trans. Wade Baskin (Peter Owen, London, 1964), p.95.

56 Ibid., p.95.

57 Ibid., p.96.

58 Ibid., p.101.

59 Jean-Paul Sartre, 'Les Peintures de Giacometti', *Derrière le Miroir*, no. 65, Paris, 1954. Reprinted in *Les Temps Modernes*, Paris, 1954, pp.2220–32; and *Situations IV*, Paris Gallimard, 1964, pp.347–63; and op. cit., *Sartre: Essays in Aesthetics*, p.61.

60 Ibid., p.61.

61 Ibid., p.63.

62 Michael Seuphor, 'Giacometti and Sartre', *Arts Digest*, 10 October 1954, p.14.

63 Quoted in Lord, op. cit., *Giacometti: A Biography*, p.375.

64 Quoted in Lord, op. cit., *A Giacometti Portrait*, p.11.

65 Ibid., p.79.

66 Ibid., p.105.

67 Sartre, op. cit., 'Existentialism', p.345.

68 Ibid., p.346.

69 Quoted in James Knowlson, *Damned to Fame: The Life of Samuel Beckett* (Bloomsbury, London, 1996), p.674.

70 González, op. cit., pp.141–2.

71 Ibid., p.151.

72 Ibid.

73 Alberto Giacometti, 'Paris Sans Fin', in *Paris Sans Fin: Lithographies Originales de Alberto Giacometti* (Tériade, Paris, 1969).

74 Quoted in Bonnefoy, op. cit., p.53.

75 Ibid., p.436.

76 Ibid., p.382.

77 Quoted in Wiesinger, op. cit., p.243.

78 Quoted in Lord, op cit., *A Giacometti Portrait*, p.89.

Fig. 21 Stampa, Switzerland
photographed by Isaku Yanaihara, 1961.

CHRONOLOGY

1901

Alberto Giacometti is born on 10 October at
Borgonovo in the Bregaglia valley, Switzerland.
He is the first son of the painter Giovanni Giacometti
and his wife Annetta. His godfather is the Fauve
painter Cuno Amiet.

1902

Birth of Giacometti's brother Diego.

1904

Birth of their sister Ottilia. The family move to a
larger house in nearby Stampa (fig. 20).

1907

Birth of their youngest brother Bruno.

1909–10

Annetta inherits a house in Maloja in 1909, where
the family spend their holidays. Giacometti takes
up drawing. He works from nature, creates book
illustrations and makes portraits of his family.

1914

Giacometti makes his first sculpture, a small portrait
bust of Diego modelled in Plasticine.

1915–19

Giacometti attends the Evangelical Secondary School
at Schiers. In 1919 he enrols at the School of Fine Arts
and later the School of Arts and Crafts, Geneva (fig. 22).

1920–1

In May Giacometti travels with his father to Venice.
In November he visits Florence, then stays with relatives
in Rome until the following summer. Attempting to
make a bust of his hosts' eldest daughter, his cousin
Bianca, he abandons the work.

1922

In January 1922 Giacometti arrives in Paris to study at
the Académie de la Grande Chaumière. After 1925,
he attends intermittently until 1927.

1925

In February Diego joins Giacometti in Paris. Increasingly,
Giacometti finds the task of copying perceived reality
impossible. In November he exhibits for the first time at
the Salon des Tuileries.

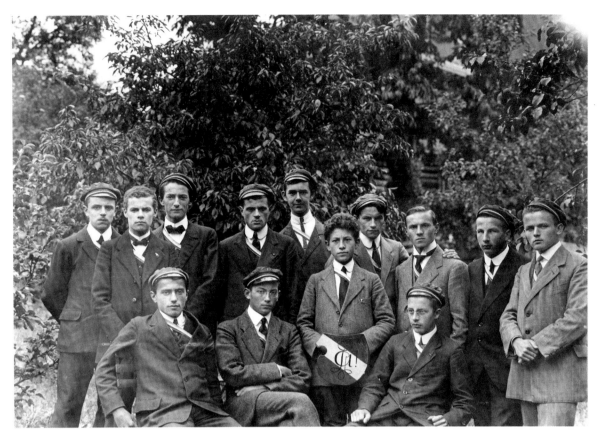

Fig. 22 Giacometti and a group of fellow students at the Evangelical Secondary School at Schiers, summer 1917. Alberto is standing, fifth from right.

1926

Inspired by Cubism and African and Oceanic sculpture, he works from memory and imagination in Paris. He continues to make portraits of his family during summer visits to Switzerland.

1927

In the spring Giacometti moves into the studio at 46 rue Hippolyte-Maindron.

1929

Giacometti's 'flat' sculptures are exhibited at Jeanne Bucher's gallery. His growing renown results in a one-year contract with the Pierre Loeb gallery. He is introduced into the Surrealist circle.

1930

Diego joins Giacometti permanently in Paris, assisting him with his artistic practice.

1931–2

Alongside his Surrealist work in Paris, he continues to work from models in Stampa and Maloja.

1932

In May the Galerie Pierre Colle mounts Giacometti's first solo exhibition.

1933

On 25 June Giovanni dies. Giacometti distances himself from the Surrealists.

1934–5

From 1934 Giacometti re-engages with making art from life in Paris. His sitters are Diego and the professional model Rita Gueyfier. Giacometti breaks with the Surrealist group. He meets Isabel Nicholas, who becomes a close friend and model.

1937

Created in Stampa, Giacometti's portrait of his mother is a turning point that anticipates his post-war work. On 10 October Ottilia dies giving birth to Giacometti's nephew, Silvio Berthoud.

1938

Giacometti is knocked down by a speeding car on the Place des Pyramides. An injured right foot leaves him with a slight limp.

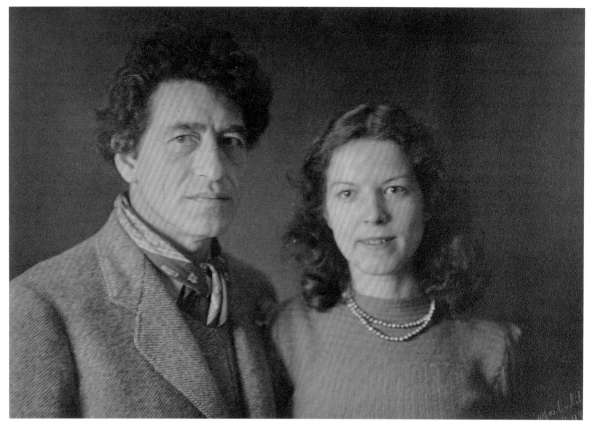

Fig. 23 Alberto with his wife Annette photographed
by Andrea Garbald, 1949.

1939

Giacometti meets Jean Paul Sartre for the first time.
On the outbreak of war, Diego and Giacometti are in
Maloja. After reporting for duty, Alberto is declared
unfit and Diego is assigned to a transport battalion.
Both subsequently return to Paris.

1940

Fleeing the German invasion of Paris, Giacometti and
Diego attempt to escape, but eventually return. Giacometti
remains there for a year after the armistice is signed.
Made from memory, his sculptures begin to get smaller.

1941–4

Giacometti leaves Paris for Geneva in December 1941.
Remaining in Switzerland for the rest of the war,
he models minuscule figurines. In October 1943 he
meets his future wife, Annette Arm.

1945

Giacometti returns to Paris carrying the work made in
Switzerland in matchboxes. He experiences an epiphany
on emerging from a cinema on the Boulevard
Montparnasse. Following this, he strives with renewed
intensity to express his subjective view of the world.

1946–7

Giacometti creates tall, elongated sculpted figures.
In July 1946 he is joined by Annette. Diego and
Annette become Giacometti's principal models,
and increasingly portraiture becomes his main
preoccupation. He recommences painting.

1948

In January Pierre Matisse holds the first solo exhibition
of Giacometti's new work in New York. The accompanying
catalogue contains Sartre's first text on Giacometti,
The Quest for the Absolute.

1949

In July Giacometti marries Annette, his main female
model, who joins him on visits to Stampa and Maloja
(fig. 23).

1950

Giacometti is invited to show his work in the French
section at the Venice Biennale alongside Henri Laurens.
He withdraws when he sees the marginal place allotted
to Laurens.

1951

Giacometti's post-war works are shown in Paris for the
first time at the Galerie Maeght.

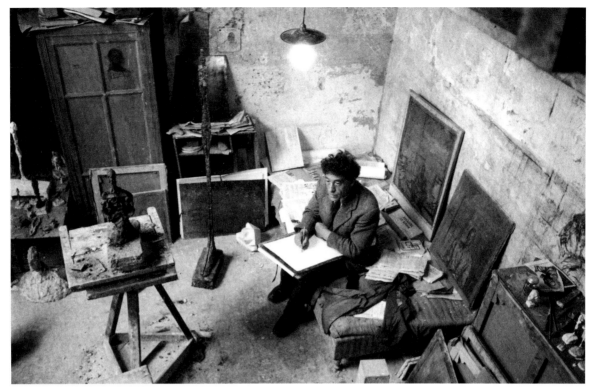

Fig. 24 Giacometti in his studio
photographed by Sabine Weiss, 1950s.

1952

Giacometti's work is included in group exhibitions in London, Paris, Zürich, Basel and various cities in the United States.

1954

Giacometti meets the writer Jean Genet, who becomes a regular sitter for him until 1957. Sartre writes another essay, *The Paintings of Giacometti*, which appears in the publication that accompanies the artist's second exhibition at the Galerie Maeght.

1955

The first retrospectives of Giacometti's work are held in London, New York and Germany. In November he meets the Japanese philosopher Isaku Yanaihara.

1956

Giacometti exhibits his series of sculptures, *The Women of Venice*, in the French Pavilion at the Venice Biennale, consolidating his international reputation. Yanaihara begins sitting for him, but the sessions trigger an artistic crisis.

1957

Jean Genet publishes *The Studio of Alberto Giacometti*, his preface to Giacometti's exhibition at Galerie Maeght.

1958

Giacometti meets Yvonne Poiraudeau, known as Caroline. She becomes his principal female model during the final phase of his life. In December he is invited to take part in a competition to conceive a monumental sculpture for the Chase Manhattan Bank Plaza in New York, but he withdraws.

1960

From October Caroline begins posing for Giacometti regularly, becoming the subject of at least thirty portraits.

1961

Giacometti has his final sittings with Yanaihara. Samuel Beckett invites the artist to design the set for a new production of *Waiting for Godot* at the Théâtre de l'Odéon.

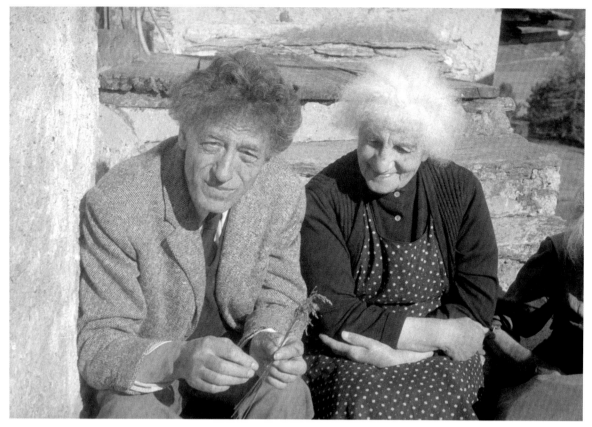

Fig. 25 Alberto and his mother Annetta outside the house in Stampa, Stampa/Bergell, photographed by Ernst Scheidegger, 1960.

1962

Giacometti wins the Grand Prize for Sculpture at the Venice Biennale. A major retrospective exhibition of his work is held at the Kunsthaus in Zürich. He starts work on a series of portrait busts of Annette.

1963

Giacometti is diagnosed with stomach cancer and undergoes an operation.

1964

On 25 January Giacometti's mother dies in Stampa (fig. 25). The photographer Eli Lotar starts posing for a series of busts.

1965

Giacometti makes his last sculptures of Diego and Lotar. Retrospective exhibitions take place in London (Tate Gallery), New York (Museum of Modern Art) and Humlebaek, Denmark (Louisiana Museum). He receives the National Arts Award from the French Ministry for Cultural Affairs.

1966

Giacometti dies on 11 January at the Cantonal Hospital, Chur. He is buried in Borgonovo cemetery on 15 January.

Fig. 26 Giacometti working in his studio in Maloja photographed by Ernst Scheidegger, late 1950s.

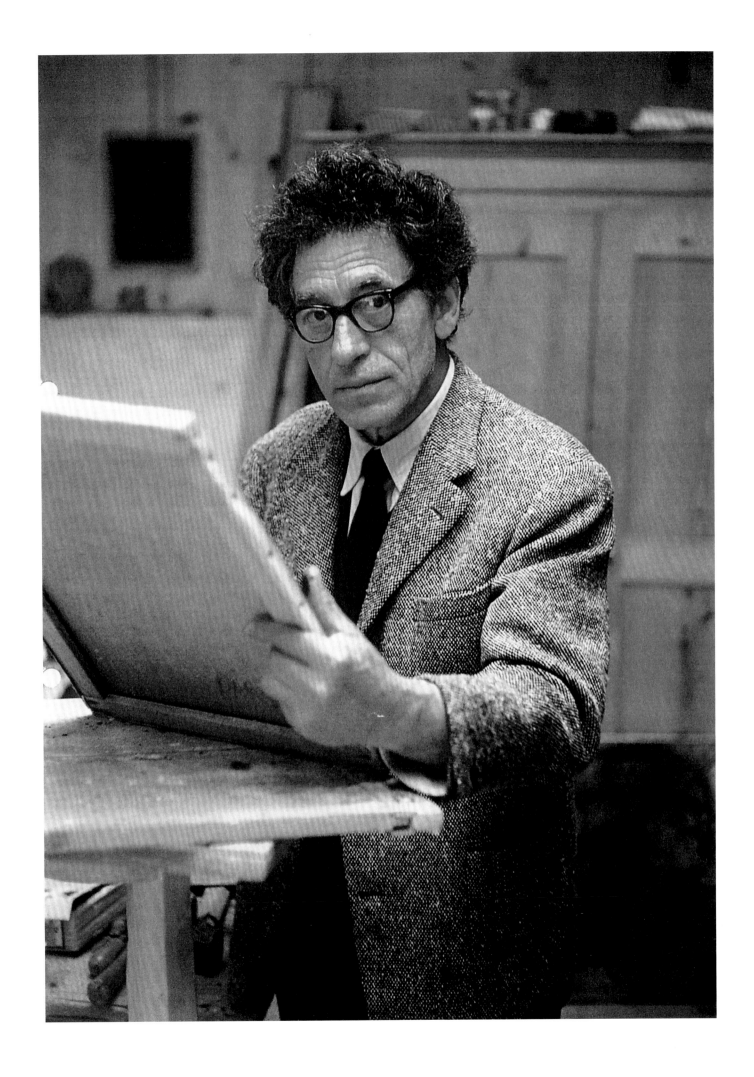

FAMILY PORTRAITS

Alberto Giacometti was born in 1901 in Borgonovo, Switzerland, a small village in the Bregaglia valley close to the Italian border. The family moved to Stampa, a nearby village, in 1904. Five years later Alberto's mother, Annetta, inherited a house at Maloja, at the top of the valley, which became a second home. Situated within a mountainous region, the valley was the scene of Giacometti's childhood and he remained closely attached to it, returning at regular intervals throughout his adult life.

Giacometti's father, Giovanni, was a Post-Impressionist painter who achieved distinction in the years following the First World War. His example influenced the development of his eldest son's early interest in art. From the age of ten, Giacometti made illustrations and drawings of his surroundings. Later he made portraits of his father and mother, his brothers Diego and Bruno, and his sister Ottilia. His first sculpture, made at the age of thirteen, was a bust of Diego. In May 1920 Giacometti visited Venice with his father, later going on to Padua and Florence. The art he saw there confirmed his wish, which he confided to his father, to be 'a painter or a sculptor', and in December 1921 he left Stampa to begin studying in Paris.

1

Portrait of Diego, 1914
Bronze
260 x 140 x 110mm
Collection P.C.C.

This is Giacometti's first sculpture, made from life when he was aged thirteen. It depicts his younger brother Diego, who was born just over a year after Alberto. Giacometti had begun making drawings at the age of ten. Having seen reproductions of some busts, he (in his own words) 'felt the urge to try my hand at the same thing'. His father supplied him with Plasticine in which the original for this bronze cast was modelled. The artist kept the head throughout his life and later said that he always regarded this youthful attempt with 'a degree of envy and nostalgia'.

2
*Ottilia, c.*1920
Oil on card
421 x 270mm
Collection Fondation Giacometti, Paris,
inv.1994-0590-1 (AGD 240)

This portrait depicts the artist's sister, Ottilia, who was
aged around sixteen or seventeen at the time it was
painted. Giacometti rarely dated his early work, but it
seems likely that he completed this painting shortly
before leaving the family home in Stampa, Switzerland,
to study art in Paris where he arrived in January 1922.
Already confident in its use of bold colour and broad
brushwork, it reveals the influence of his father Giovanni's
own stylistic affinity with Post-Impressionism. Ottilia sat
frequently for both her father and brother at this time,
and would be the subject of later portraits by Alberto.

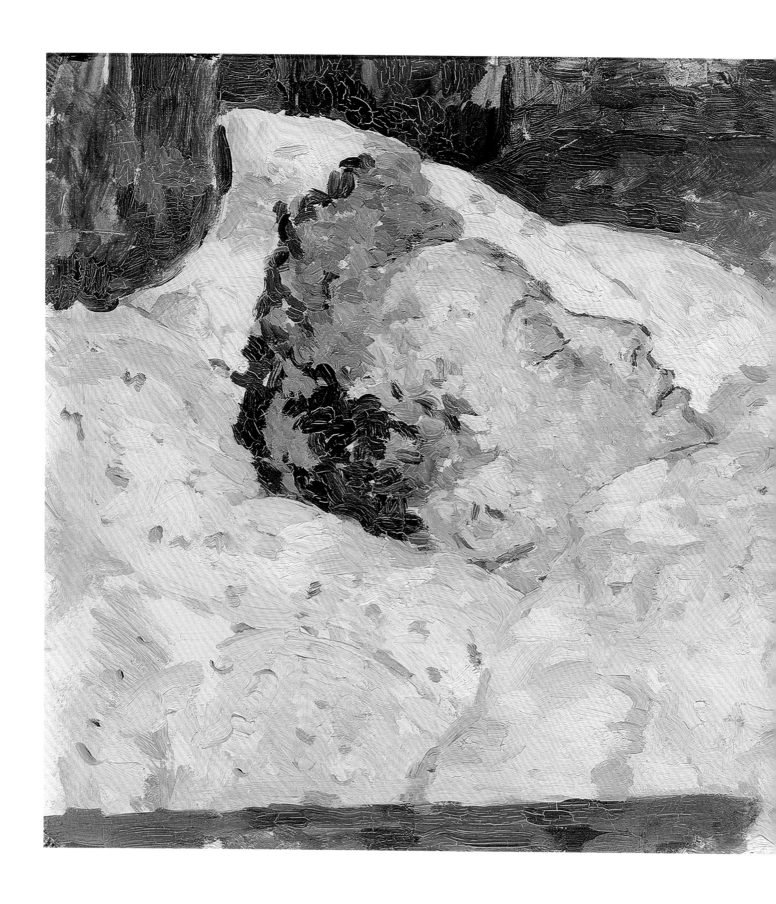

3
Bruno Asleep in Bed, 1920
Oil on cardboard
325 x 455mm
Kunsthaus Zürich, Bequest Bruno Giacometti, 2012

In the summer of 1920, which Giacometti spent at the family holiday home in Maloja, Switzerland, he painted two portraits of his youngest brother, Bruno, of which this is one. Earlier that year he had accompanied his father to Venice and spent a month studying the work of Titian, Veronese and Tintoretto. Moving on to Padua, the Arena Chapel frescoes by Giotto had made an even deeper impression. Despite these revelations, Giacometti continued to absorb a range of different influences. As this portrait shows, his own work remained indebted to his father's Post-Impressionist style.

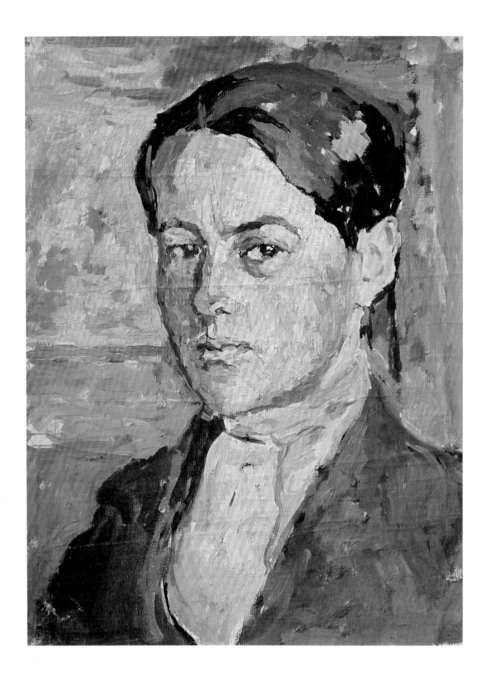

4

Diego, c.1920
Oil on canvas
364 x 283mm
Kunsthaus Zürich, Bequest Bruno
Giacometti, 2012

In 1915 Giacometti enrolled
as a boarder at the Evangelical
Secondary School at Schiers,
a village in the Landquart valley,
forty-five miles from his home in
Stampa. As a student there, he
painted still-life and landscape
subjects, but also made portraits
of his schoolfriends. Indeed,
his increasing involvement with
portraiture dates from that time.
This painting of Diego is one of a
later group of family portraits. Like
those of Ottilia and Bruno, which
are close in date, it is characterised
by Giacometti's confident handling
in depicting the sitter's features.

5

*Portrait of a Young Woman
(Maria Giacometti-Meuli)*, 1921
Oil on canvas
605 x 505mm
Bündner Kunstmuseum Chur,
Depositum aus Privatbesitz

In the spring of 1921 Giacometti
experienced an artistic setback.
While staying with relatives in
Rome, he spent several months
working on a bust of his cousin
Bianca, with whom he had fallen
in love. The attempt was abortive
and, discarding the work, he now
doubted his ability as a sculptor.
Even so, the painted portraits
he made in the aftermath of that
episode remained confident.
This portrait depicts the wife of his
uncle Otto, and is one of several
made while living at his family's
homes in Switzerland that summer.
In contrast to his earlier family
portraits, the palette has darkened.

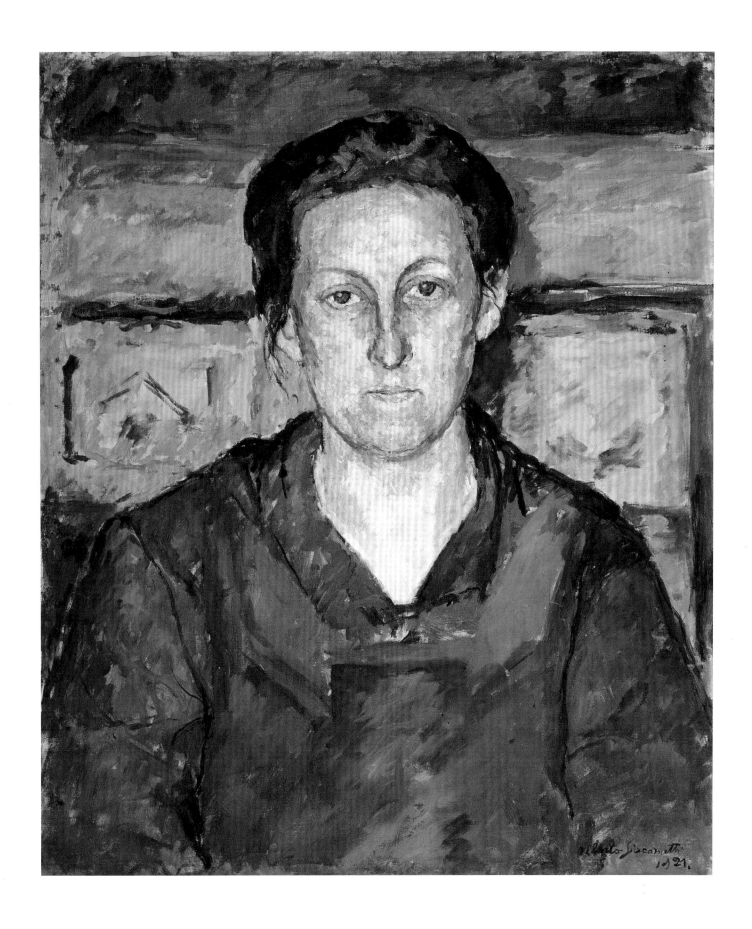

6

The Artist's Mother, 1921
Marble
320 x 195 x 60mm
Kunsthaus Zürich, Alberto
Giacometti-Stiftung, Gift of Bruno
and Odette Giacometti, 1988

The subject of this marble relief is
the artist's mother. Relief sculpture
is extremely rare in Giacometti's
oeuvre, and this early work was
made when the youthful artist
was looking at a range of different
artistic models. In 1919 his father
had asked him, 'Do you want to be
a painter?' His reply was, 'A painter
or a sculptor.' This relief was made
when Giacometti was experimenting
with both means of depiction.
Based on a much earlier drawing
made by his father, it also seems
to have been influenced by seeing
ancient Egyptian portrait sculpture
during a visit to Florence in 1920.

7

Annetta, by Giovanni Giacometti,
1908–10
Chalk on paper
432 x 303mm
Kunsthaus Zürich, Alberto
Giacometti-Stiftung, Gift of Bruno
and Odette Giacometti

This drawing of Annetta was made
by Giacometti's father, Giovanni,
when the sitter was in her late
thirties. Giovanni's own parents
encouraged his artistic aspirations
from an early age, and he studied
in Munich and Paris. His subsequent
reputation as a painter of distinction,
both in Switzerland and abroad,
dates from the First World War
onwards. This drawing precedes
that recognition and was made
around the time that Annetta
inherited a house near Maloja from
her uncle. The family had spent
their summers there since 1901,
and Giacometti continued that
pattern throughout his life.
Giovanni had a studio at Maloja
that was also used by his son.

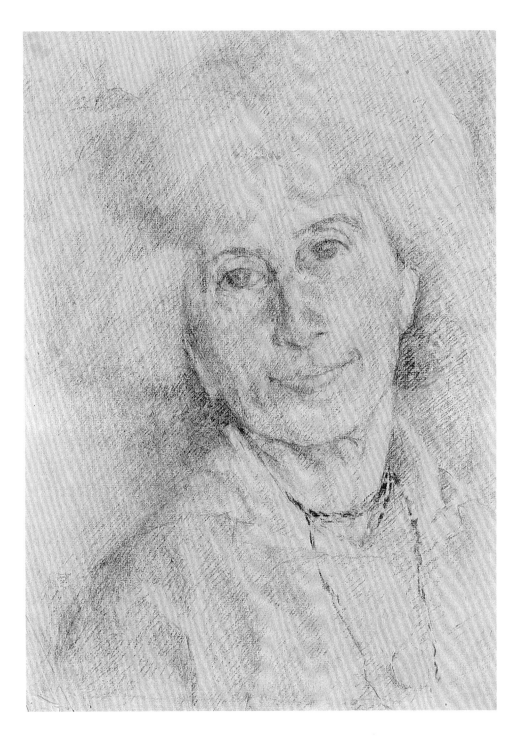

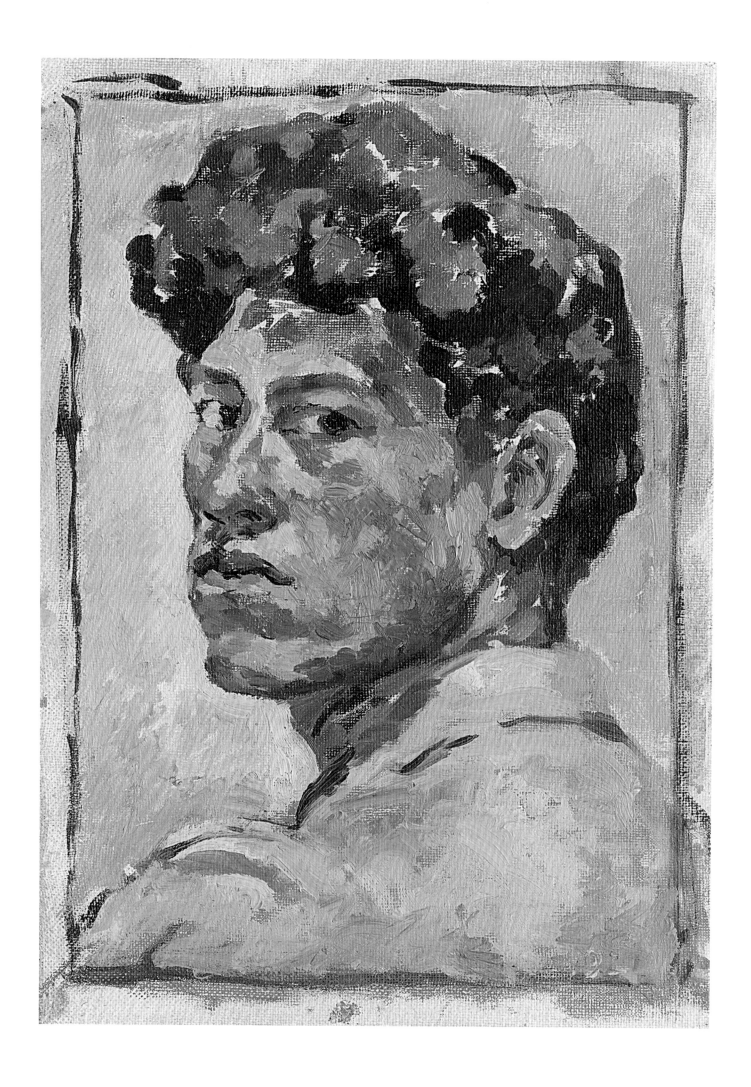

8
Small Self-portrait, 1921
Oil on canvas
345 x 245mm
Kunsthaus Zürich, Bequest Bruno Giacometti, 2012

This painting is closely related to a larger, full-figure
self-portrait, which was also completed in 1921. By this
time Giacometti had made several self-portraits, and
this pair of works is the summation of his progress
with himself as model. In the larger work, he depicted
himself painting in his father's studio. In this smaller
work, he focuses intently on his own features.
Made shortly before he began studying in Paris,
the two portraits mark a high point of his early, Post-
Impressionist style. Giacometti subsequently painted
only two further self-portraits, although he continued
to make drawings of himself.

9

Diego standing in the Living Room, Stampa, 1922
Oil on canvas
636 x 502mm
Collection Fondation Giacometti, Paris,
inv.1994-0569 (AGD 230)

This portrait of Diego is inscribed with the date
'11.11.1922'. It would seem that Giacometti might have
begun the portrait as a way of marking his brother's
twentieth birthday, which fell on 5 November 1922.
By then Giacometti had begun living in Paris but, initially
at least, he continued to make long return visits to
Stampa. The portrait was made during one such visit,
its background depicting objects and furniture belonging
to the living room in his parents' home. It thus marks
the beginning of what would be a pattern of parallel
activity, his portraits in Switzerland coexisting with more
experimental work in Paris.

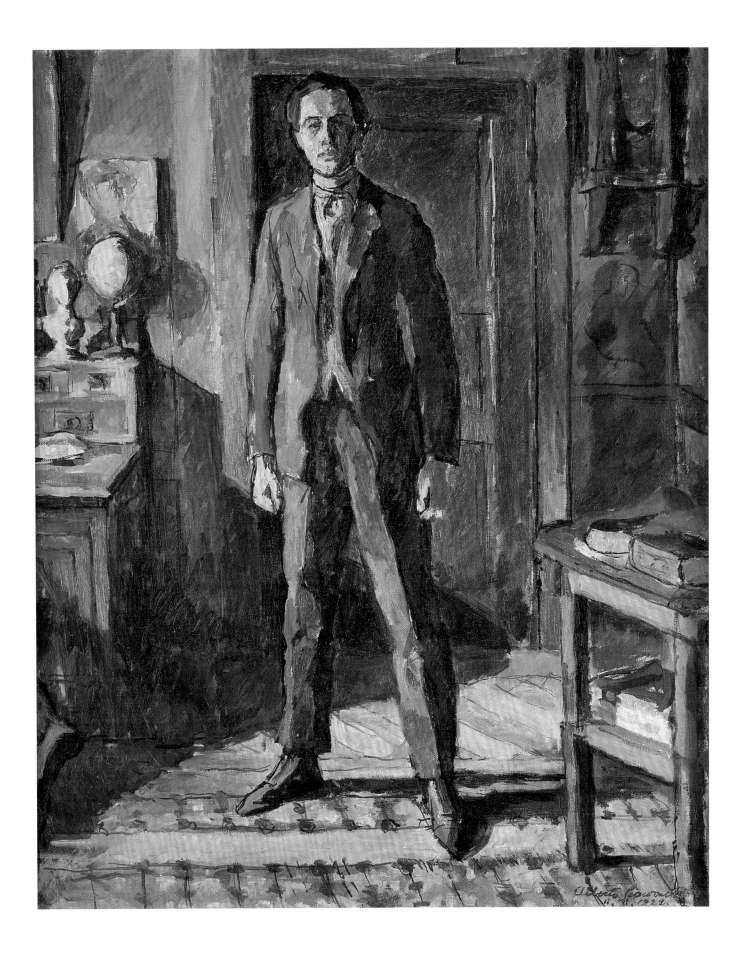

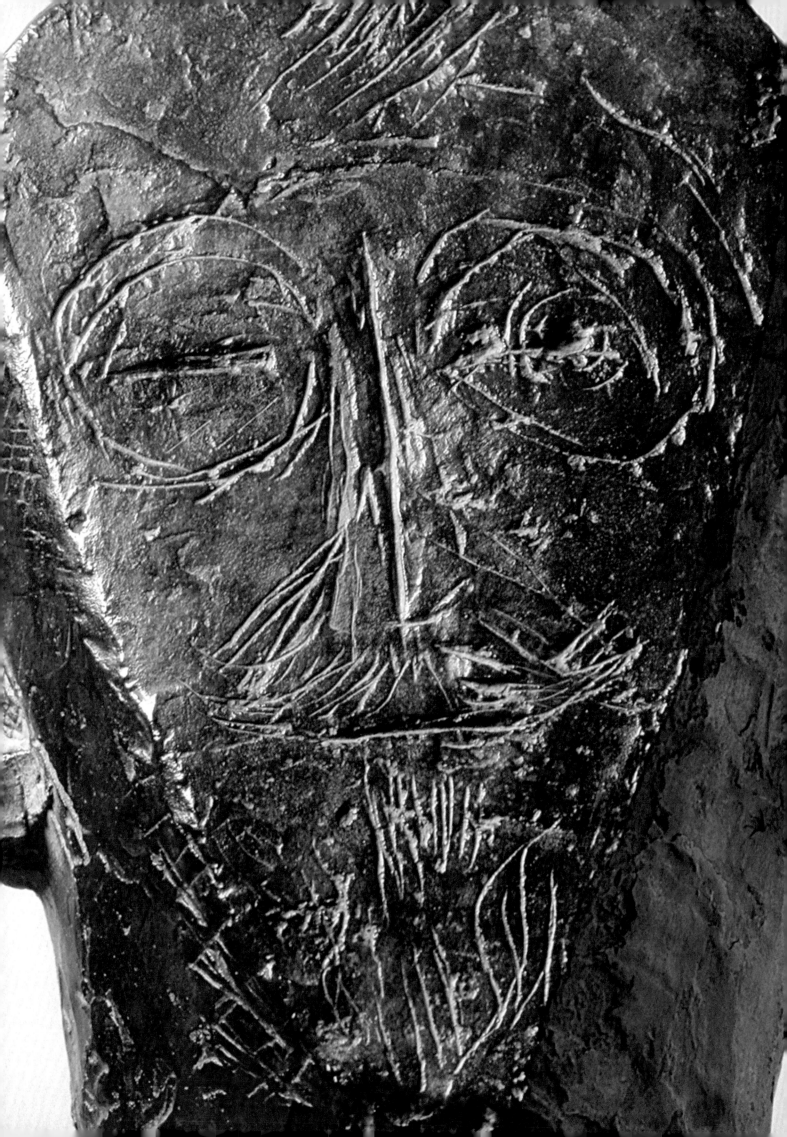

STRUCTURE AND FORM

After arriving in Paris in early 1922, Giacometti began attending classes with Antoine Bourdelle at the Académie de la Grande Chaumière. He remained there until 1927, studying life drawing and sculpture. From the outset he experienced difficulties that would later recur. The principal problem was the impossibility, as he saw it, of achieving his main aim, which was 'to copy exactly … appearance'. In the life-drawing classes he found himself unable to capture his constantly changing impressions of the observed model. Concerned with problems of structure and form, he experimented with various styles. By 1925 he decided 'to abandon the real'. For the next nine years his work in Paris became progressively abstract and imaginative, and he gravitated towards the Surrealist group.

Despite Giacometti's claim to have abandoned observation, from 1925 onwards the work he made during summer visits to Switzerland nevertheless remained rooted in portraiture. He continued to make busts and paintings of Diego, his father, mother and sister, as well as self-portrait drawings. Following his father's death in 1933, Giacometti ended his Surrealist work, and he resumed making portraits from life in Paris. The busts of his lover Isabel Nicholas and his paid sitter Rita Gueyfier mark a renewed involvement with 'facing the model, endeavouring to copy what I saw'.

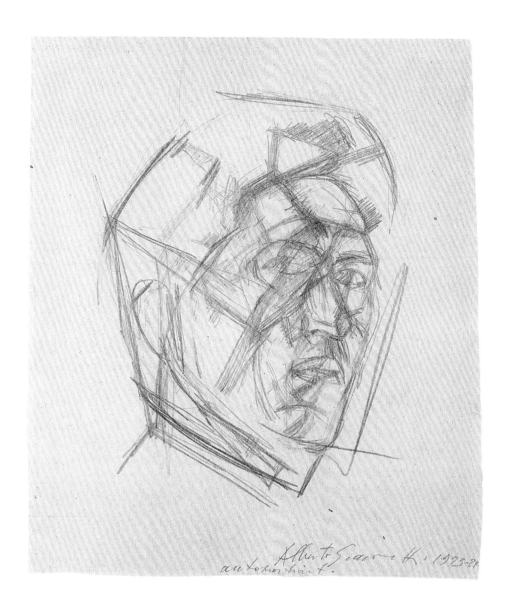

10

Self-portrait, c.1923–4
Pencil on paper
275 x 230mm
Kunsthaus Zürich, Alberto
Giacometti-Stiftung

This self-portrait drawing dates from the early years of Giacometti's attendance at Antoine Bourdelle's classes at the Académie de la Grande Chaumière in Paris. Immersed in sculpture and life drawing, he almost immediately experienced a recurrence of the problems he had encountered earlier with the bust of Bianca. The main difficulties were those of relating individual details to each other and of depicting particular anatomical forms. This drawing was partly inspired by a Cubist-influenced analysis of his head. While Giacometti's fellow students were impressed, he remained critical of his own efforts. Of these difficulties he recalled, 'the shape dissolves … it has no limits … everything escapes'.

11

Head of Diego, c.1924
Bronze
305 x 179 x 233mm
Kunsthaus Zürich, Bequest Bruno
Giacometti, 2012

Despite the early setback he had experienced with the failed bust of Bianca, Giacometti persisted in his attempt to create a credible human head in sculptural form. Indeed, his fascination with this aim deepened: '… once I begin to look at it and want to draw, paint, or rather sculpt it, everything changes into a form that is taut and, it always seems to me, intense in a highly contained way'. Made while still attending Bourdelle's academy, this bust of Diego (at his teacher's suggestion) was cast in bronze and exhibited at the Salon des Tuileries – Giacometti's first exhibition – in 1925.

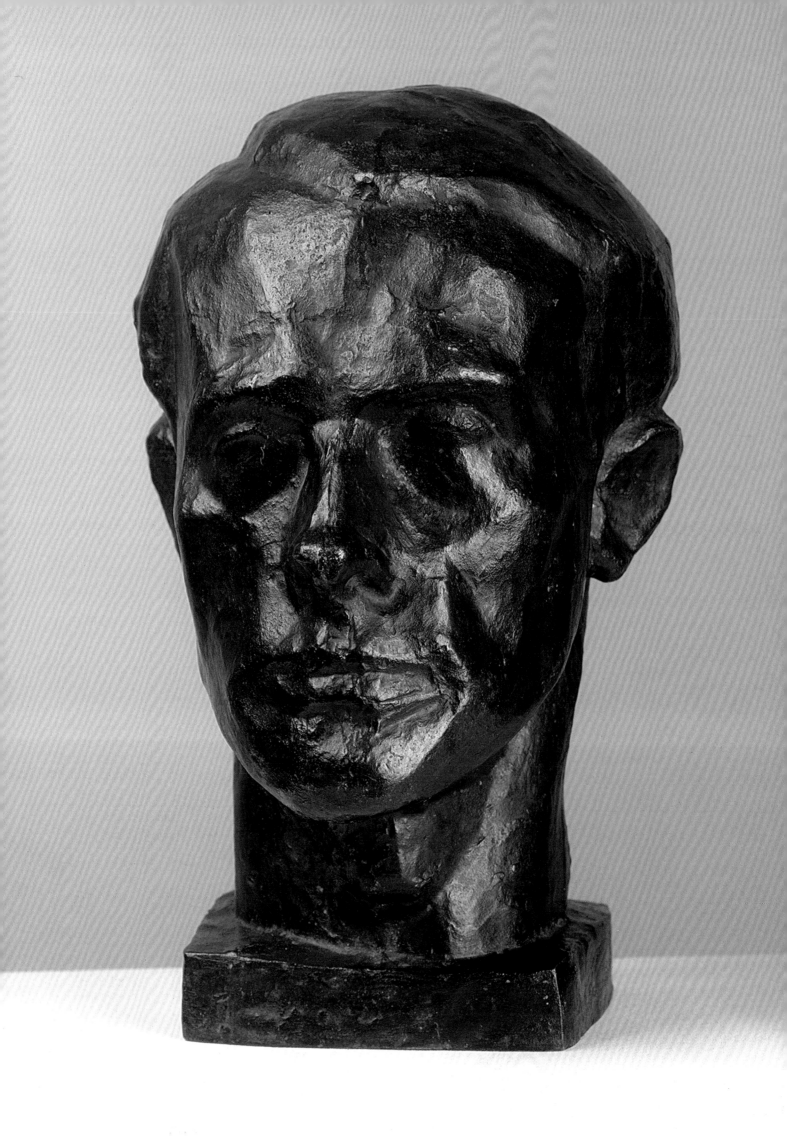

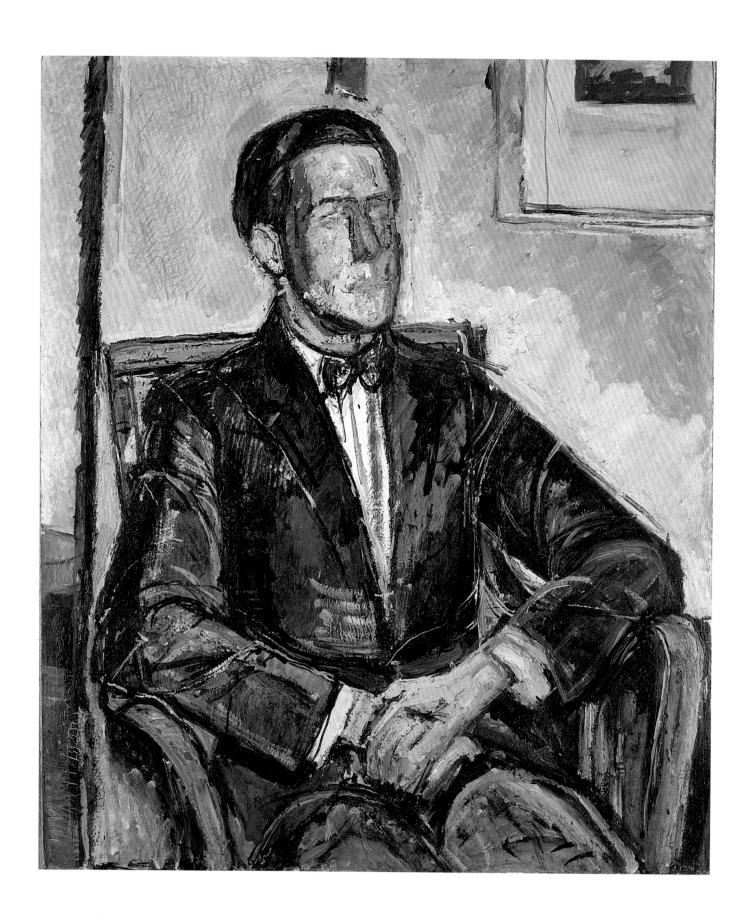

12
Portrait of Diego, 1925
Oil on cardboard
660 x 550mm
Collection P.C.C.

'Around 1925,' Giacometti recalled,
'I began to see that it was impossible
to create a painting or a sculpture
of things exactly as I saw them,
and that it was necessary to
abandon the real.' In that year he
began work on his first sculpture
that dispensed with literal
representation. *Torso* incorporated
highly abstracted shapes and, in
Paris, Giacometti now explored an
unconventional and experimental
mode of expression. However, this
portrait of Diego was made in
Maloja in the summer of 1925.
It shows that, despite his assertion
to the contrary, he continued his
earlier commitment to observation
while working in Switzerland.

13
Bruno Reading, 1927–8
Pencil on paper
480 x 300mm
Collection P.C.C.

Drawing formed the beginning of
Giacometti's artistic activity as a
child, and it remained central to his
mature practice too. In his view,
'drawing is the basis of everything'.
The activity enabled him to
'copy what I saw', and he further
claimed that drawing 'helped me
to see'. The exact transcription
of appearance was his aim. In
addition to the formal training
in life drawing that he received
at Bourdelle's academy – an
experience he found frustrating –
he continued to make spontaneous
drawings, such as this one. Made
at the family home during one
of Giacometti's summer visits,
it captures his younger brother
reading.

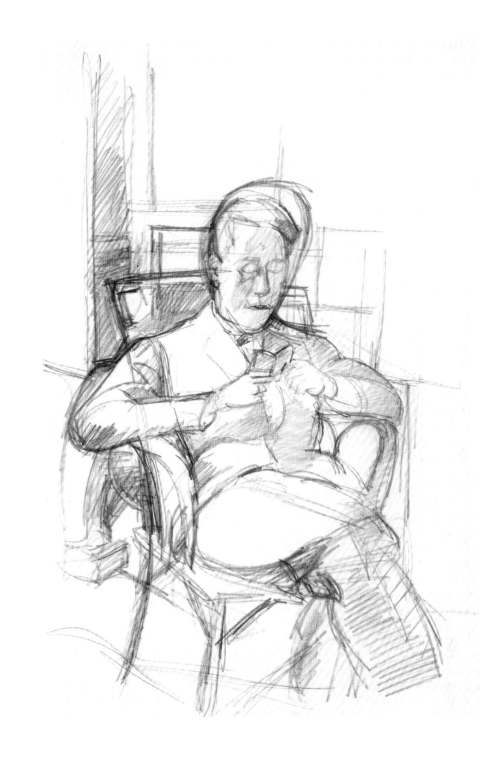

14

The Artist's Mother, 1927
Bronze
325 x 233 x 122mm
Kunsthaus Zürich, Bequest Bruno Giacometti, 2012

Throughout the 1920s, Giacometti's work proceeded
in different yet concurrent directions – abstracted
while working in Paris but also rooted in observation
when staying in Switzerland. Around 1924, while he was
working on a naturalistic head of his mother, he 'realised
that it was impossible. I would have to start again from
scratch.' As a result, from 1927 to 1929 he made a series
of abstracted, plaque-like sculptures, some evoking
heads. In 1927 he also made several experimental
flattened heads depicting his mother and father. This
head of his mother belongs to that second, parallel
phase of activity.

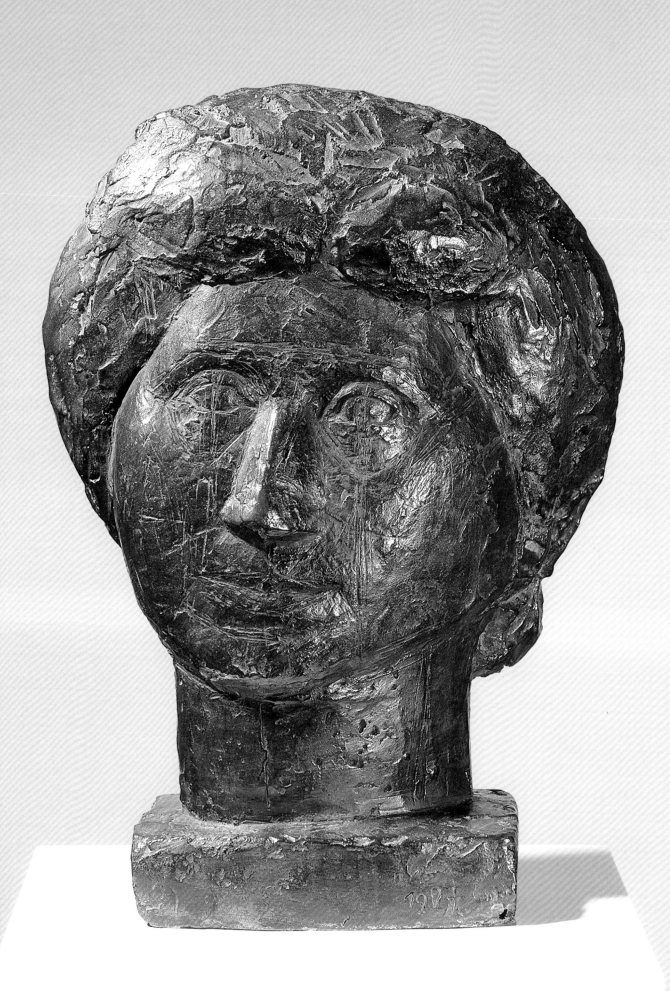

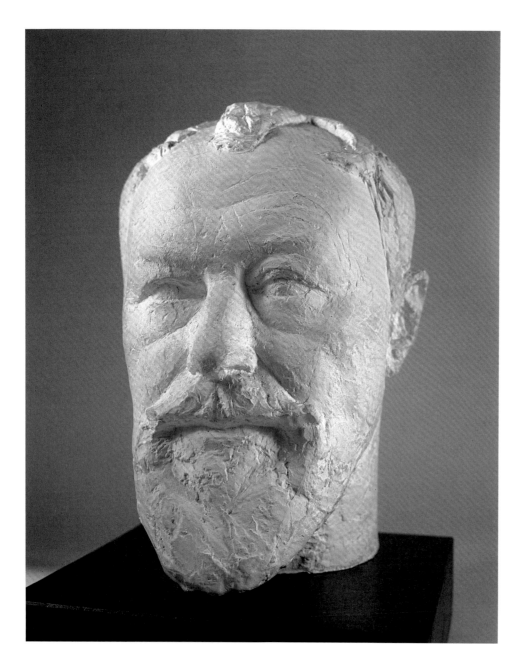

15
Head of the Artist's Father, 1927
Plaster
275 x 230 x 205mm
Collection P.C.C.

This sculpture belongs to the series
of busts of his father and the one of
his mother that Giacometti made
in the late 1920s while staying in
Switzerland. As this head shows,
naturalistic depiction remained
part of his approach. Giovanni's
appearance is conveyed in a
relatively straightforward way.
No doubt it was a likeness of
which he and his wife would have
approved. It contrasts markedly
with the highly abstracted sculpture
that Giacometti was then making
while living in Paris. This artistic
double-life, of which his parents
would have been only partly aware,
defines Giacometti's existence
at this time.

16

Portrait of Giovanni Giacometti,
1929–30
Bronze
279 x 200 x 232mm
Kunsthaus Zürich, Bequest Bruno
Giacometti, 2012

This bronze head is related to the
plaster sculpture *Head of the Artist's
Father*, which was initially modelled
in clay. Sometimes the original clay
sculptures would be cast in plaster,
and sometimes, as in this case,
in bronze. Later Giacometti
developed a more complex way
of creating an initial image. This
involved modelling in clay and then
creating plaster casts that would be
developed further using modelling
and carving. He also applied
plaster directly to an armature
(framework), which would then be
modelled and carved. As these
different ways of working and
creating casts suggests, Giacometti
was profoundly sensitive to the
different characteristics of these
various media and processes.

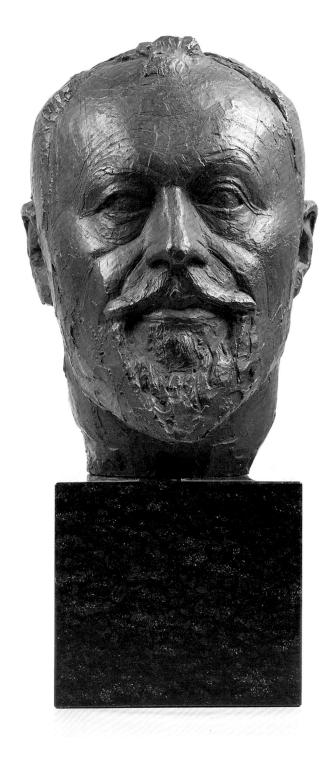

17
The Artist's Father,
(Flat and Engraved), 1927
Bronze
275 x 210 x 140mm
Kunsthaus Zürich, Alberto Giacometti-Stiftung,
Gift of the Artist

This head is the remarkable terminus to the series
of portrait busts of his father and mother made in
Switzerland. While closely copying his father's features,
he also progressively abstracted the face, finally rendering
it as a flattened plane on which the features were
incised. This range of activity suggests Giacometti's
interrogation of the process of looking, moving from
what is 'known' to a progressive questioning of what is
actually seen. The flattening of the heads of his father
and mother relates to seeing a face frontally, when
there is no apparent mass or depth.

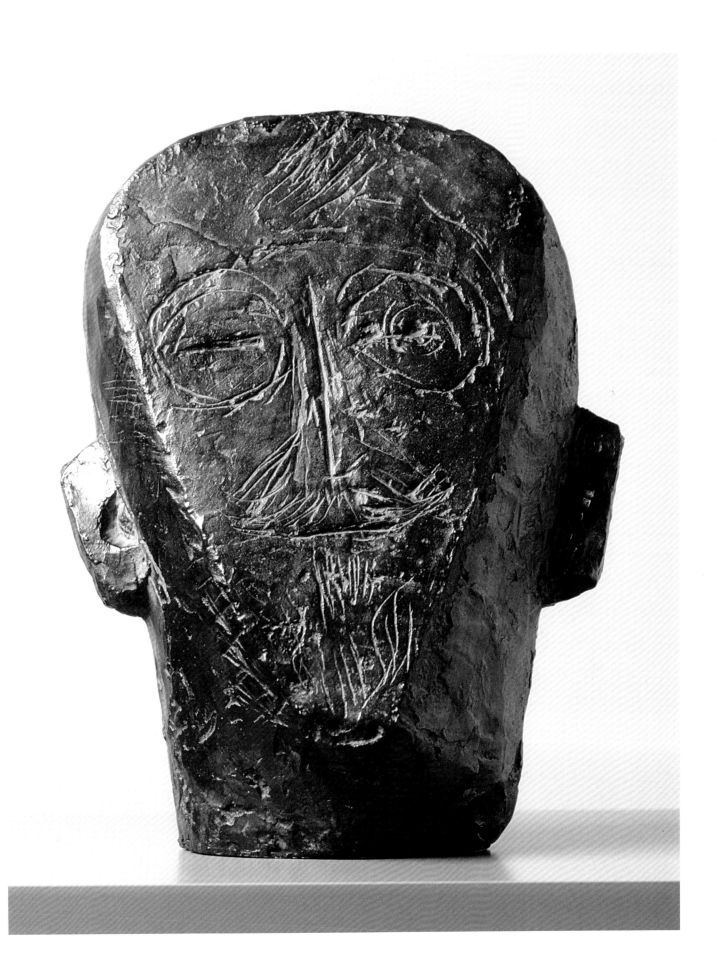

18

Portrait of the Artist's Father, c.1932
Oil on canvas
424 x 325mm
Kunsthaus Zürich, Bequest Bruno Giacometti, 2012

This portrait of Giovanni was painted in Switzerland,
during Giacometti's usual summer visit. The contrast
with the Surrealist work he was then making in Paris
could hardly be greater. The fantastic subject matter
he had been pursuing there reached a climax in the
sculpture *Woman with Her Throat Cut* (1932). Alongside
those developments, portraits from life (such as this
one) continued to be a preoccupation. At this date
his father's artistic reputation was widespread, and this
portrait suggests that, while in Switzerland, Giacometti
deferred to his influence. His father's death in the
following year affected Giacometti profoundly.

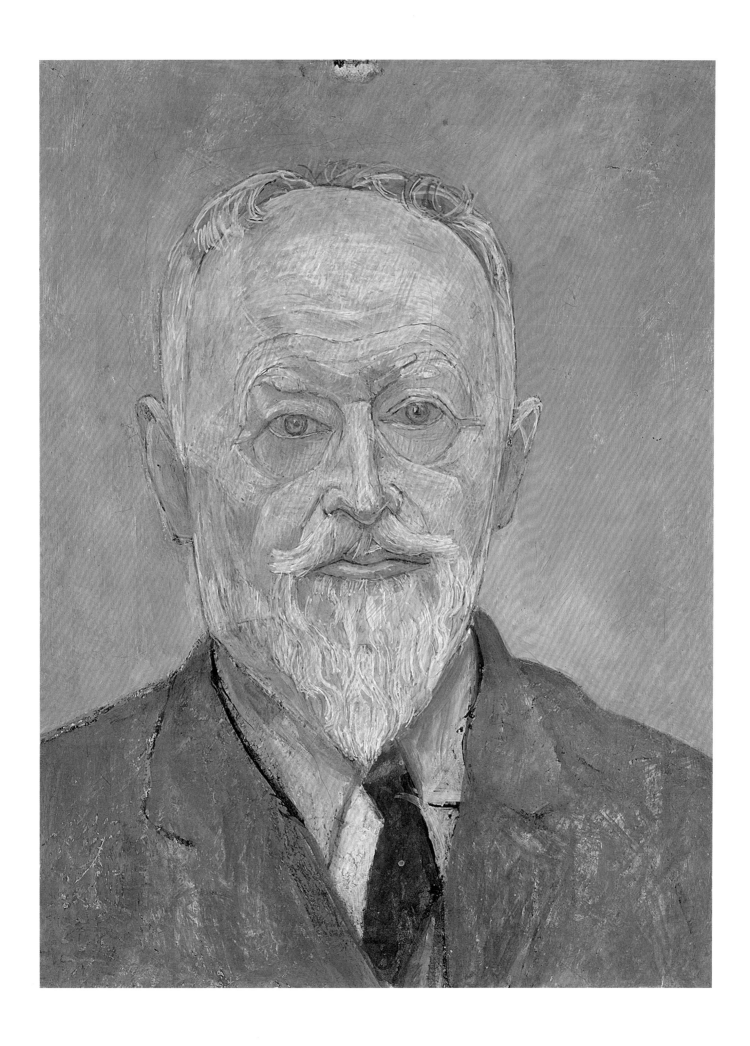

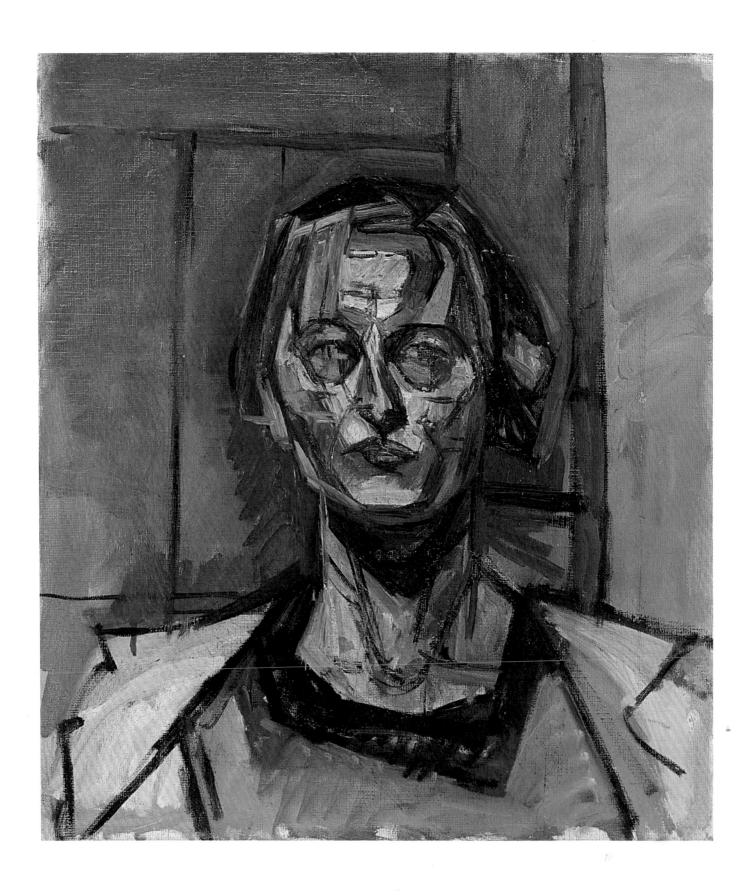

19
Ottilia, 1934
Oil on canvas
460 x 400mm
Private Collection

Following the death of his father in June 1933, Giacometti
began to lose interest in Surrealism. While his portraiture
had continued unabated in Switzerland since 1925 –
a period when he claimed it had been necessary to
'abandon the real' – he now returned to making portraits
from life in Paris also. As a result of his return to 'reality',
in December 1934 he broke with the Surrealist group.
This portrait of his sister Ottilia belongs to that transitional
phase. Painted in Switzerland, it confronts the sitter,
dissecting her appearance into planes, as if the artist
was seeking to penetrate its underlying structure.

20

Self-portrait, 1935
Pencil on paper
297 x 240mm
Robert and Lisa Sainsbury Collection, Sainsbury Centre
for Visual Arts, University of East Anglia, UK

From 1935, Giacometti focused on making portraits
from life. He later explained, 'Forgetting that in 1925
I had abandoned the idea of working from life because
I found it impossible, I went back to taking a model with
the intention of making sculpture straight away.' This
drawing forms part of that major change in direction
and, as in 1923 (cat. 10), here he again used his own
features as subject. Giacometti's relatively few self-
portraits are associated with adjusting to new
circumstances, apparently providing a context for
personal examination. This drawing is an analytical
study, part of his renewed endeavour 'to understand
the construction of a head'.

Alberto Giacometti 1935.

21

Head of Isabel, 1936
Plaster
303 x 235 x 219mm
Collection Fondation Giacometti, Paris,
inv.1994-0343 (AGD 400)

This is Giacometti's first bust of Isabel Nicholas, who
was one of his three principal models from 1935 to
1940, the others being Diego and Rita. She began
sitting in 1935, commencing a pattern of daily sessions
in which Giacometti's entire aim was to 'make a head
just as I see it'. Frustration quickly ensued. He recalled,
'The more I stared at the model, the thicker the screen
grew between myself and the real thing.' Each fresh
perception added to the store of visual information,
confounding the creation of a single, definitive image.
Even so, influenced by ancient Egyptian portraiture,
this head has an apparent serenity.

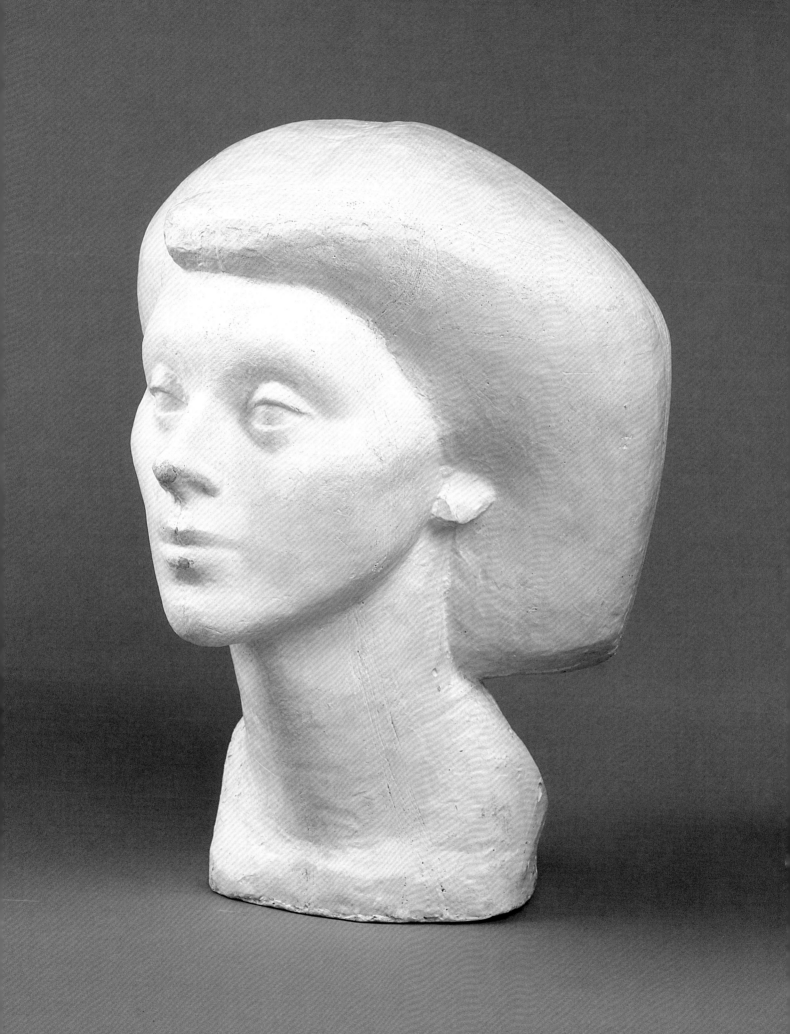

22

Head of Isabel, c.1938–9
Plaster and pencil
216 x 160 x 174mm
Collection Fondation Giacometti, Paris,
inv.1994-0344 (AGD 401)

This, the second of Giacometti's two heads of Isabel,
contrasts markedly with its predecessor. Having created
an original in clay, Giacometti would make plaster casts
that could be worked on further. Here the head has
been heavily remodelled and marked in pencil. Unlike
the earlier, somewhat idealised likeness, this work
bears the evidence of the artist's struggle to capture his
shifting impressions. Indeed, Giacometti referred to the
'contained violence' inherent in that process. Evidently,
creating an image of what he saw involved not only a
literal record of appearance, but an attempt to create
a material equivalent for a living presence.

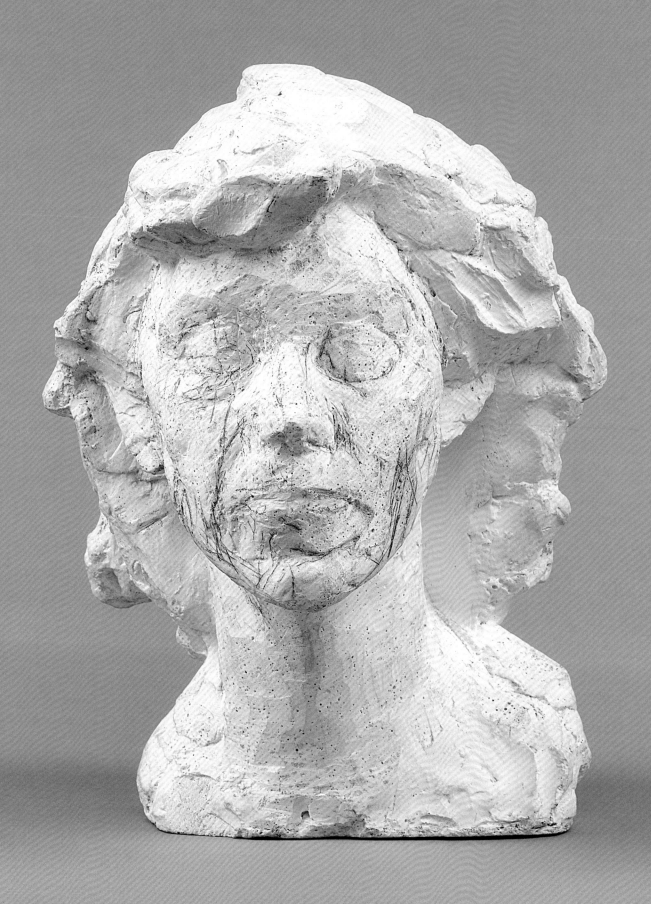

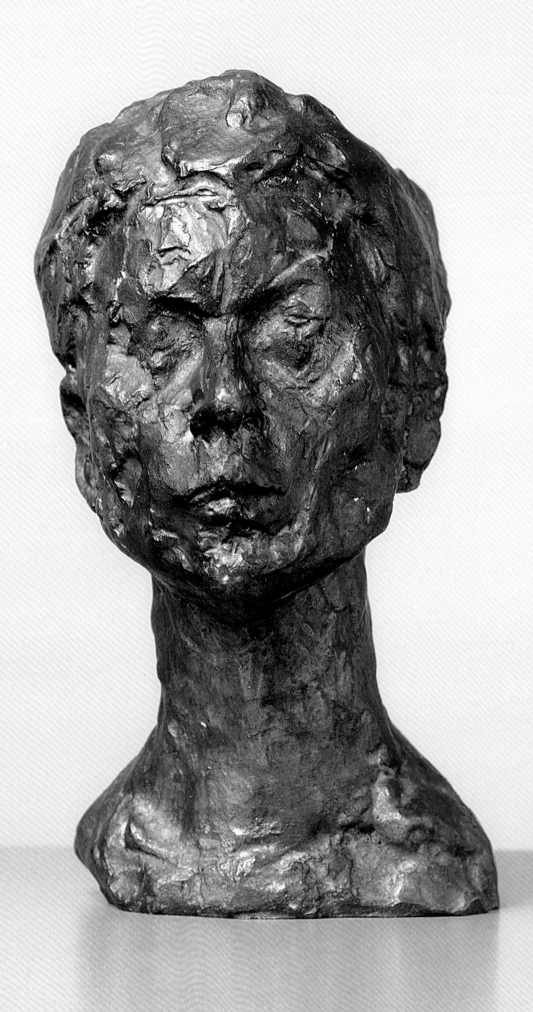

23
*Rita, c.*1938
Bronze
220 x 133 x 165mm
Kunsthaus Zürich, Vereinigung Zürcher Kunstfreunde,
Gift of Bruno and Odette Giacometti, 1978

Alongside the sittings with Isabel, with whom Giacometti
began to form a close attachment, he employed a paid
model, Rita Gueyfier. His endeavours with Rita were
no less dissatisfying. 'I just wanted to make ordinary
heads,' he explained, 'but since I always failed, I always
wanted to make a new attempt. I wanted to be able
once and for all to make a head as I saw it. But since
I never succeeded, I persevered in the effort.' As this
head shows, Giacometti now re-engaged with the
question of size. The head is smaller than life-size,
as if seen from afar.

24

Head of Rita, 1938
Bronze
83 x 54 x 74mm
Robert and Lisa Sainsbury Collection, Sainsbury Centre
for Visual Arts, University of East Anglia, UK

This head of Rita is even smaller than the other (cat. 23).
Towards the late 1930s, Giacometti found – to his
consternation – that in reproducing his models'
appearance, the sculptural images he created now
shrank in a way that seemed beyond his control. He was
determined to copy what he saw, as opposed to what
he knew about the subject. The visual phenomenon
of apparent reduction in size as the result of distance
therefore dominated his response. This manifestation,
which began to alarm him, underpins one of the
paradoxes of Giacometti's portraits. Apparently not
literal likenesses, in actuality they manifest appearance
– as it is experienced – faithfully.

THE ARTIST'S MOTHER

Annetta Giacometti was born in 1871. Her maiden name
was Stampa, the village close to where she was born, and
the place where, following her marriage to Giovanni in
1900, she spent the rest of her life. Her strength, self-
assurance and clearly expressed views were rooted in
her deep-seated Calvinist faith. In a photograph of the
Giacometti family taken in 1907 (fig. 3), Annetta and
Alberto are looking intently at each other, intimating the
special bond between them. The comfortable, cheerful
homes she created for her family were a vital part of
Alberto's childhood 'paradise', the opposite to the
ramshackle studio he later occupied in Paris.

During Giacometti's regular visits to Switzerland, when his
involvement with portraiture continued, his mother was a
recurrent sitter. The portrait he painted in 1937 marks a
stylistic breakthrough, a work in which close observation
and an expressive response are powerfully combined.
The portrait is less an exploration of the sitter's psychology
than an evocation of a living presence. Giacometti's
subsequent portraits of his mother are equally intimate
and intense. Annetta continued to sit for her son until
her death in 1964, predeceasing him by only two years.

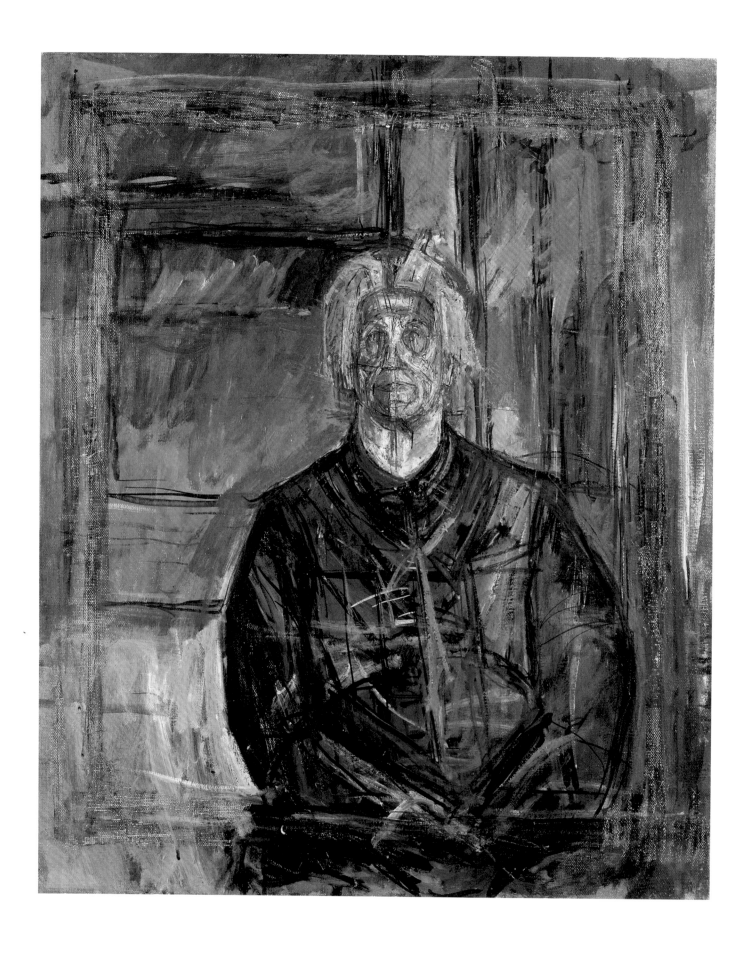

25
The Artist's Mother, 1937
Oil on canvas
600 x 500mm
Private Collection

As usual, Giacometti spent the summer of 1937 at Maloja. During that holiday, he produced three important related paintings, including this portrait of his mother. The other two paintings were still-lifes, depicting with great intensity a single apple on a sideboard. In this portrait, which features the same location, his mother has replaced the still-life motif as the object of his attention. Eschewing psychological characterisation and eliminating superficial details, he has instead concentrated on evoking something even more elusive: a sense of her solitary presence.

26
Portrait of the Artist's Mother, 1947
Oil on canvas
670 x 435mm
Private Collection

By 1947, while in Paris, Giacometti had embarked on a
series of tall, elongated figure sculptures that depicted
an anonymous standing man or woman and a walking
man. As this portrait made in 1947 shows, when
staying at the family home in Switzerland, painting
the observed model also continued to preoccupy
him. However, the two kinds of activity are connected.
Following the epiphany he experienced in 1945, he
'began to see heads in the void, in the space which
surrounds them'. Like the figure sculptures, this
portrait of his mother presents the sitter in relation
to a surrounding void, as though the two states –
being and nothingness – are continuous.

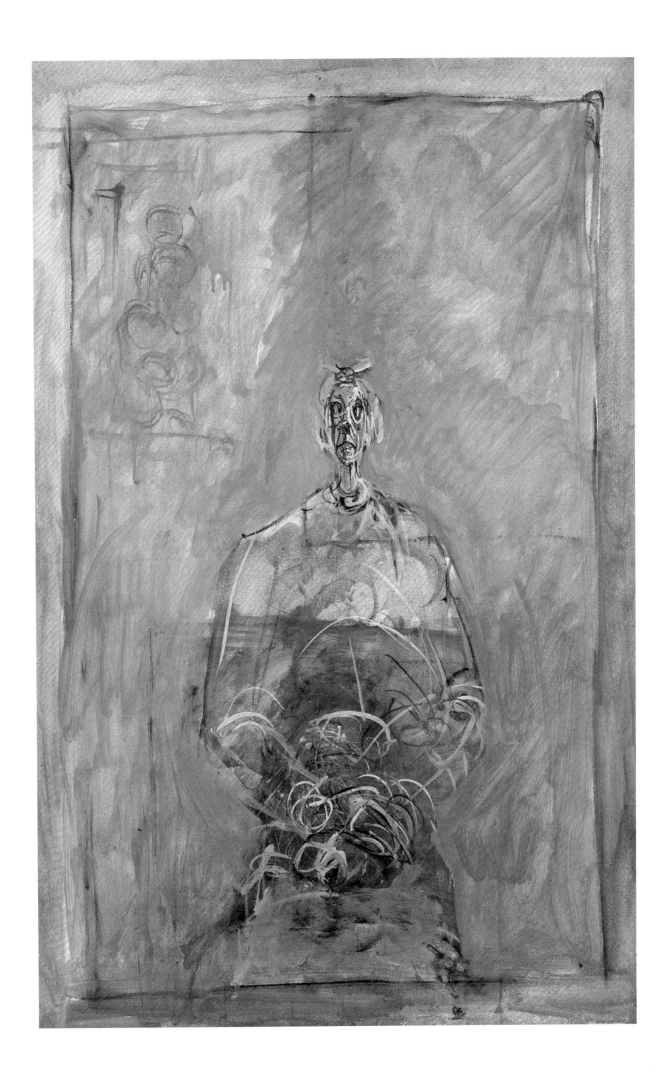

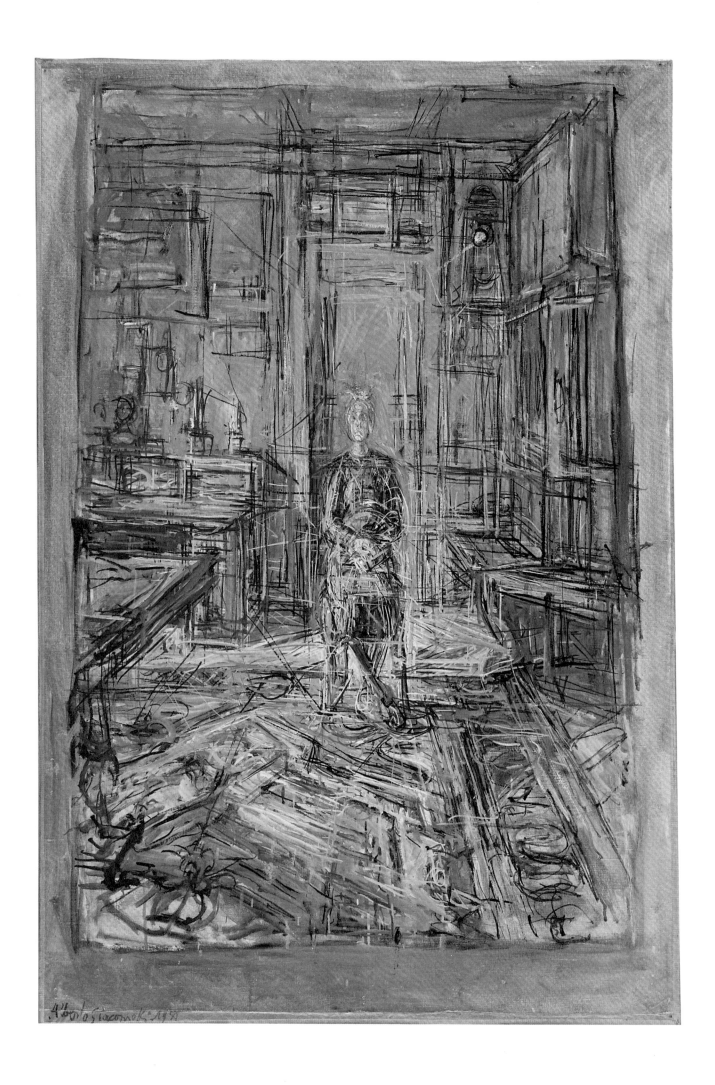

27

The Artist's Mother, 1950
Oil on canvas
899 x 610mm
The Museum of Modern Art, New York. Acquired
through the Lillie P. Bliss Bequest, 1953

Painted in the summer of 1950, this portrait depicts
Giacometti's mother at the family home in Stampa.
Giacometti's presentation of figures within an engulfing
space was by now seen in relation to existentialism,
the philosophy that sought to identify man's significance
in a meaningless universe. Represented within a web of
interpenetrating lines, the central, ghostly figure here
seems coexistent with her surroundings in which a clock,
carpet, table and dresser can be discerned. During the
same holiday, Giacometti painted a portrait of Annette,
whom he had married in 1949, in exactly the same setting
and position – as if the identities of the two women
had merged.

28

The Artist's Mother in the Studio, 1962
Oil on canvas
650 x 460mm
Kunsthaus Zürich, Bequest Bruno Giacometti, 2012

Among the last paintings that Giacometti made of
his mother, this portrait was completed when she was
ninety-one years old and becoming too frail to sit for
extended periods. The subsequent portraits that he
made before her death two years later are all drawings.
In contrast to his usual, highly protracted way of
working, this painting is evidently a spontaneously
executed image. In 1913, aged twelve, Giacometti had
made a drawing of Annetta knitting. Here, almost fifty
years later, he depicted his mother engaged in a similar
activity, the intervening years dissolved by the same
process of observation.

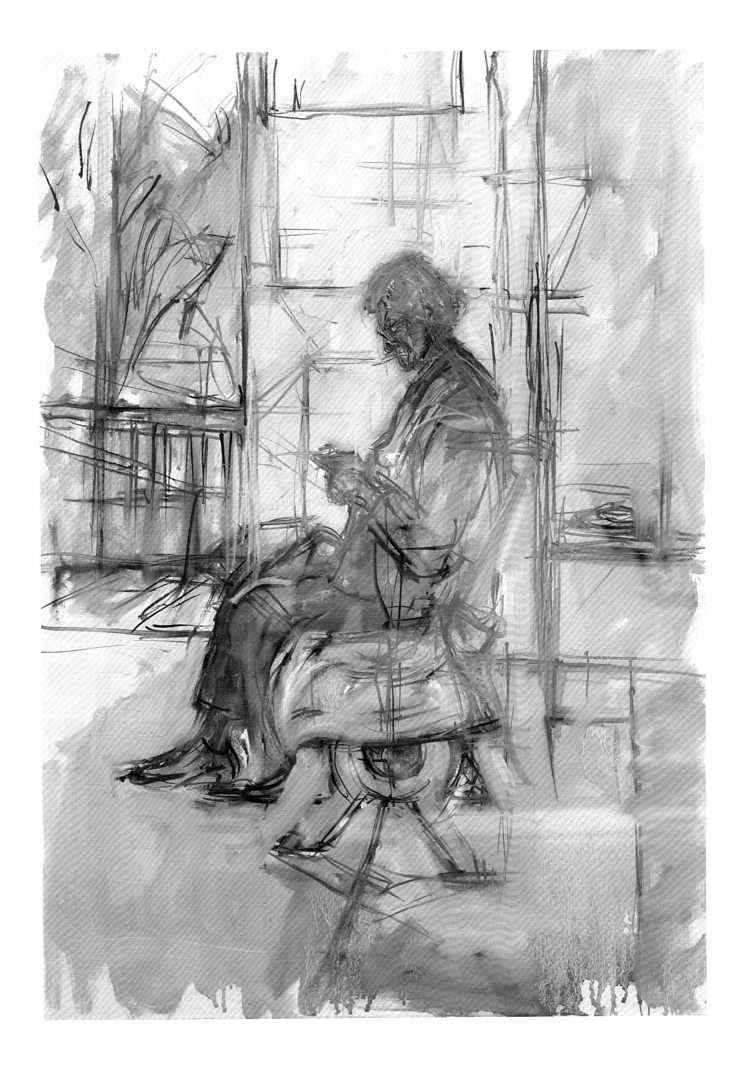

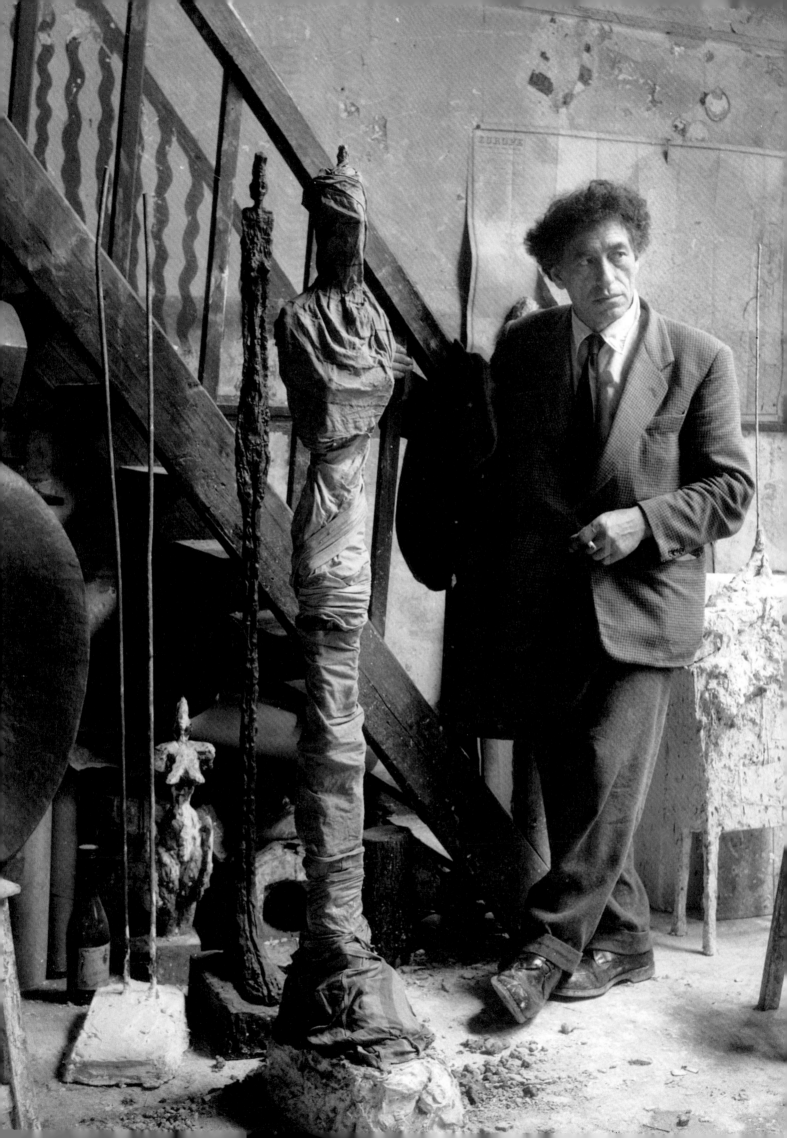

PURE PRESENCE

During the war years, while Paris was under German occupation, Giacometti lived for part of the time in Geneva. Occupying an improvised studio at a local hotel, he concentrated on making sculptures of anonymous human figures. The source for this activity seems to have been a memory of seeing Isabel from a distance in Paris one evening, while she was standing in the Boulevard Saint-Michel. The apparition of her far-off figure surrounded by space made a profound, unforgettable impression. The sculptures that resulted were tiny in scale. Giacometti later recalled that they 'only seemed to me to be slightly real if they were minute'.

These works, which he brought back to Paris in matchboxes, preceded the tall, thin figure sculptures that he commenced after returning to France in 1945. The new, elongated works were the result of a concerted effort to overcome his compulsion to reduce the size of the sculptures. However, as he later explained, 'to my great surprise, they were only lifelike if they were long and thin'. Like the tiny figurines that preceded them, they seem abstracted from his accumulated observations of people. Rather than portraits of particular individuals, these standing or walking figures evoke a non-specific human presence.

Giacometti at the stairway in the studio, Paris, photographed by Denise Colomb, 1954

29

Woman of Venice VIII, 1956
Bronze
1210 x 150 x 330mm
Kunsthaus Zürich, Alberto Giacometti-Stiftung

Giacometti's creation of tall, elongated figures, a
development linked with the evolution of his mature
style, dates from 1946. His imperative was 'to create
an object capable of conveying a sensation as close as
possible as one felt at the sight of the subject'. Rooted
in observation, his abstracted sensations of standing
and walking – both universal human experiences – were
the subject of these figures, which proceeded alongside
his portraits of specific individuals. *Femme de Venise* is
one of a series of ten related sculptures that Giacometti
exhibited at the 1956 Venice Biennale.

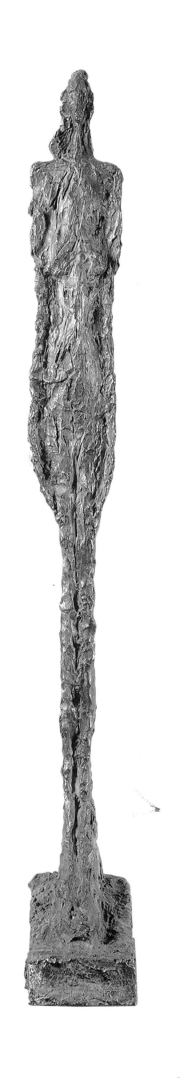

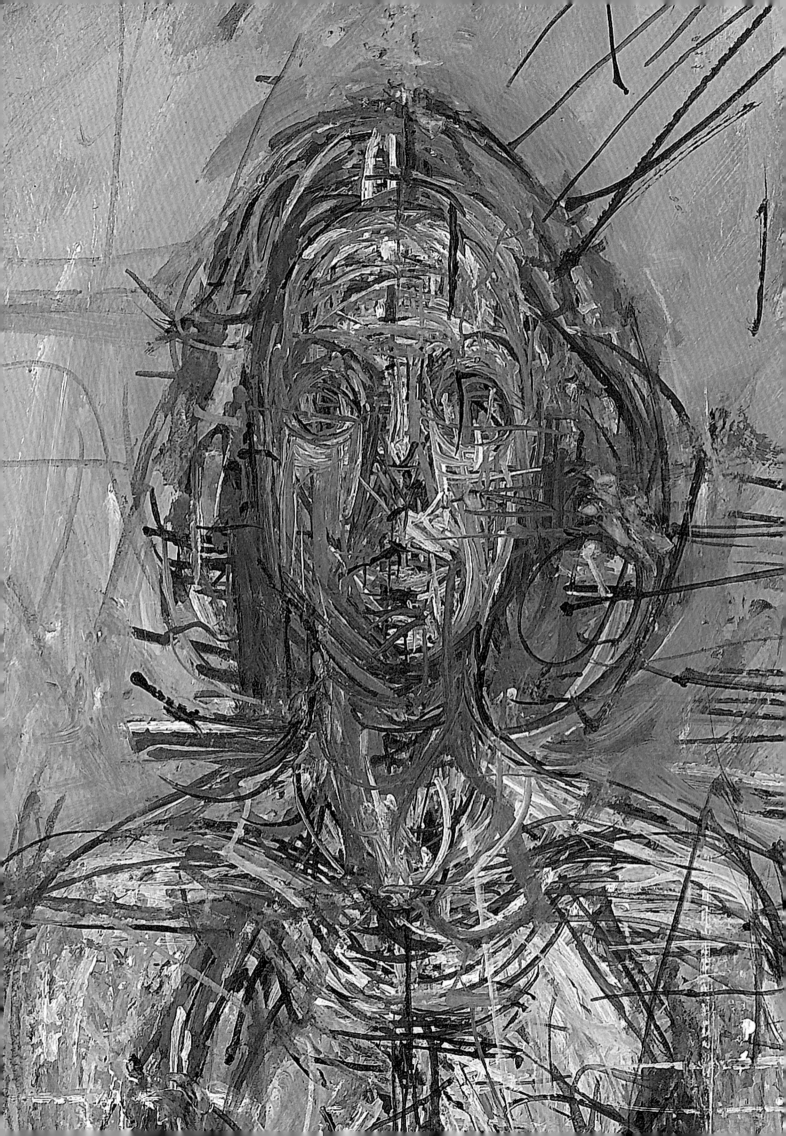

ANNETTE

From the late 1940s, Giacometti's two main models were
Diego and Annette. Born in 1923, Annette Arm was the
daughter of a primary school teacher and was brought
up in a small town near Geneva. She met Giacometti
in 1943, while he was living in exile in the Swiss capital.
Pretty and vivacious, the 20-year-old immediately attracted
his attention. The two subsequently formed a close
relationship and began living together at the artist's
makeshift studio in the Hôtel de Rive, although Annette
did not begin modelling for him until later.

Following the end of the war, Annette joined Giacometti in
Paris. They married in 1949, and her important role as the
artist's assistant and principal female sitter dates from that
time. Giacometti's first portraits of Annette were paintings,
for which she sat in Paris and also during their visits to
Switzerland. Characteristically, she is depicted in a frontal
position, a pose that accorded with her very open, receptive
personality. She is shown sitting, both clothed and nude,
and also as the subject of closer head-and-shoulders studies.
Developing from the paintings, Giacometti's subsequent
busts of Annette explore the sitter's relationship with an
enveloping space.

30

Annette Seated, c.1951–2
Oil on canvas
588 x 388mm
Collection Fondation Giacometti, Paris,
inv.1994-0617 (AGD 728)

After she joined Giacometti in Paris in 1946, Annette
began sitting for him and became – with Diego – one of
his two main sitters. A friend who had known them both
in Geneva commented that she was 'a young woman
who faces one directly, looks and speaks and behaves
directly, infinitely frank and infinitely reserved, with
wonderful straightforwardness'. That double-edged
aspect of Annette's demeanour is evident in this portrait.
Although she is depicted face-on, her presence is
strangely elusive. Contained within a painted framing
device, she appears poised between being and
non-being: a figure situated in space, yet remote.

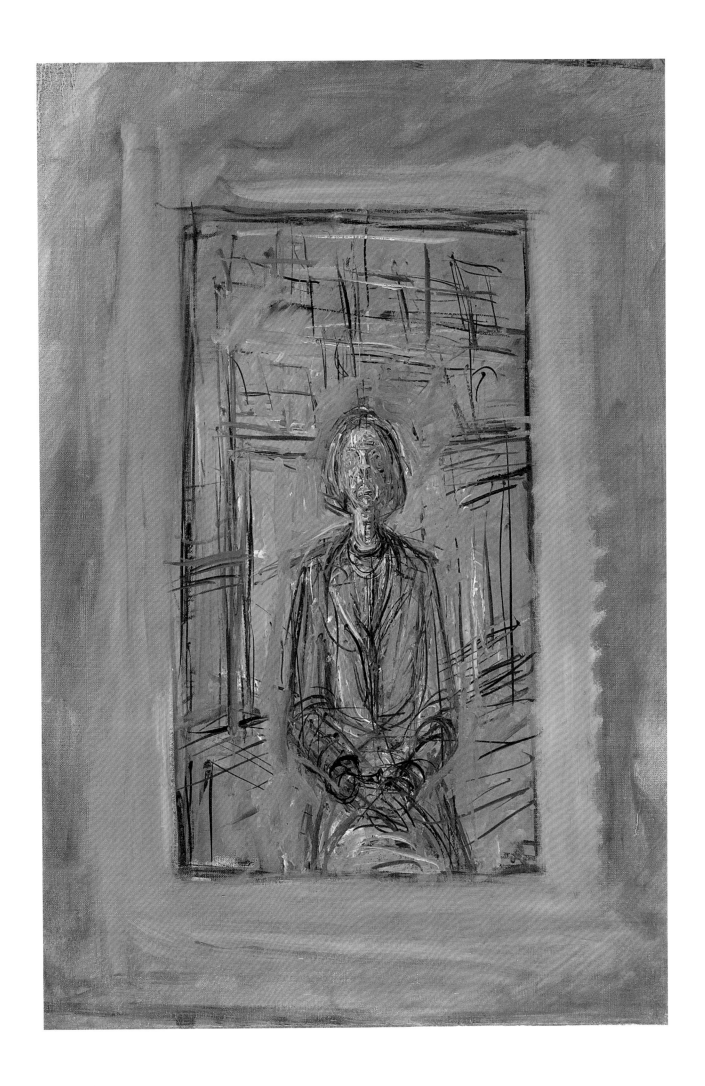

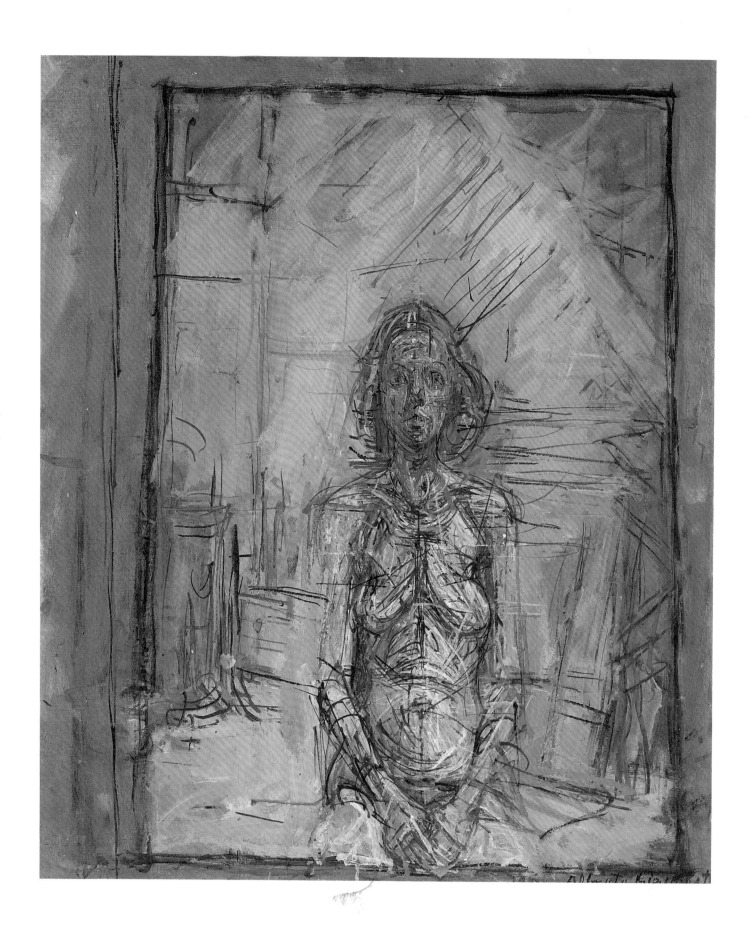

31

Portrait of Annette, 1954
Oil on canvas
650 x 544mm
Staatsgalerie Stuttgart

Living with Giacometti in the studio on rue Hippolyte-
Maindron, Annette was intimately involved with his life
and art. In addition to being his principal female model,
she looked after the workspace and generally assisted
with his many artistic requirements. That proximity and
commitment meant that she was always available to
pose, and accounts for her conspicuous presence
as a sitter. Paintings of Annette predominated at
first, and she posed both clothed and, as here, nude.
The portrait's understated palette evokes the pale
light in the studio, which Giacometti preserved,
refusing to remove the dust covering the windows.

32

Bust of Annette, 1954
Oil on canvas
290 x 220mm
Private Collection

From the mid-1950s, paintings and sculpture became
increasingly interchangeable in Giacometti's portraits
of Annette. That 'dialogue' between the two ways of
working is evident in the title and treatment of this
painted portrait, which allude to sculpture. With just
the sitter's head and shoulders as its focus, this small,
frontal image renders Annette's features with a tangible
intensity. Whereas the model's relationship with the
surrounding space exemplifies his earlier portraits of
her, here the image provides the visual evidence of his
struggle to model the sitter's facial topography. An accent
of colour on the forehead is an expressive addition
within the surrounding context of calibrated marks.

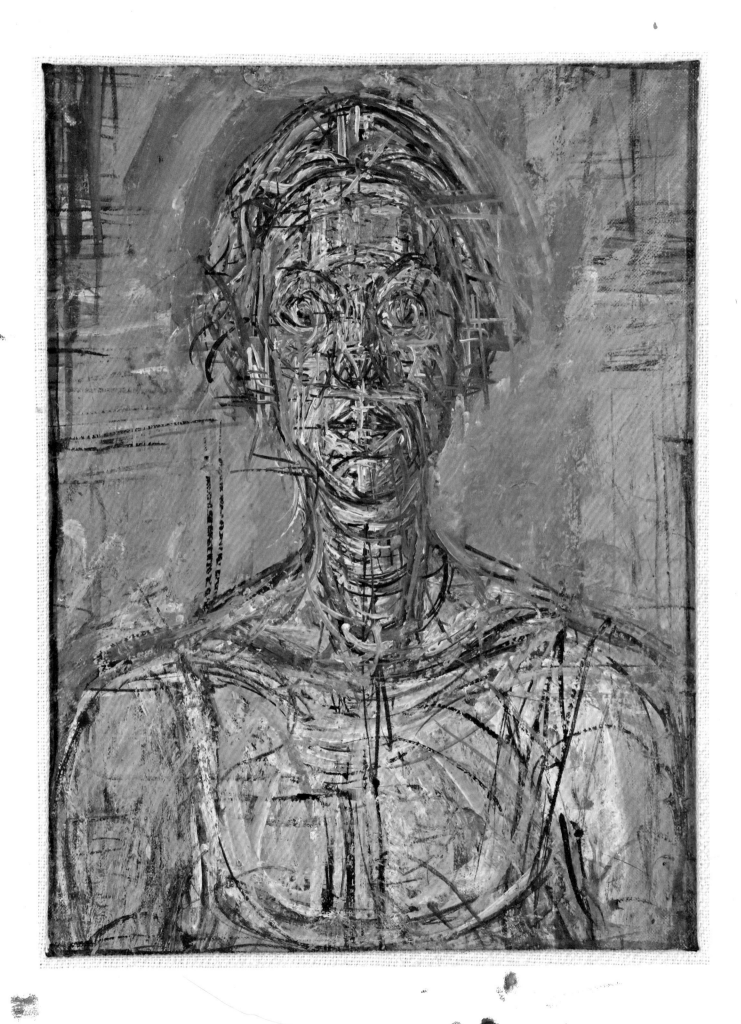

ANNETTE 113

33

Seated Woman, Annette, c.1954
Pencil
486 x 317mm
Robert and Lisa Sainsbury Collection, Sainsbury Centre
for Visual Arts, University of East Anglia, UK

In addition to the numerous painted portraits that
Giacometti made of Annette, he also made many
drawings. Indeed, making rapidly formed images with
a pencil on paper remained a continuous activity, not
only in relation to this sitter, but as a general means of
recording and assisting the process of looking. Drawing
was the most immediate way of capturing the flux of
changing appearances. It also served to imprint a sitter's
features in the artist's mind, enabling him to resort to
memory when the situation required it. Here, although
spontaneous, the drawing manifests the evidence of
penetrating observation.

34

Annette IV, 1962 (cast 1965)
Bronze
578 x 236 x 218mm
Tate, Purchased with assistance from the Friends of the
Tate Gallery 1965

From 1956, Giacometti increasingly turned to sculpture
in making portraits of Annette. These proceeded
alongside the series of busts and heads of Diego
that he had commenced earlier, and that continued
throughout the decade. This portrait belongs to a series
of eight busts of Annette made in 1962, augmented by
a ninth in 1964. As a whole, the series has an extraordinary
vitality, fed by Giacometti's preceding drawings and
paintings of her. This is evident in the sculptures'
sensuous and yet intensely observed modelling.
The series formed the climax of a major retrospective
of his work held at the Kunsthaus, Zürich, in 1962.

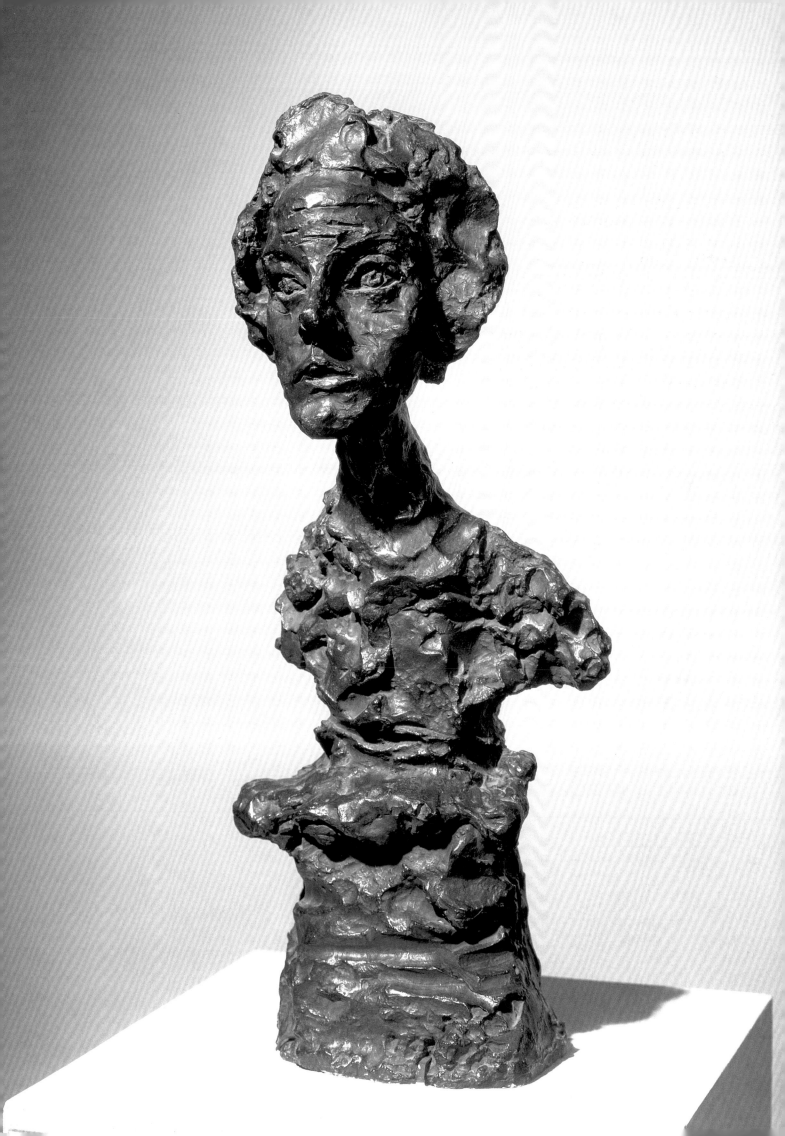

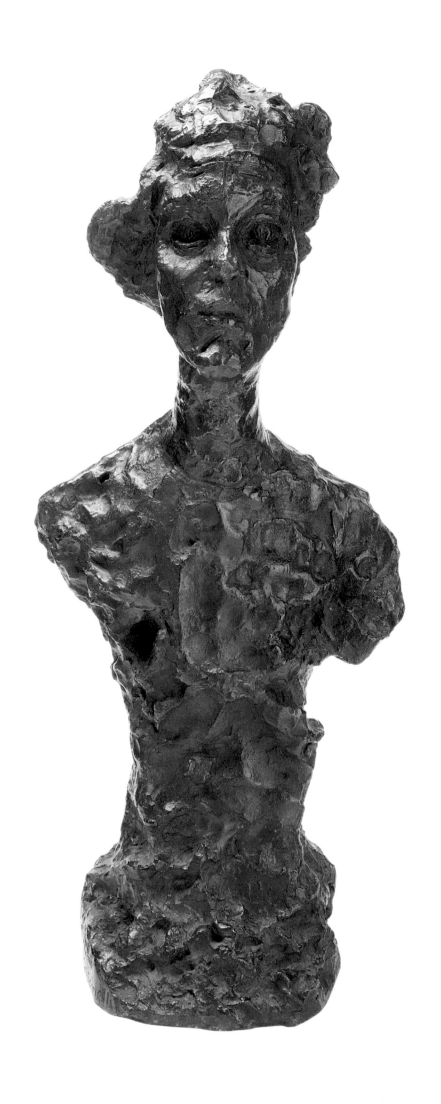

35

Annette VI, 1962
Bronze
605 x 253 x 201mm
Loaned by The Kasser Mochary Foundation,
Montclair, New Jersey

In common with his other portraits of Annette created in 1962, this bust is rooted in drawing. In the related works on paper, Giacometti subjected his sitter's face to a process of close analysis. In some of the drawings, the relation of the different parts of the face is the main preoccupation, and a web of lines connects the features. In others, the focus of Giacometti's attention shrinks, concentrating on the eyes in particular. Those observations underpinned the creation of the busts, which, nevertheless, proceeded beyond specific details in expressing, more generally, 'all the strength there is in a head'.

36
Annette Without Arms (Annette IX), 1964
Bronze
450 x 190 x 155mm
Robert and Lisa Sainsbury Collection, Sainsbury Centre
for Visual Arts, University of East Anglia, UK

This is the final head in the *Annette* series, completing
the body of work Giacometti had commenced two
years earlier. In the meantime, he had undergone an
operation for stomach cancer and, at the beginning
of 1964, his mother died. He now re-engaged with the
subject that had previously preoccupied him. Referring
to his practice of returning repeatedly to the same
motif, on an earlier occasion he remarked, 'There is
not even a face left, having looked at it so much.'
This bust suggests the way that Giacometti's later
portraits proceeded beyond a particular model's
features, attaining a sense of pure presence abstracted
from its specific origins.

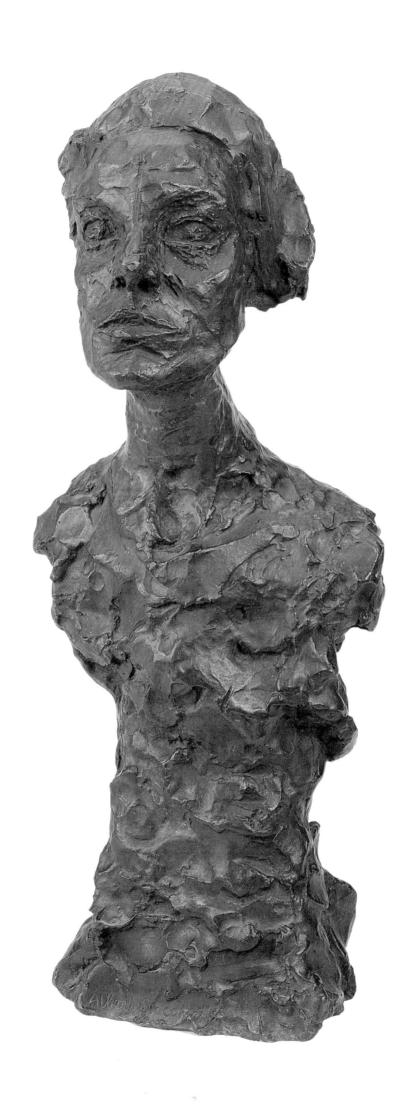

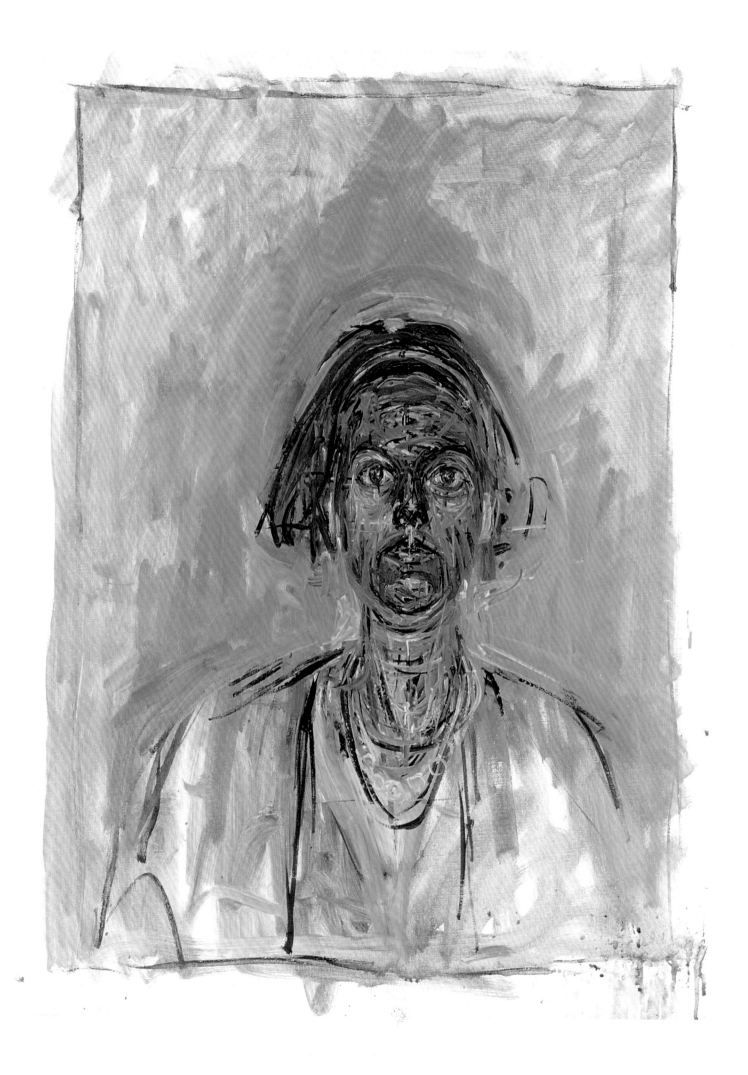

DIEGO

Giacometti's younger brother Diego was born in 1902.
The two were boarders at the same school, and Diego
joined his brother in Paris in 1925, partly in order to reassure
their mother that Alberto could keep an eye on him. Unlike
Alberto, Diego had little interest in being an artist, and his
outgoing personality led to youthful escapades. Initially,
he lived in the Paris studio at rue Hippolyte-Maindron, and
later occupied an adjacent studio.

Diego's role gradually developed from 1929. As Giacometti's
assistant, he undertook the making of armatures, and
eventually assumed responsibility for making casts and
patinating the sculpture. Having been the subject of
Giacometti's first bust (cat. 1), he also modelled for him,
sitting for several hours daily from 1935. From 1942 to
1945, while Giacometti was in Geneva, Diego looked
after the Paris studio.

Throughout the post-war period, Diego was Giacometti's
main male sitter, the subject of numerous drawings,
paintings and sculptures. In several paintings he is shown
informally, sitting amid the clutter of the studio. In others,
he has a more severe, frontal presence contained within
a painted frame-like device. In making the later portraits
of Diego, particularly the sculptures, Giacometti worked
from memory, the sitter's features ingrained in his mind.

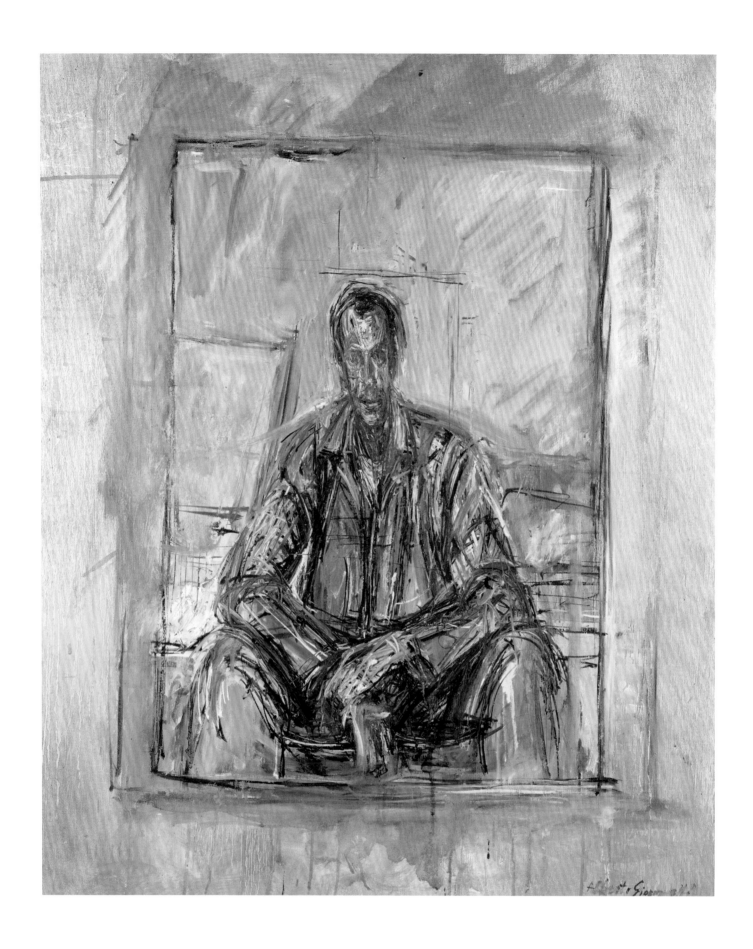

38
Portrait of the Artist's Brother Diego, 1948
Oil on canvas
730 x 597mm
Private Collection

Giacometti's first bust had been a portrait of Diego, and, alongside Annette, his brother was the individual to whom he remained closest. In addition to the studio assistance he provided, from the post-war years onwards Diego was a regular sitter. Giacometti's response in painting, sculpture and drawing is characterised by a great diversity of treatment. As this portrait suggests, one aspect of the way Giacometti depicted Diego is the projection of an informality that is less evident in his portraits of other sitters. Here, Diego is posed casually, his relaxed demeanour suggestive of the understanding between the two men.

39
Diego Seated, 1948
Oil on canvas
806 x 502mm
Robert and Lisa Sainsbury Collection, Sainsbury Centre
for Visual Arts, University of East Anglia, UK

Painted in the same year as cat. 38, this portrait is
entirely different in terms of the way the sitter is
depicted. Characteristically, Giacometti's early painted
portraits of his brother show the sitter in a comfortable
position: seated, legs splayed or crossed, his hands
draped casually in his lap. That position is repeated
here. However, its treatment has an energetic,
even frenetic, quality that contradicts an ostensible
informality. The figure and the surrounding space
seem almost deconstructed by nervous brushstrokes,
the situation as a whole contained with a painted
frame-like device. The effect is a resonant tension
between the sitter and his surroundings.

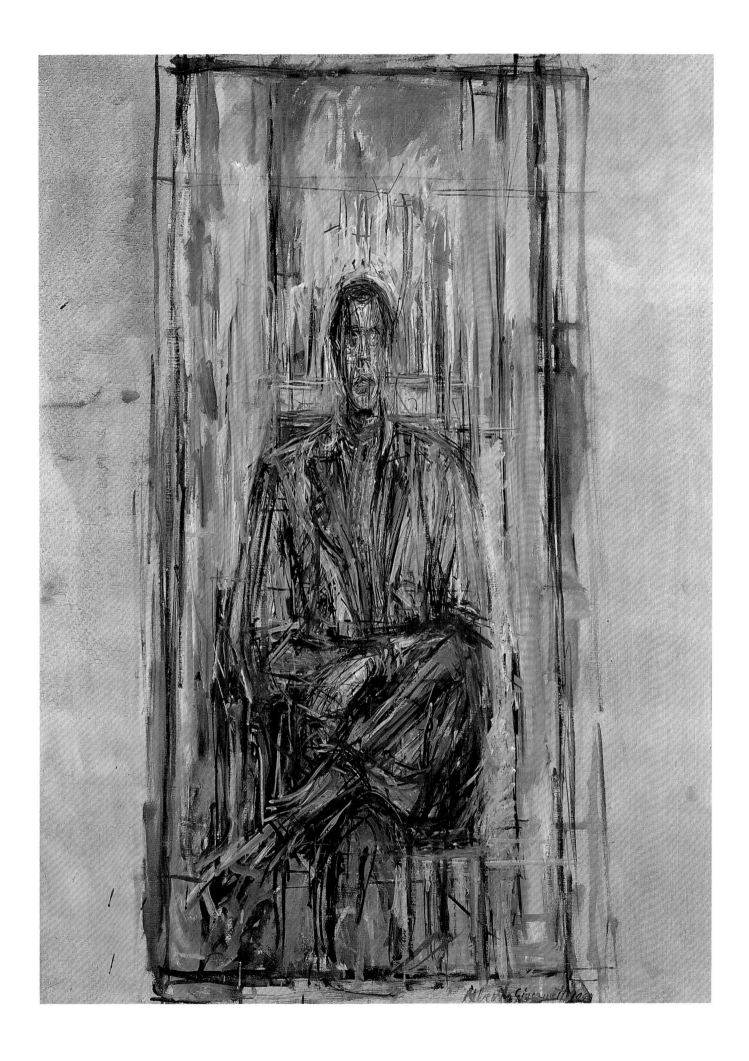

40

Portrait of the Artist's Brother, 1948
Pencil
490 x 310mm
Robert and Lisa Sainsbury Collection, Sainsbury Centre
for Visual Arts, University of East Anglia, UK

In common with Giacometti's portraits of Annette, those
of Diego developed in terms of painting and sculpture,
and his means of negotiating the relation of these
two media was provided by drawing. Of the two,
he explained, 'both of them are drawing'. However,
whereas painting and sculpture tended to call for
protracted treatment involving constant revision,
drawing could be undertaken more spontaneously,
and Giacometti was apparently content to preserve
fewer different impressions. This drawing of Diego
has a transparent, almost spectral quality that captures
the fugitive nature of the artist's visual sensations.

41
Diego, 1950
Oil on canvas
800 x 584mm
Robert and Lisa Sainsbury Collection, Sainsbury Centre
for Visual Arts, University of East Anglia, UK

Here Diego is depicted at an apparent distance, seated
in the confined space of the studio and among the
objects that defined Giacometti's daily existence. The
workplace was both cramped and austere: in the artist's
words, 'too small – just a hole'. Initially, Diego slept on
a balcony at the back of the room, with Alberto below.
Later Giacometti rented two adjacent spaces, one for
Diego and another as a bedroom for Annette and
himself. Here Diego is sitting on a divan; a sculptor's
stand can be seen in the foreground, and stacked
paintings at the left. Of this situation, Giacometti wryly
commented, 'The longer I stayed, the larger it grew.'

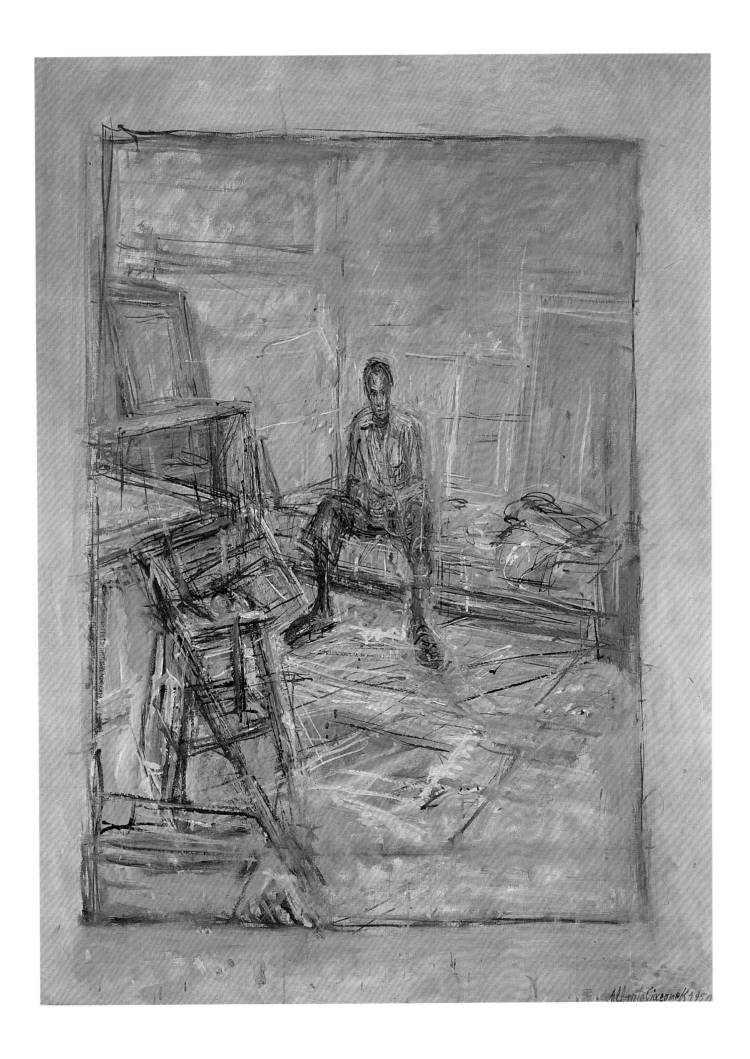

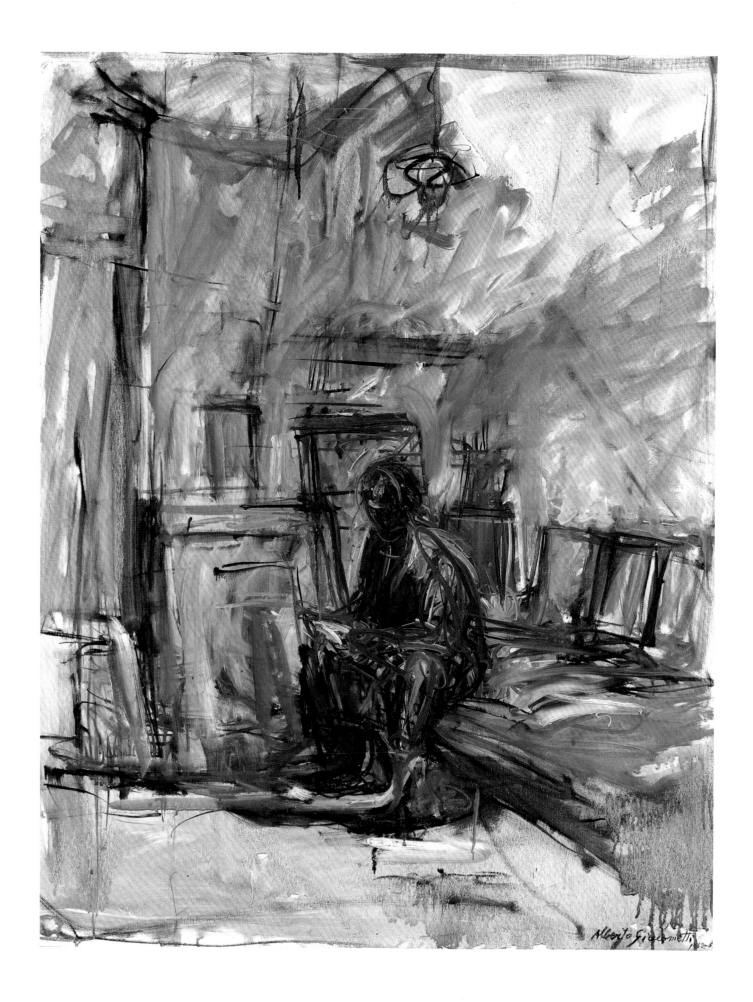

42

Man Seated on the Divan while Reading the Newspaper, 1952–3
Oil on canvas
920 x 710mm
Kunstmuseum Winterthur, purchased in 1961

By the early 1950s, Diego's assistance had become an indispensable part of Giacometti's process and life. While Alberto worked on his painting and sculpture, Diego was responsible for making armatures and casts, and supervising the production of bronzes and their patination. Anxious in temperament, Alberto found support in Diego. For his part, Alberto encouraged Diego's own work and, around the time this portrait was made, Diego began to make the bronze furniture for which he later became famous. Something of their shared existence is evident in this intimate image, which presumably depicts Diego quietly reading in the corner of the studio.

43
Diego in a Sweater, 1953
Bronze
490 x 280 x 225mm
Kunsthaus Zürich, Alberto Giacometti-Stiftung

After making a few small-scale sculptures of Diego in
1950 and 1951, Giacometti grew in confidence from
1952 onwards. This celebrated work is one of a number
of sculptures made between 1953 and 1956 that have
a distinctive material presence. The unusual relation
of the head and body is a defining characteristic.
Here the head is diminished in size relative to the
massive, textured treatment of the torso, arms and
hands. This echoes Giacometti's earlier tendency to
reduce the proportions of a subject as an effect of
distance, thus asserting the nature of the artist's
perception.

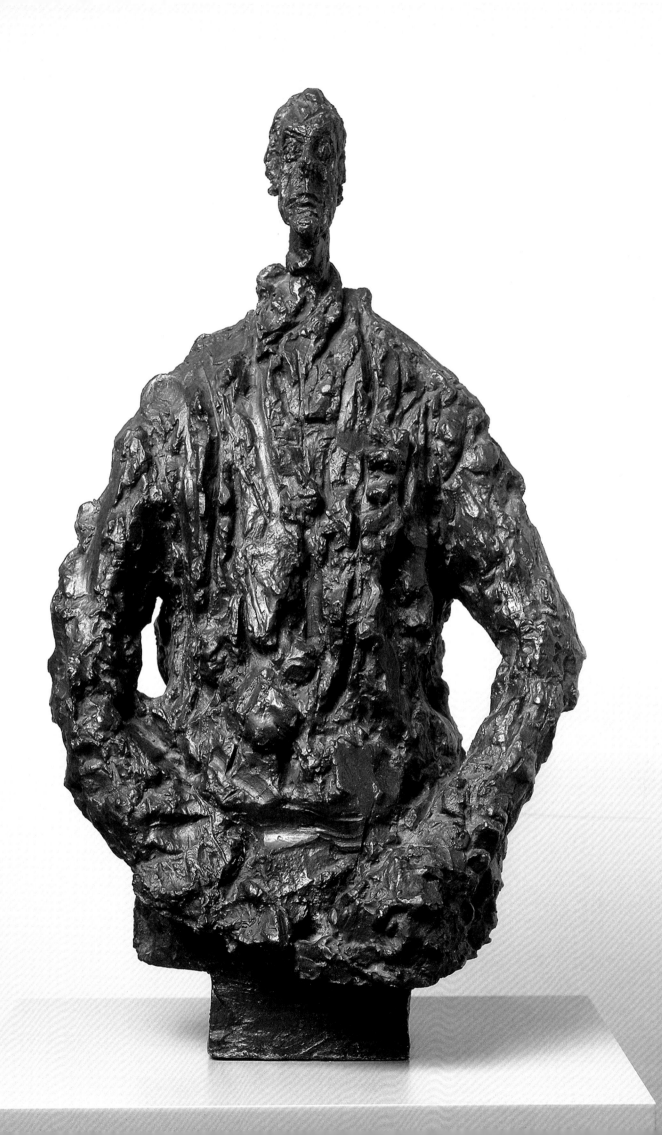

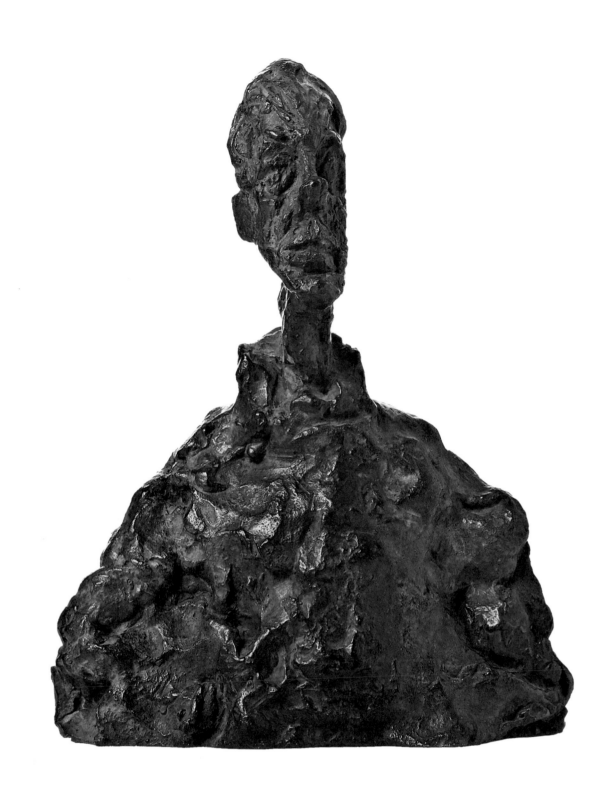

44

Bust of Diego, 1954
Bronze
267 x 205 x 110mm
Private Collection

Contrasting with the larger busts of Diego, this relatively
small work exemplifies the highly abstracted nature of
Giacometti's sculpted portraits of his brother. Its size is
a surprising departure from literal depiction. But, as if
compensating for the modest proportions, its surface
is modelled with an extreme emphasis on texture. This
asserts its independent existence as an object with its
own identity and presence, irrespective of size. Another
aspect of that autonomy is the way the creation of a
conventional likeness has been relinquished. Rooted
in observation, Giacometti's portraits of his brother also
drew on the digested memory of Diego's appearance.

45

Bust of Diego, 1955
Bronze
565 x 320 x 145mm
Tate, purchased with assistance from the
Friends of the Tate Gallery 1965

During the mid-1950s, Giacometti not only reduced the
size of the heads he modelled, but also, as here, their
physical mass. In this remarkable sculpture, Diego's
head, when seen face-on, has a blade-like thinness.
These developments are partly related to his creation,
from the late 1940s, of tall, thin, elongated figures. This
tendency towards attenuated forms expressed his vision
of a figure in space, the body apparently eroded by
the surrounding void. It also resulted from Giacometti's
sense that a sculpture's internal inert matter was at odds
with the vitality he wished to convey. His solution was
to eliminate that superfluous filling, thus reducing the
figure's mass.

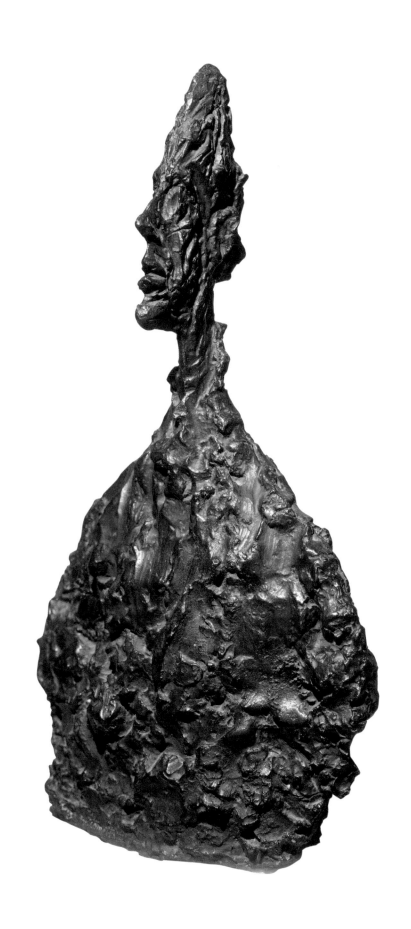

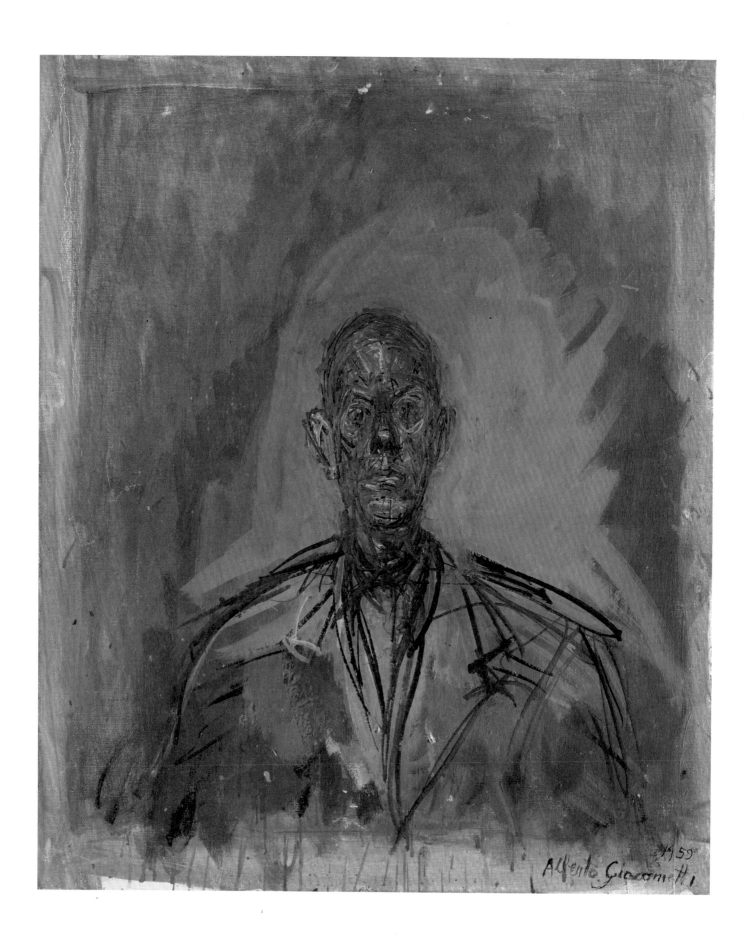

46

Diego, 1959
Oil on canvas
610 x 498mm
Tate, purchased 1960

As Giacometti explained to his biographer James Lord, 'Diego's head is the one I know best.' On a different occasion he added, 'the most difficult thing to do is what's most familiar'. Giacometti was constantly seeking to circumvent his knowledge in pursuit of 'a new sensation, a sensation I had never experienced before'. By the late 1950s, when this portrait was painted, Giacometti's images of Diego moved between sculpture and painting, and from observation to memory, in a mutually enriching way. Each of these independent experiences informed the other. According to his own account, this portrait was made in two short evening sessions.

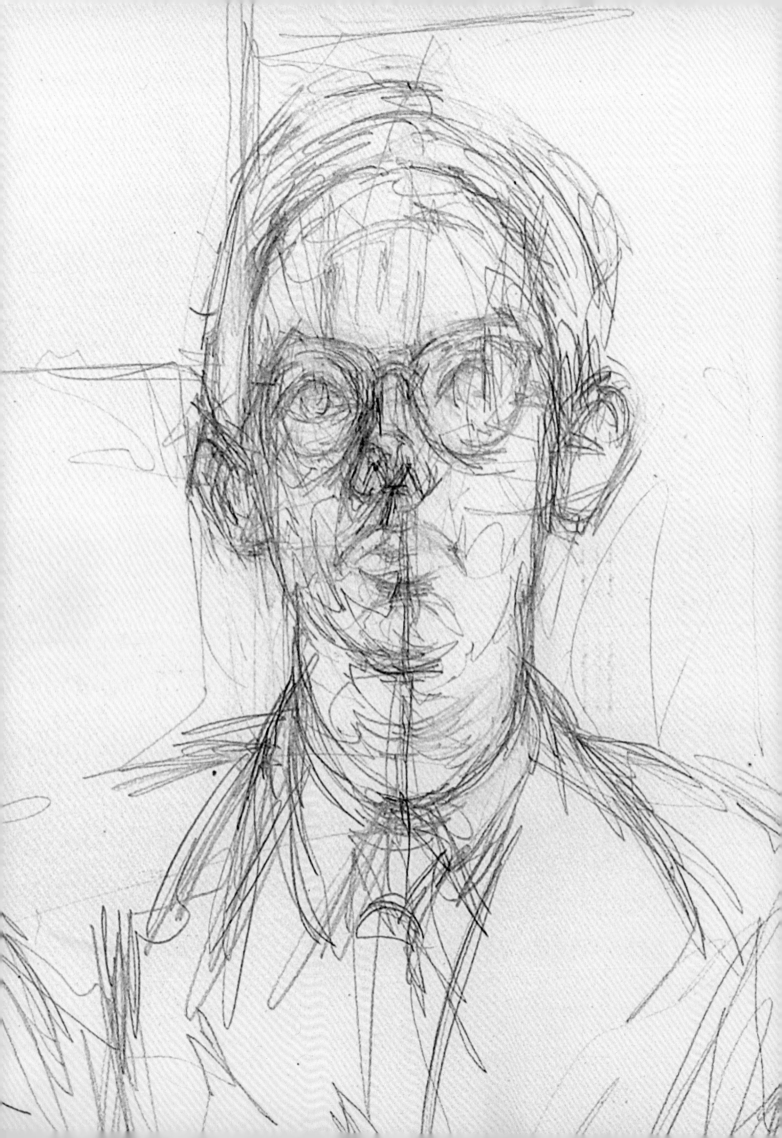

THE IMAGE OF MAN

The years following Giacometti's first one-man show in New York in 1948 saw the expansion of his reputation internationally. Accompanying that exhibition, Jean-Paul Sartre's essay *The Quest for the Absolute* linked Giacometti's art with certain existentialist ideas. Focusing on the relation of the figure to space, Sartre saw the work as 'always mediating between nothingness and being'. That way of viewing Giacometti's art gained currency, one critic in 1954 describing him as 'the artist of existentialism'. This perception was encouraged by the Paris-based circle in which the artist moved. In addition to Sartre, Giacometti was in contact with Simone de Beauvoir, Samuel Beckett and others associated with existentialism.

As well as his regular sitters Annette and Diego, Giacometti made portraits of a range of individuals. These included the writer Jean Genet, the Japanese philosopher Isaku Yanaihara, the Surrealist poet Louis Aragon, his later biographerJames Lord, and the art collector David Thompson. In portraying these sitters, Giacometti generally positioned each figure at the centre of the image. This maximises a sense of what Sartre described as 'pure presence'. However, this characteristic of Giacometti's art predated his association with existentialism, and the entirely personal nature of his vision remained distinct from wider philosophical developments.

47
Louis Aragon, 1946
Pencil on paper
525 x 370mm
Private Collection c/o Lefevre Fine Art Ltd.

This drawing of the Surrealist poet and novelist belongs
to a two-year period, from 1946 to 1947, when Giacometti
made numerous studies from life in pencil on paper.
Having returned to Paris in 1945, he now resumed contact
with a wide circle of individuals, several of whom sat for
portraits. In addition to drawings of Diego, Annette and
Aragon, he drew his mother Annetta, the gallery owner
Pierre Loeb, and the philosopher Jean-Paul Sartre.
He also sketched people seen in the street. As he later
observed, his uncertainty during the war years was
now replaced by a renewed vigour, 'thanks to drawing'.

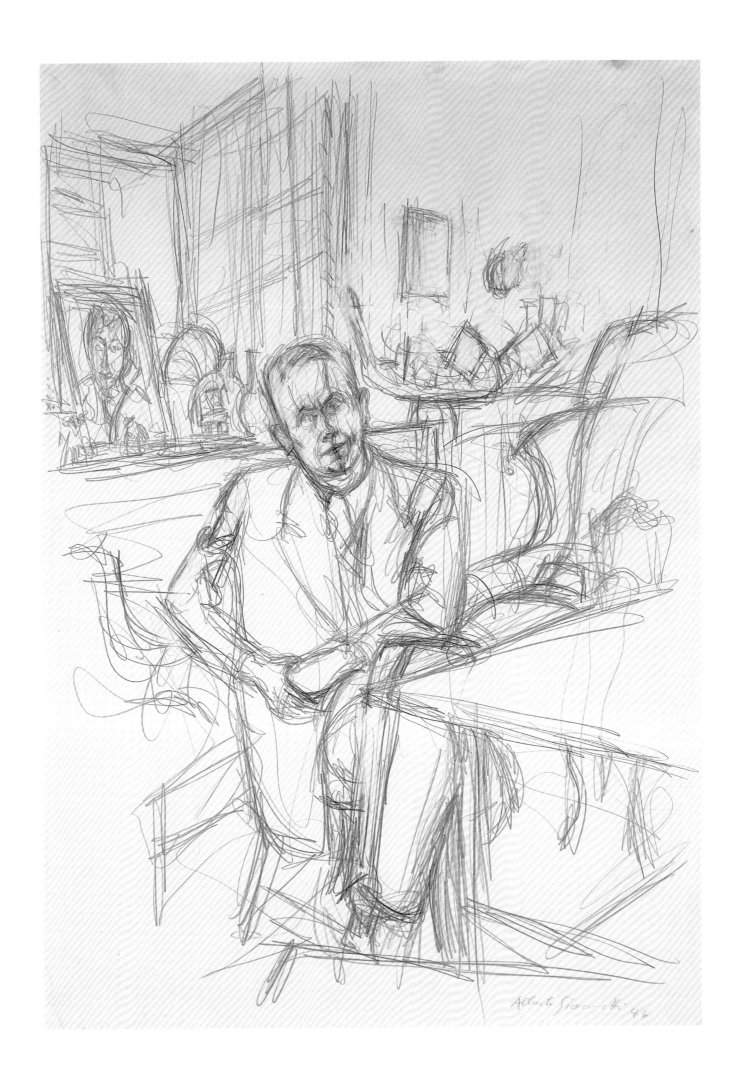

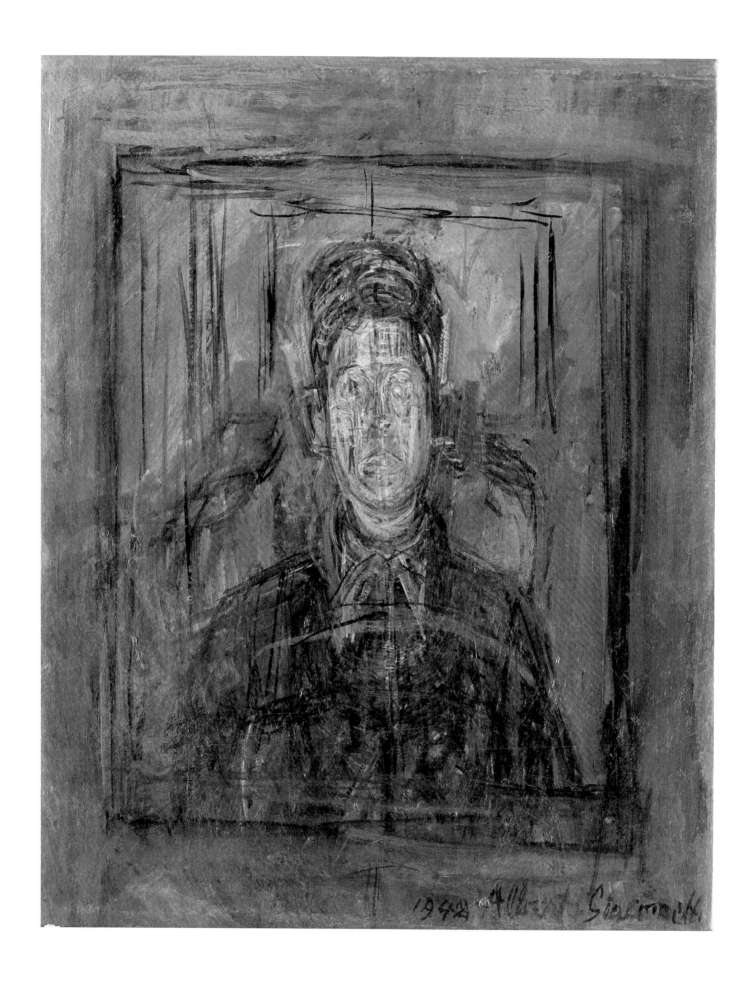

48

Silvio Berthoud, 1948
Oil on canvas
322 x 253mm
Private Collection

Silvio was Giacometti's nephew, orphaned when his mother Ottilia died in childbirth in 1937. While living in Geneva during the war, Giacometti modelled several tiny portraits of his young sitter. This later portrait was made during a holiday in Switzerland, either at the family home in Stampa or Maloja. The features are abstracted, a sense of the sitter's presence being a prime concern. A distinctive feature is Giacometti's incorporation of multiple painted frames that surround the sitter. As well as containing the figure, these pictorial devices create an impression of recession, as if situating Silvio within a separate, distant space.

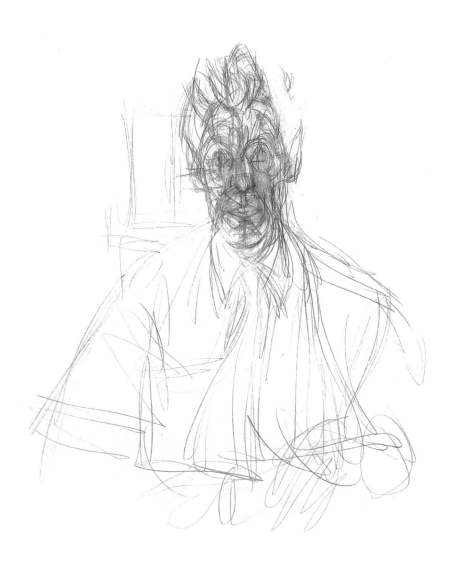

49
Self-portrait, 1954
Pencil on paper
490 x 317mm
Thomas Gibson

In May 1954 the Galerie Maeght mounted a second major one-man exhibition of Giacometti's work. Comprising paintings, sculpture and drawings, including several portraits of Annette and Diego, it consolidated Giacometti's reputation as an artist of singular importance. Sartre's essay *The Paintings of Giacometti*, which was published at the time, contained the insight that Giacometti's portraits, in particular their 'lack of precision', revealed the perception that 'a face is forever changing'. This self-portrait drawing can be seen in that light. Turning his gaze upon himself, the artist represents his face as a conglomeration of fleeting sensations.

50
Portrait of James Lord, 1954
Pencil on paper
493 x 317mm
Thomas Gibson

This drawing depicts the American writer James Lord, whose biography of Giacometti was published in 1985. Lord also wrote a vital account of sitting for the portrait that Giacometti made of him in 1964. As this drawing shows, Lord began visiting the artist's studio at a much earlier date. The two men met in 1952 and became friends. The drawing is one of several made of Lord in 1954. By this time, Giacometti's approach to portraiture was established, his preference for frontal poses, as is the case here, a defining characteristic. This direct relationship with his sitters was both intimate and confrontational.

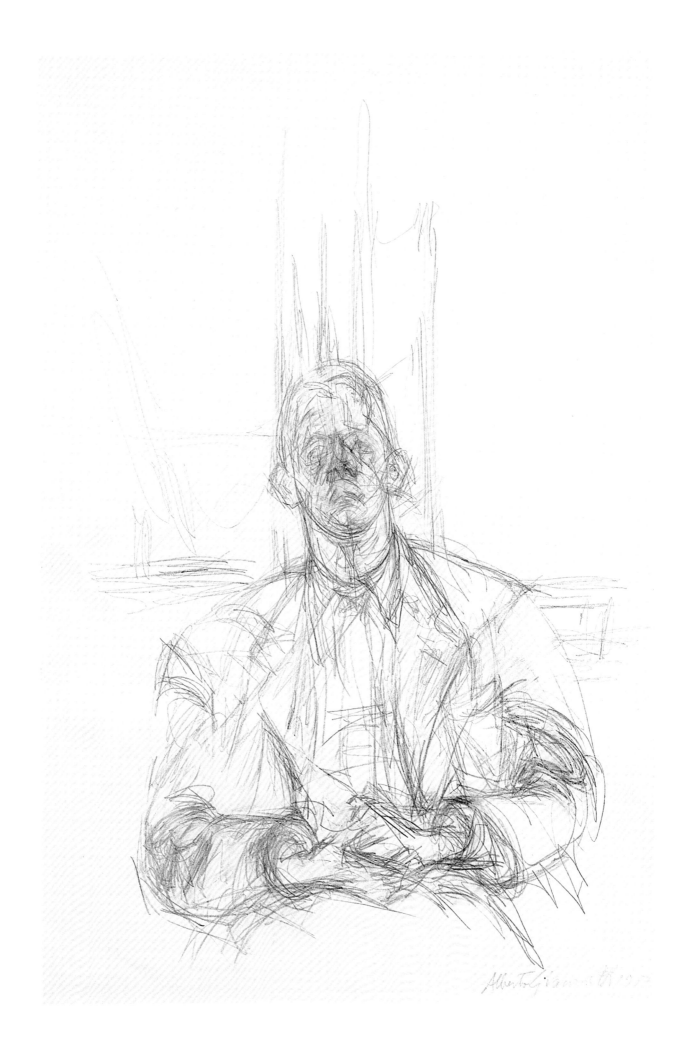

51
Jean Genet, 1954–5
Oil on canvas
653 x 543mm
Tate, accepted by HM Government in lieu of tax
and allocated to the Tate Gallery 1987

The writer Jean Genet was born in 1910. His mother was
a prostitute and he was adopted at an early age. After
various teenage misdemeanours, he joined the French
Foreign Legion. Subsequently discharged, he drifted
around Europe. Contact with its underworld led to his
eventual imprisonment. While in prison, he composed
his first literary efforts, and subsequently wrote numerous
novels, three plays and poems. Giacometti was
fascinated by Genet from the outset and completed
three painted portraits and several drawings of him.
In response to his portrait, Genet observed, 'the face … .
became such a presence, such a reality and such a
terrible impression of relief'.

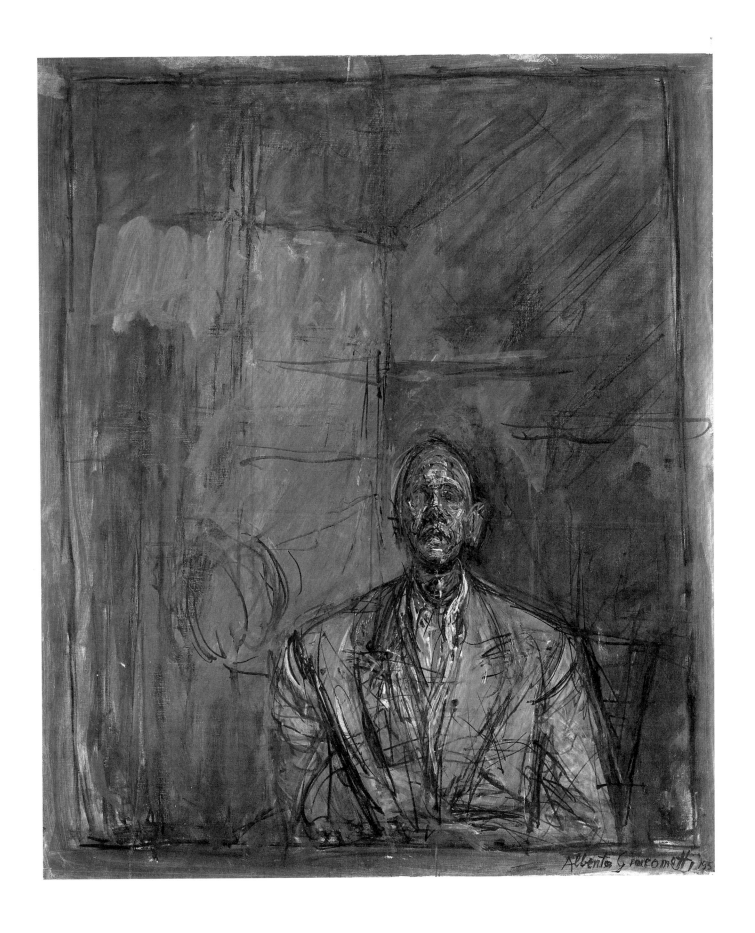

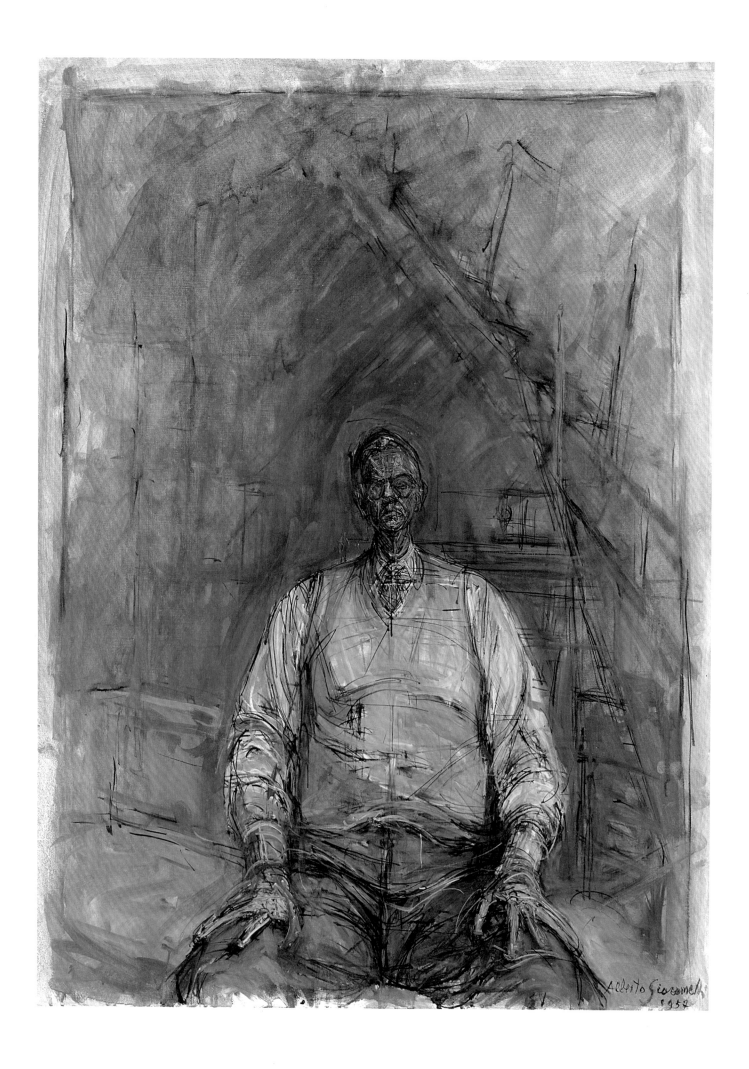

52

Portrait of G. David Thompson, 1957
Oil on canvas
1000 x 930mm
Kunsthaus Zürich, Alberto Giacometti-Stiftung

Giacometti met the American millionaire G. David
Thompson in 1954. Thompson had begun collecting
Giacometti's work somewhat earlier as part of his
ambition to form an important collection of twentieth-
century art by modern masters. He went on to form
a pre-eminent group of works by the artist – around a
hundred in total – including sculpture, paintings and
drawings. This is one of three portraits of Thompson
made between 1955 and 1957. Given that Giacometti
made portraits mainly of those with whom he formed
a close relationship, this portrait is unusual. As neither
man spoke the other's language, their communication
was almost entirely visual.

53
David Sainsbury, 1955
Pencil on paper
557 x 389mm
Lefevre Fine Art Ltd., London/Thomas Gibson
Fine Art Ltd.

In common with G. David Thompson, the distinguished
art collectors Sir Robert and Lady Sainsbury also
assembled an important collection of Giacometti's
work. In this instance, however, the relationship
between artist and patron was one of personal
friendship. Giacometti painted a portrait of Lord
Sainsbury in 1958 and, prior to that, also drew his son,
David (later Baron Sainsbury), in 1955. This is one of
several drawings made at the same sitting, from which
three were selected by the sitter's parents. A notable
aspect of this portrait, and others made for patrons,
is the relative absence of evident struggle in its
completion.

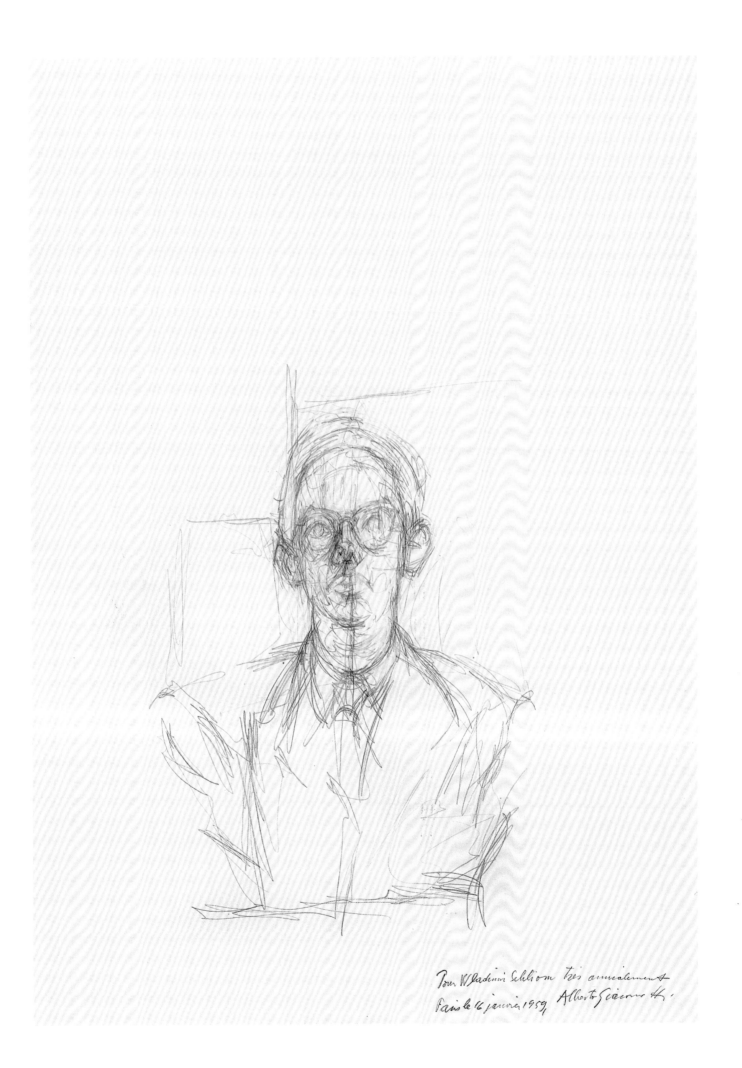

Pour Wladimir Schlion très amicalement
Paris le 16 janvier 1959, Alberto Giacometti

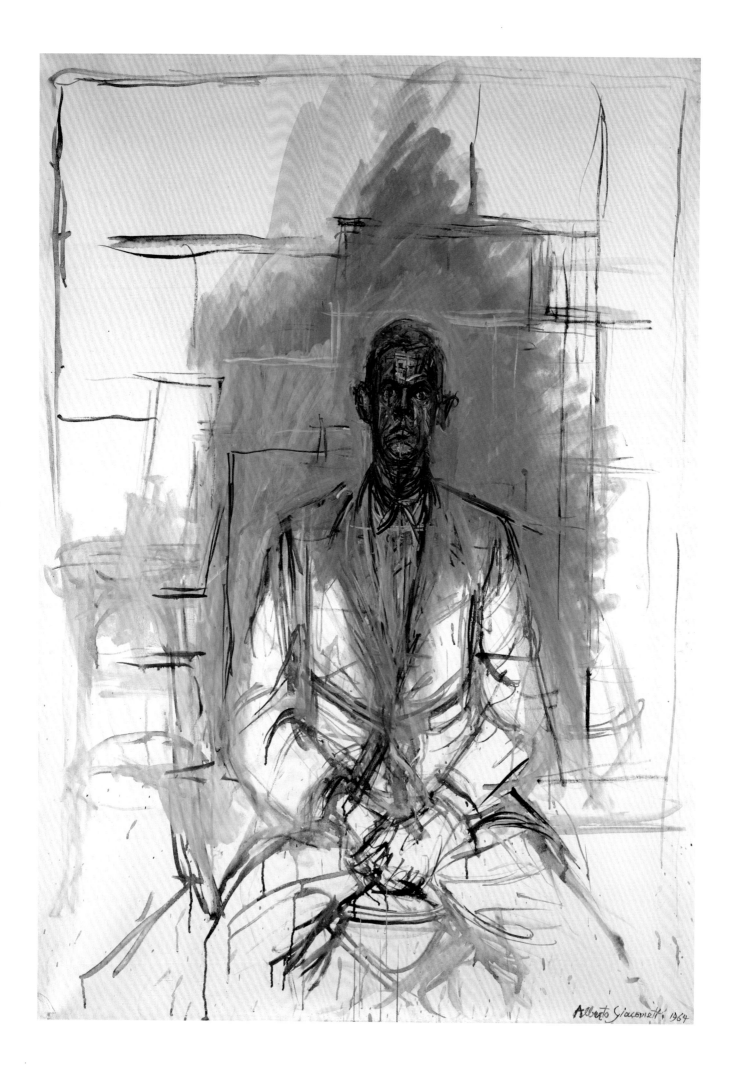

54
Portrait of James Lord, 1964
Oil on canvas
1170 x 815mm
Thomas Gibson Fine Art Ltd., courtesy of Guzon Ltd.

Lord sat for this portrait from 12 September until
1 October 1964. A vivid account of the eighteen daily
sittings that took place appears in his book *A Giacometti
Portrait*, published in 1980. The original idea was to
make a quick sketch on canvas. However, photographs
taken by Lord record the innumerable changes that
ensued. Giacometti began, as usual, without preparatory
drawings. As work progressed, though, his confidence
wavered constantly, as if pursuing different appearances
that were forever forming and disappearing. After the
sittings came to an end, Giacometti observed, 'We'd
only started.'

55
Portrait of Nelda, 1964
Oil on canvas
545 x 460mm
Kunsthaus Zürich, Alberto Giacometti-Stiftung,
Gift of the Artist, 1965

The subject of this portrait is Nelda Negrini, a waitress
who lived in Stampa. Giacometti painted her on three
occasions and she also sat for drawings. She was
related to the Giacometti family, her mother being
Alberto's cousin. Her grandmother was a seamstress
who had made clothes for Alberto and Diego during
their childhood. The painting was made in Stampa
during one or two of the artist's last visits to Switzerland.
Although the model was not a regular sitter, and this
portrait is relatively modest in scale, the emphatic
modelling of her features is nevertheless striking.

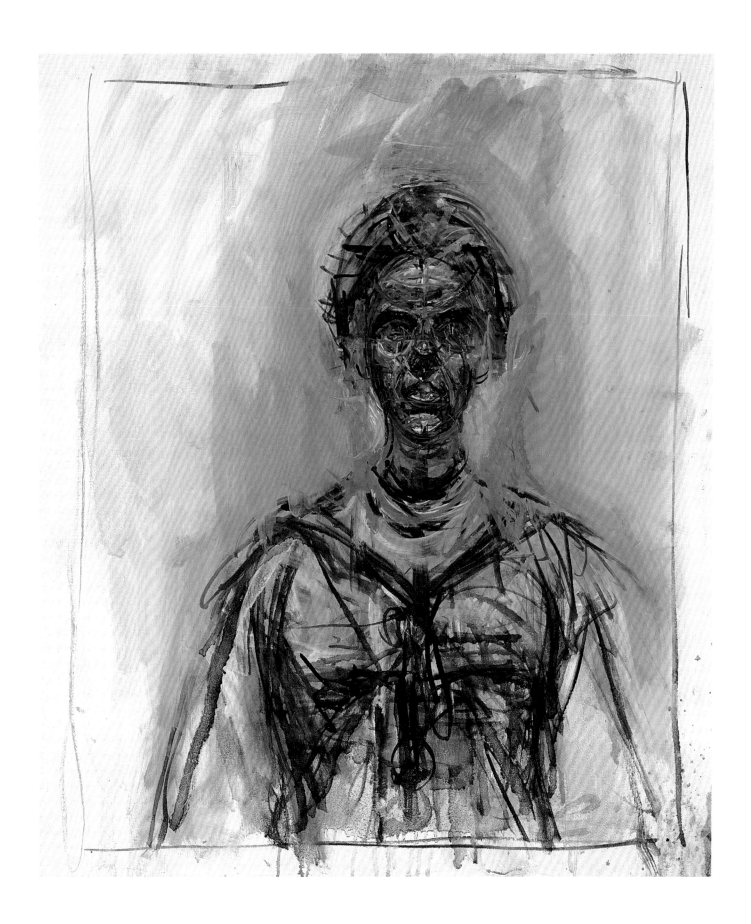

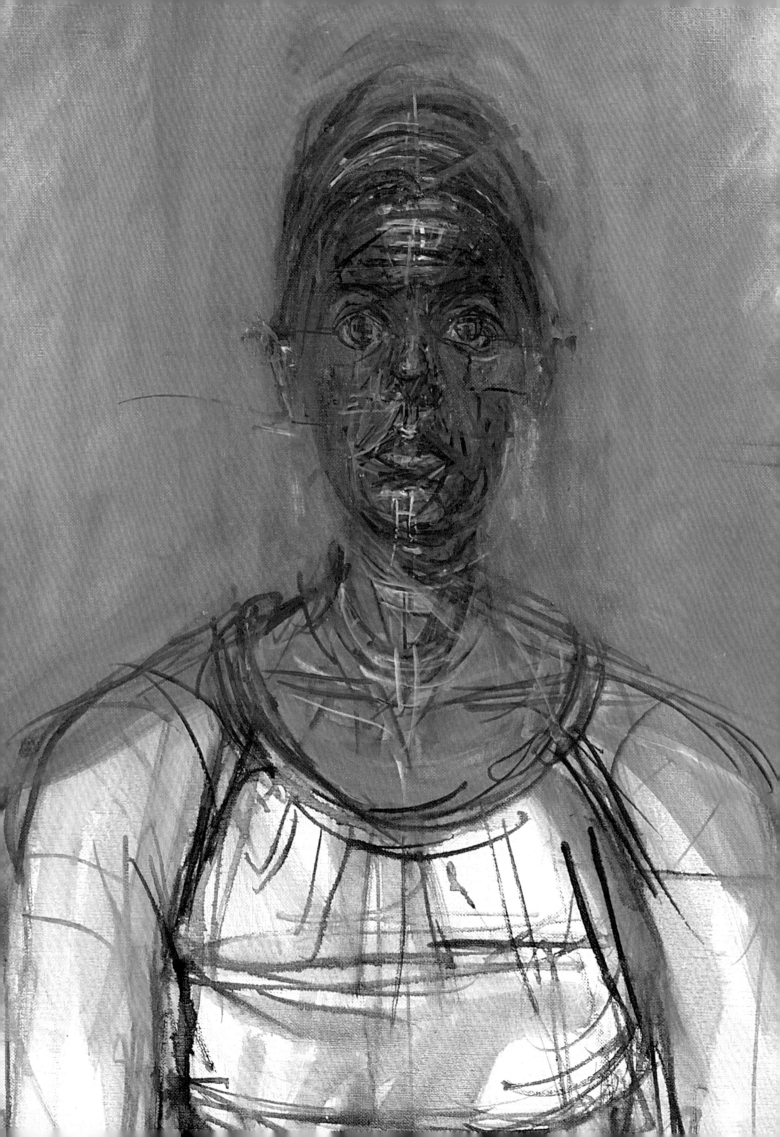

CAROLINE

Joining his long-term sitters Annette and Diego, Caroline
was Giacometti's final female model. The subject of over
thirty portraits – almost exclusively paintings – she sat for
Giacometti from 1960 to 1965. Born in 1938, her real name
was Yvonne Poiraudeau, and she was brought up in a small
town on the east coast of France. After moving with her
parents to a suburb of Paris, she was sent to a reform
school. From there she became associated with the city's
underworld. Although she denied being a prostitute
herself, many of her friends were, and her circle included
gangsters and thieves.

From the outset, Giacometti was fascinated by Caroline's
high-spirited, unconventional nature and disregard for
social customs. They first met in 1958 at Chez Adrien,
a bar frequented by Giacometti. The artist's initial
admiration grew and in 1960, after Caroline was arrested
and imprisoned for theft for over six weeks, Giacometti
tried to secure her release. Their relationship was close
from that point onwards, and she began regular sittings
shortly afterwards. Although Caroline was petite,
Giacometti's portraits of her present a charged, hieratic
presence and an intense stillness. Progressively his
attention focused on his sitter's head and, finally, her eyes.

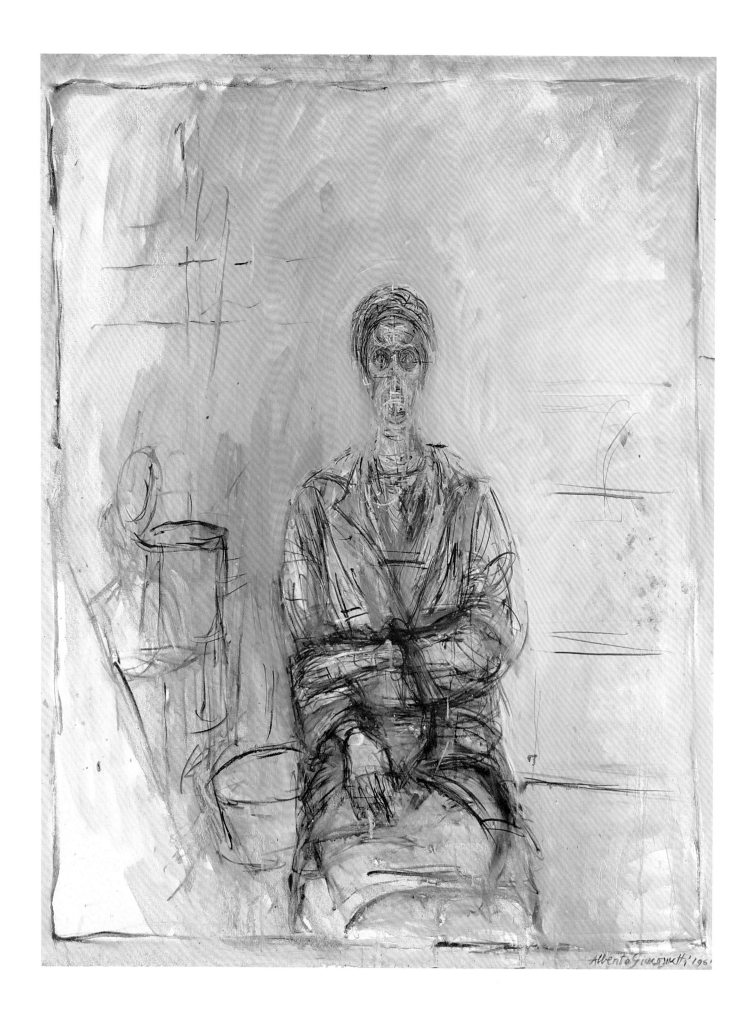

56

Portrait of Caroline, 1961
Oil on canvas
1162 x 889mm
Private Collection

When Giacometti first met Caroline she was living at the Hôtel de Sèvres near Montparnasse. Subsequently, they began seeing each other more frequently, and Caroline visited Giacometti's studio on a number of occasions. During that early phase, however, she did not sit for any portraits. In early April 1960 Caroline went missing, and Giacometti traced her to the Prison de la Petite Roquette, where she was being held on a charge of theft. In an attempt to have her freed, he met the magistrate responsible for imprisoning her, but failed to get the decision overturned. After her eventual release in May, she began sitting regularly. This portrait belongs to the early days of her relationship with Giacometti.

57
Caroline, 1961
Oil on canvas
1000 x 820mm
Fondation Beyeler, Riehen/Basel, Beyeler Collection

After Caroline began sitting regularly for Giacometti, she visited the studio almost every evening. This painting comes from a first phase of activity – one of five portraits in which she is shown wearing a pink coat over a red sweater. The portrait that preceded it (cat. 56) shows a stove to her left, but here Giacometti has concentrated on the figure alone. The head in particular forms an arresting focus of attention. Contrasting with the dominant red of her clothing, Caroline's features are realised in a densely modelled black. The treatment of the eyes – as if possessing a hypnotic gaze – signals Giacometti's growing preoccupation with this aspect.

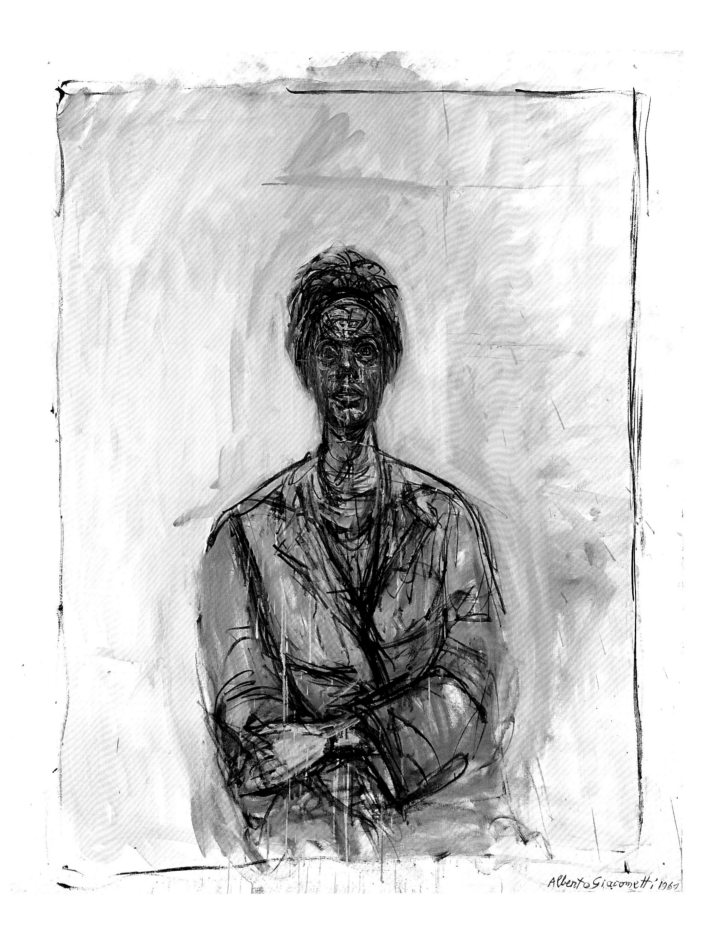

Alberto Giacometti 1961

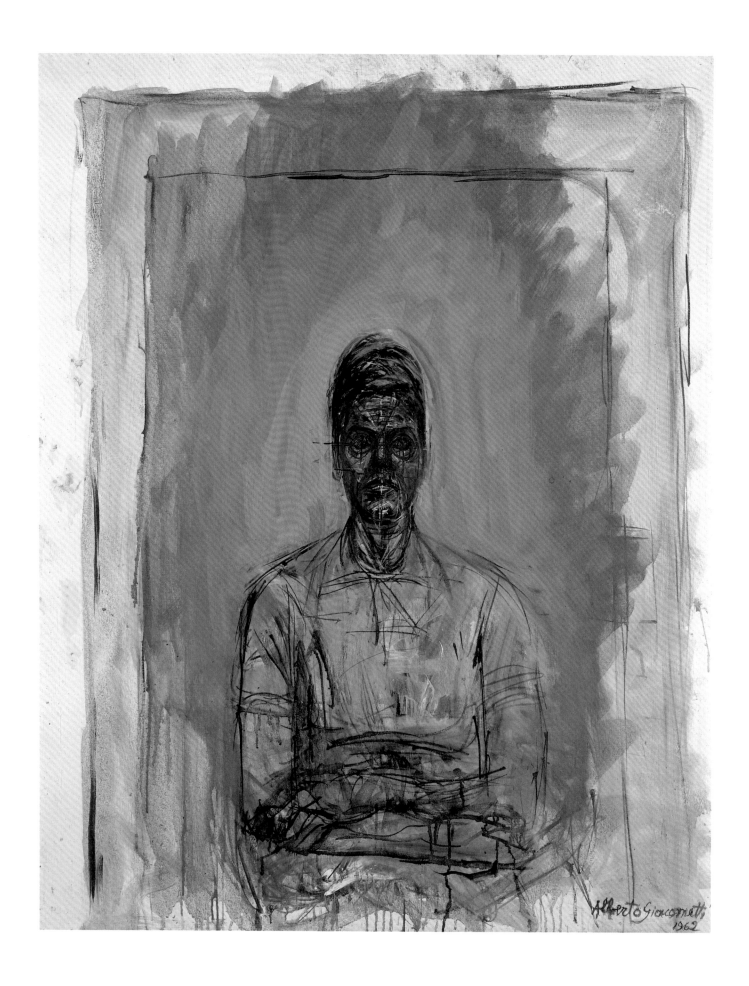

58
Portrait of Caroline, 1962
Oil on canvas
920 x 730mm
Private Collection, New York

This portrait belongs to a second phase of activity, between 1962 and 1963, when Giacometti worked on nine portraits of Caroline. The earliest paintings in this group continue to depict his model wearing winter clothes, while the later ones (like this) show Caroline wearing lighter apparel, a high-necked dress with short sleeves. The portrait also includes a painted frame around the sitter, a device that first appeared towards the end of the previous phase. This characterises most of Giacometti's subsequent portraits of Caroline. The effect is to situate the figure within its own self-contained space.

59

Portrait of Caroline, c.1964
Oil on canvas
1302 x 889mm
Private Collection

Caroline usually sat for Giacometti late at night,
commencing at around nine o'clock, when his earlier
session with Annette had finished. Observed by artificial
light, Caroline has a stark, confrontational presence in
her portraits, in which, typically, the details of the studio
surroundings are dissolved. As this portrait demonstrates,
the figure has an intense, self-contained quality that
became progressively concentrated, first on the head
and finally on the model's own gaze. In that respect,
Giacometti's portraits of Caroline have a relationship
with the busts of Diego and Lotar, also made in this
late phase.

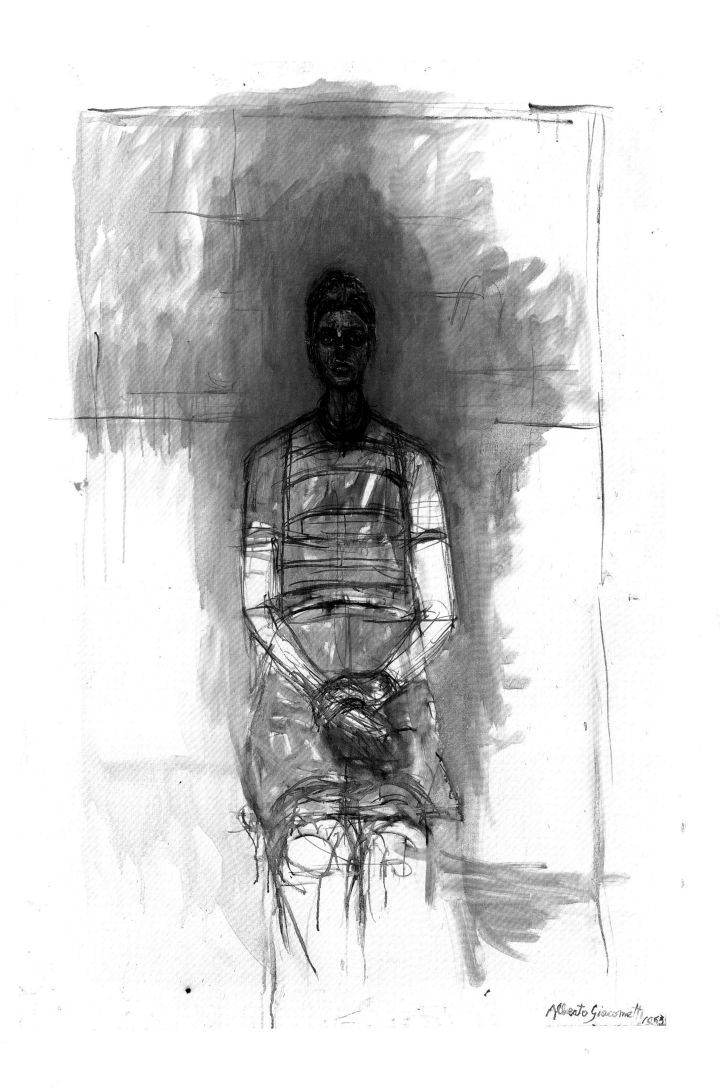

Alberto Giacometti 1963

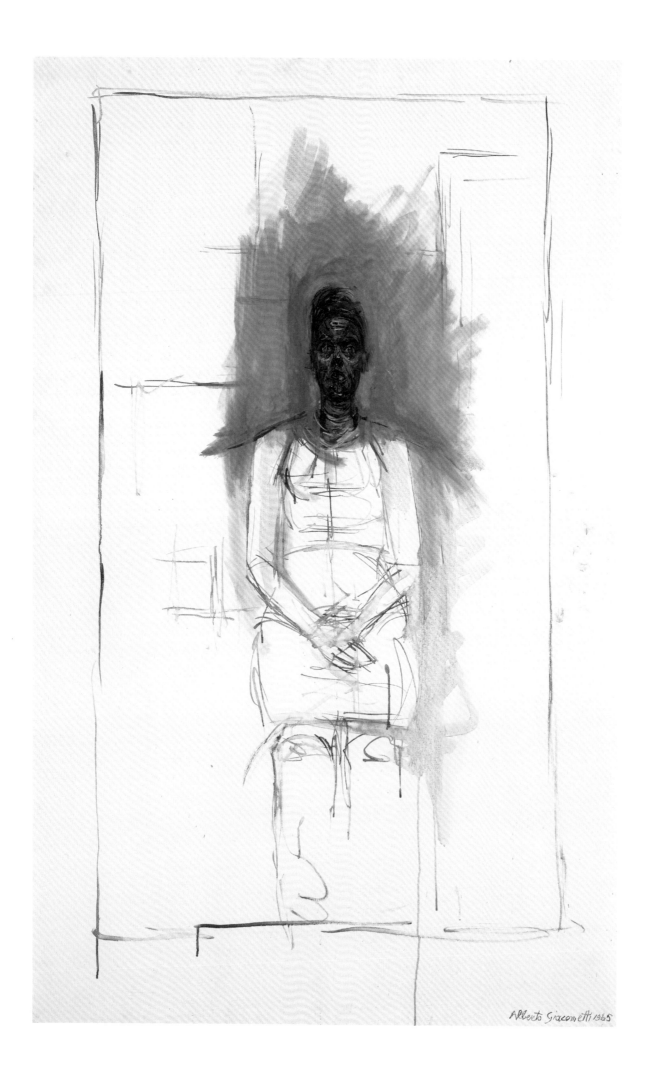

60
Caroline, 1965
Oil on canvas
1302 x 813mm
Tate, purchased with assistance from the
Friends of the Tate Gallery 1965

This late portrait of Caroline reveals the raw, apparently
unfinished state that characterises Giacometti's final
work. However, rather than being incomplete, such
portraits have a reductive quality, their focus confined
to essentials. By this time the artist had eliminated all
superfluous detail, the model's gaze becoming his
overriding preoccupation. Of these developments,
he commented, 'I noticed that the only thing that
remained alive was the gaze. The rest, the head made
into a skull, became equivalent to a death's head …'.
For Giacometti, the intimation of life in the sitter's
eyes animated the whole, and for that reason became
his quarry.

61

Caroline, 1965
Oil on canvas
1295 x 806mm
Tate, purchased with assistance from the
Friends of the Tate Gallery 1965

Giacometti's nickname for Caroline was *la Grisaille*
(the Grey One) This contrasted with her outgoing and
colourful personality, and related instead to the grey
appearance she conveyed during their nocturnal
modelling sessions. As Giacometti concentrated
increasingly on Caroline's head and eyes, the paintings
became drained of local colour. Eventually her
surroundings ceased to register, the corresponding
areas of the image being left unpainted, the surface
exposed. The resulting monochrome of this late
portrait was not, however, just a visual phenomenon.
As Giacometti attested, the colour grey had a
significance that was deeply personal and expressive,
one that 'I feel, that I see ... which for me signifies
life itself.'

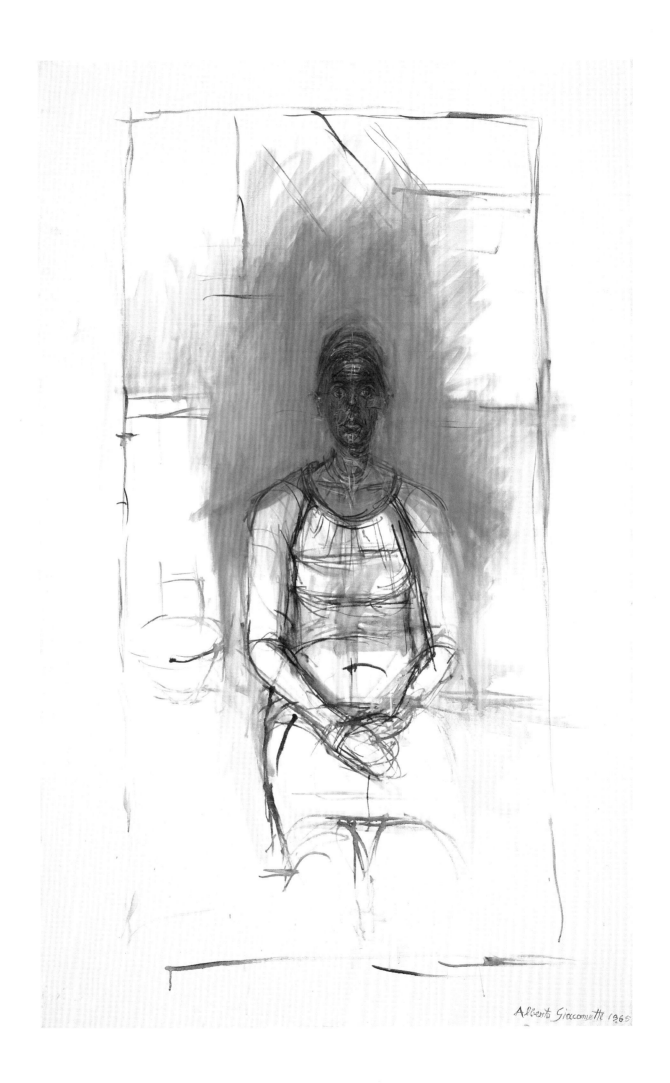

Alberto Giacometti 1965

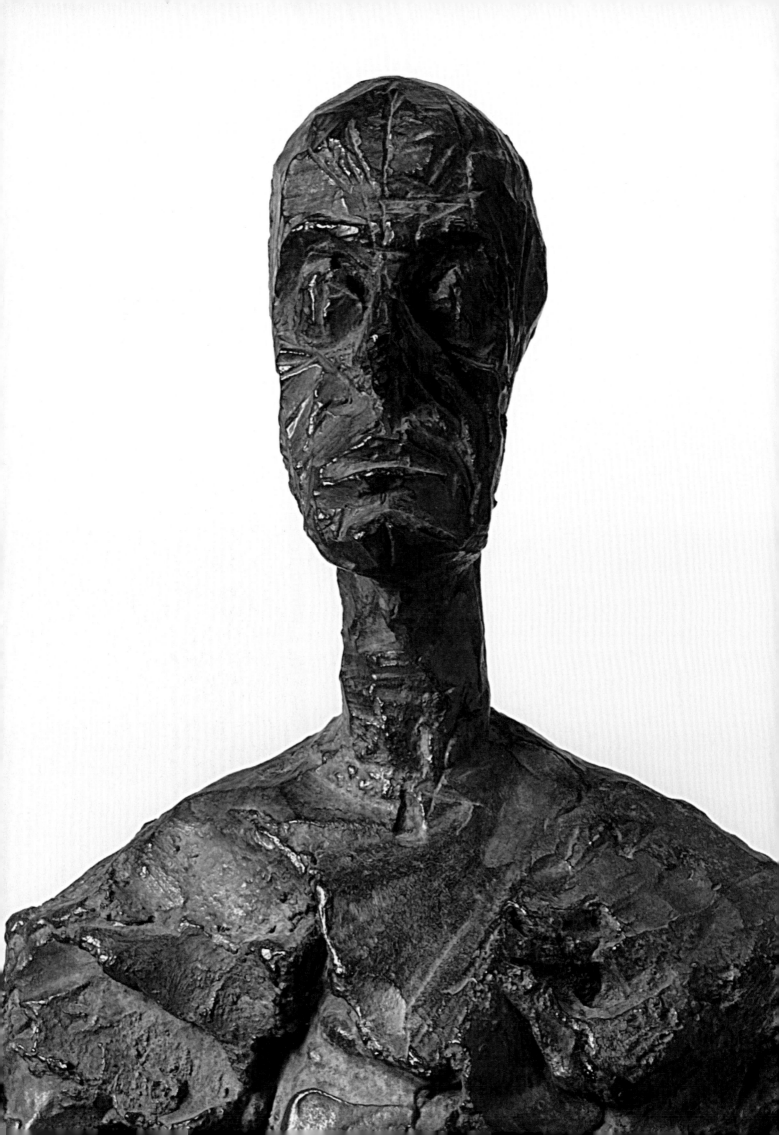

LAST PORTRAITS

Giacometti's final years saw the consolidation of his standing as one of the world's leading artists. In 1961 he was awarded the Carnegie Sculpture Prize of the International Painting and Sculpture Exhibition in Pittsburgh. The following year he received the Grand Prize for Sculpture at the Venice Biennale, and, in 1964, the Guggenheim International Painting Award. The French government honoured him with the Grand Prize for Art in 1965. The same period saw major retrospective exhibitions of his work held in Zürich, London, New York and Copenhagen. By this time, however, Giacometti's health had begun to deteriorate. In 1963 he underwent an operation for stomach cancer and, although he recovered, the experience took its toll. Soon after, he was deeply affected by the death of his mother.

Giacometti's last portraits depict Annette, Caroline and, finally, the photographer Eli Lotar and Diego, whom he modelled in clay. Collectively, these portraits have a raw, apparently unfinished character that preserves the artist's ongoing attempt to capture a fleeting impression. Of that struggle, which continued to the end, he commented, 'Sometimes I think I can catch an appearance, then I lose it and so I have to start all over again.' Giacometti died on 11 January 1966. He was buried in Borgonovo, his birthplace.

62

Chiavenna Bust I, 1964
Bronze
410 x 197 x 152mm
Tate, purchased with assistance from the
Friends of the Tate Gallery 1965

This late bust depicts Diego, and is one of two that
Giacometti made of him in 1964 and 1965. Diego had
been the subject of Giacometti's first bust made fifty
years earlier, and in the intervening years, among all
the artist's sitters, his features had become the most
ingrained in Giacometti's mind. For that reason,
while Giacometti continued to make portraits of
Diego, during this latter phase he worked from memory.
The Chiavenna busts were made in Stampa during
Giacometti's usual summer sojourn there. Their title
derives from the Italian town of Chiavenna, just across
the border, where they were cast, originally in plaster.

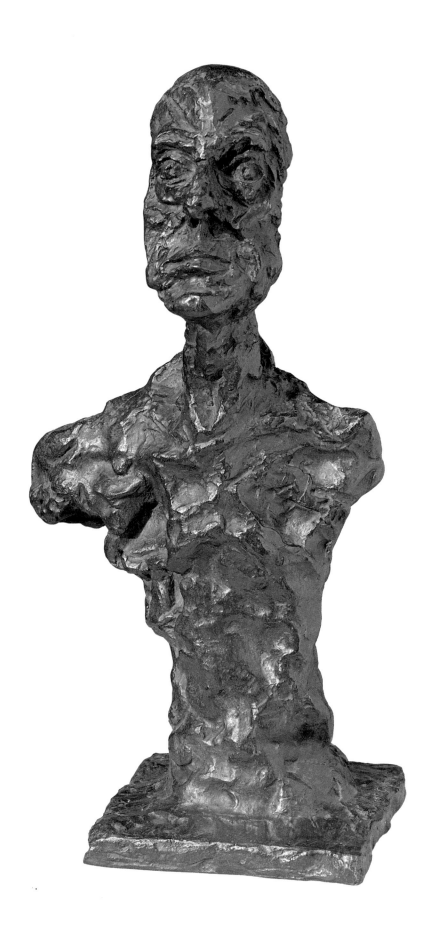

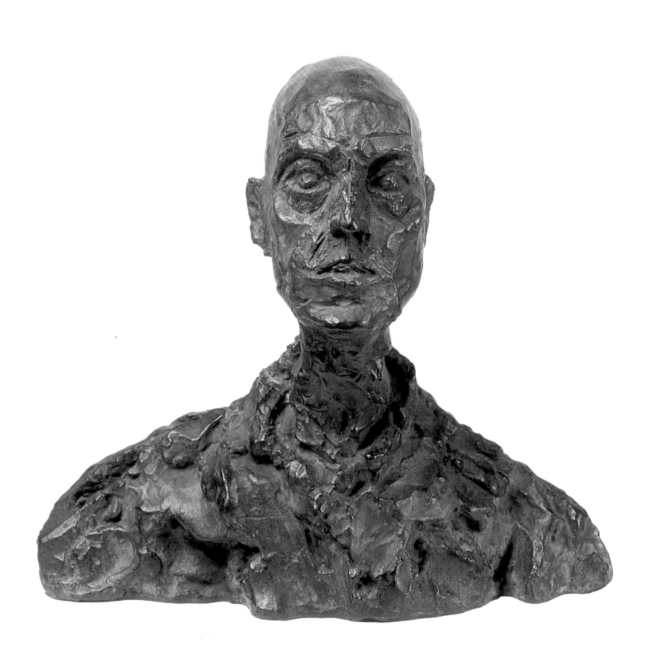

63

Bust of Lotar I, 1965
Bronze
258 x 283 x 149mm
Kunsthaus Zürich Alberto Giacometti-Stiftung,
Gift of Bruno and Odette Giacometti, 2012

The subject of this bust is Eli Lotar, a friend of Caroline
and the artist. Having been a photographer, Lotar had
drifted into an itinerant existence, frequenting the bars
and cafés also used by Giacometti. Having observed
some of the sittings with Caroline, Lotar eventually
began to sit for Giacometti. The sense of resignation
and failure that he projected was possibly an allure to
an artist himself preoccupied with these human frailties.
This is one of three busts of Lotar on which Giacometti
worked in the final two years of his life, each an
embodiment of melancholy and also a strange,
unbowed dignity.

64

Bust of Lotar II, 1964–5
Bronze
582 x 375 x 259mm
Fonte Susse (1981), 2/8
Collection Fondation Giacometti, Paris,
inv.1994-0189 (AGD 1765)

This is Giacometti's penultimate sculpture and relates
closely to *Lotar I*, on which Giacometti worked
concurrently. Like the smaller work, Lotar's head
appears to arise from a mound of matter, poised as it
were between states of resignation and resistance.
There is also a sense that the portrait transcends the
incidental details of the sitter's features, expressing a
presence that is at once personal but also essentially
human. In common with Giacometti's late work as a
whole, the figure seems unfinished. He acknowledged
the difficulty of completing his works, seeing each as
'a fragment … a little of what I would like to create
one day'.

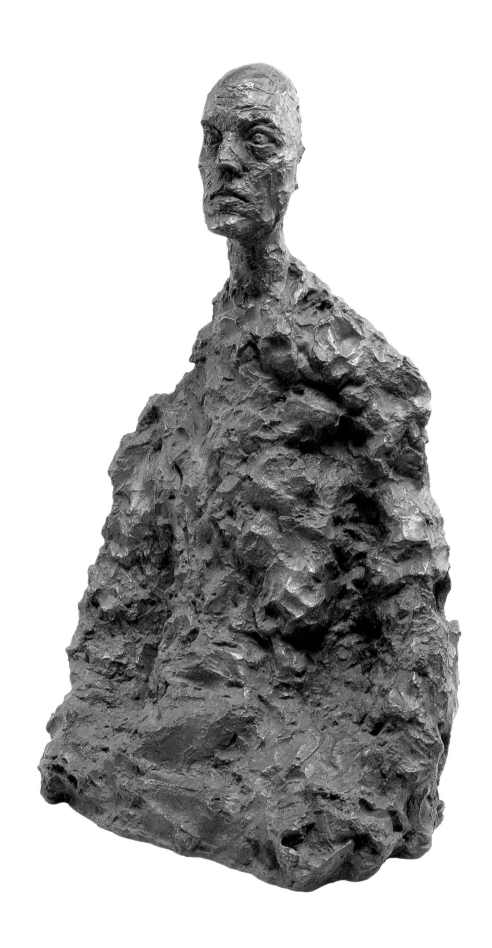

65

Diego Seated, 1964–5
Bronze
590 x 185 x 330mm
Louisiana Museum of Modern Art, Humlebaek,
Denmark. Donation: The New Carlsberg Foundation,
The Augustinus Foundation and The Louisiana
Foundation

Like *Chiavenna Bust I*, this large portrait of Diego was
modelled from memory. Commenced in 1964, it
followed the death of the artist's mother in January of
the same year. By that time, Giacometti's own health
was deteriorating. Cleared of the cancer that had
necessitated an operation the previous year, he was
now suffering from extreme exhaustion. Even so, in
addition to working on portraits of James Lord,
Caroline, Diego and Lotar, he attended openings of his
exhibitions in New York and London. Created amid
death, illness and continued activity, the figure seems
formed from earth-like matter.

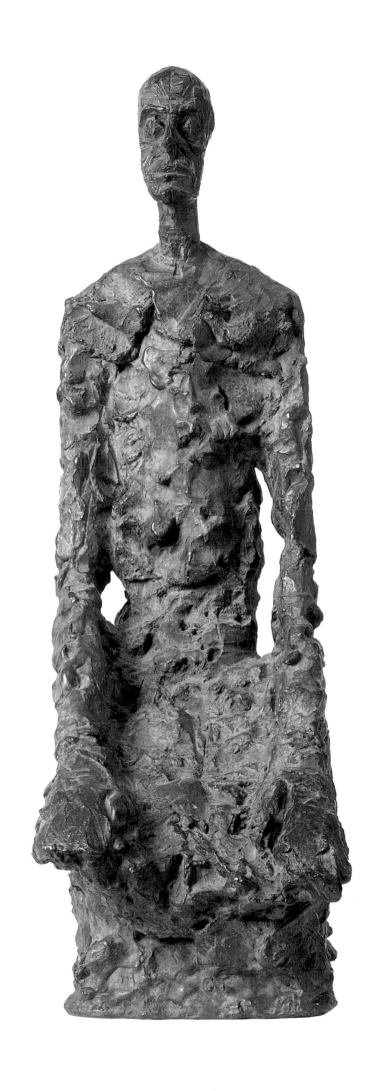

FURTHER READING

Bonnefoy, Yves, *Alberto Giacometti: A Biography of His Work*, Flammarion, Paris, 1991

Dupin, Jacques, *Alberto Giacometti*, Maeght Editeur, Paris, 1962

Giacometti, Alberto, 'Paris Sans Fin' in *Paris Sans Fin: Lithographies Originales de Alberto Giacometti*, Tériade, Paris, 1969

González, Ángel, *Alberto Giacometti: Works, Writings, Interviews*, Ediciones Polígrafa, Barcelona, 2006

Hohl, Reinhold, *Alberto Giacometti: Sculpture, Painting, Drawing*, Thames & Hudson, London, 1972

Hohl, Reinhold, *Giacometti: A Biography in Pictures*, Hatje Cantz, Ostfildern, 1998

Knowlson, James, *Damned to Fame: The Life of Samuel Beckett*, Bloomsbury, London, 1996

Leiris, Michel and Dupin, Jacques (eds), *Ecrits: Alberto Giacometti*, Hermann, Paris, 1990

Liberman, Alexander, *The Artist and His Studio*, Viking Press, New York, 1960

Lord, James, *A Giacometti Portrait*, Faber & Faber, London, 1981

Lord, James, *Giacometti: A Biography*, Farrar Strauss Giroux, New York, 1985

Matter, Herbert, and Matter, Mercedes, *Alberto Giacometti*, Abrams, New York, 1987

Megged, Matti, *Dialogue in the Void: Beckett and Giacometti*, Lumen Books, New York, 1985

Peppiatt, Michael, *In Giacometti's Studio*, Yale University Press, New Haven and London, 2010

Read, Peter and Kelly, Julia (eds), *Giacometti Critical Essays*, Ashgate, Farnham, 2009

Sartre, Jean-Paul, 'La Recherche de l'absolu', *Les Temps Modernes*, vol. III, no. 28, 1948, pp.1153–63. Translated as 'The Search for the Absolute' in *Alberto Giacometti: Exhibition of Sculpture, Paintings and Drawings*, exhibition catalogue, Pierre Matisse Gallery, New York, 1948, pp.2—22. Reprinted in *Sartre: Essays in Aesthetics*, trans. Wade Baskin, Peter Owen, London, 1964

Sartre, Jean-Paul, 'Les Peintures de Giacometti', *Derrière le Miroir*, no. 65, Paris, 1954. Reprinted in *Les Temps Modernes*, 103, Paris, 1954, pp.2221–32. Translated as 'The Paintings of Giacometti' in *Sartre: Essays in Aesthetics*, trans. Wade Baskin, Peter Owen, London, 1964

Sartre, Jean-Paul, 'Existentialism and Human Emotions', 1957, in *Basic Writings of Existentialism*, Gordon Marino (ed.), The Modern Library, New York, 2004

Scheidegger, Ernst, *Traces of a Friendship: Alberto Giacometti*, Scheidegger & Spiess, Zürich, 2001

Schneider, Angela, *Alberto Giacometti: Sculpture, Painting, Drawings*, Prestel, New York, 1994

Sylvester, David, *Looking at Giacometti*, Holt, New York, 1996

Wilson, Laurie, *Alberto Giacometti: Myth, Magic and the Man*, Yale University Press, New Haven and London, 2003

EXHIBITION CATALOGUES

Alberto Giacometti [including introduction by Peter Selz and autobiographical statement by the artist], Museum of Modern Art, New York, 1965

Alberto Giacometti: Sculpture Paintings Drawings 1913–65 [including David Sylvester, 'The Residue of a Vision'], Arts Council of Great Britain, London, 1965

Alberto Giacometti 1901–1966, Hirshhorn Museum and Sculpture Garden, Smithsonian Institution, Washington DC, 1988

Giacometti [including text by Ulf Kuster, Pierre-Emanuel Martin-Vivier, Véronique Wiesinger], Fondation Beyeler, Riehen/Basel, and Hatje Cantz, Ostfildern, 2009

Klemm, Christian (ed.), *Alberto Giacometti*, Museum of Modern Art, New York, 2001

Peppiatt, Michael, *Alberto Giacometti in Postwar Paris*, Yale University Press, New Haven and London, in association with the Sainsbury Centre for Visual Arts, Norwich, 2001

Stoos, Toni and Elliot, Patrick, *Alberto Giacometti 1901–1966*, Scottish National Portrait Gallery, Edinburgh, 1996

Trapping Appearance: Portraits by Francis Bacon and Alberto Giacometti from the Robert and Lisa Sainsbury Collection, Sainsbury Centre for Visual Arts, Norwich, 1996

Watkins, Nicholas, *Behind the Mirror: Aimé Maeght and His Artists – Bonnard, Matisse, Miró, Calder, Giacometti, Braque*, Royal Academy of Arts, London, 2008

Wiesinger, Véronique, *Isabel and Other Intimate Strangers: Portraits by Alberto Giacometti and Francis Bacon*, Gagosian Gallery, New York, 2008

Wiesinger, Véronique (ed.), *The Studio of Alberto Giacometti: Collection of the Fondation Alberto et Annette Giacometti*, Fondation Alberto et Annette Giacometti/Centre Pompidou, Paris, 2007

PICTURE CREDITS

PLATES

All original underlying works are © Alberto Giacometti Estate, ACS/DACS, 2015 unless otherwise stated. Dimensions given height x width x depth (mm).

1. *Portrait of Diego*, 1914
 Bronze, 260 x 140 x 110
 Collection P.C.C.

2. *Ottilia*, c.1920
 Oil on card, 421 x 270
 Collection Fondation Giacometti, Paris,
 inv.1994-0590-1 (AGD 240)

3. *Bruno Asleep in Bed*, 1920
 Oil on cardboard, 325 x 455
 Kunsthaus Zürich, Bequest Bruno Giacometti,
 2012

4. *Diego*, c.1920
 Oil on canvas, 364 x 283
 Kunsthaus Zürich, Bequest Bruno Giacometti,
 2012

5. *Portrait of a Young Woman (Mara Giacometti-Meuli)*, 1921
 Oil on canvas, 605 x 505
 Bündner Kunstmuseum Chur, Depositum aus
 Privatbesitz

6. *The Artist's Mother*, 1921
 Marble, 320 x 195 x 60
 Kunsthaus Zürich, Alberto Giacometti-Stiftung,
 Gift of Bruno and Odette Giacometti, 1988

7. *Annetta, by Giovanni Giacometti*, 1908–10
 Chalk on paper, 432 x 303
 Kunsthaus Zürich, Alberto Giacometti-Stiftung,
 Gift of Bruno and Odette Giacometti

8. *Small Self-portrait*, 1921
 Oil on canvas, 345 x 245
 Kunsthaus Zürich, Bequest Bruno Giacometti,
 2012

9. *Diego standing in the Living Room, Stampa*, 1922
 Oil on canvas, 636 x 502
 Collection Fondation Giacometti, Paris,
 inv.1994-0569 (AGD 230)

10. *Self-portrait*, c.1923–4
 Pencil on paper, 275 x 230
 Kunsthaus Zürich, Alberto Giacometti-Stiftung

11. *Head of Diego*, c.1924
 Bronze, 305 x 179 x 233
 Kunsthaus Zürich, Bequest Bruno Giacometti,
 2012

12. *Portrait of Diego*, 1925
 Oil on cardboard, 660 x 550
 Collection P.C.C.

13. *Bruno Reading*, c.1927–8
 Pencil on paper, 480 x 300
 Collection P.C.C.

14. *The Artist's Mother*, 1927
 Bronze, 325 x 233 x 122
 Kunsthaus Zürich, Bequest Bruno Giacometti,
 2012

15. *Head of the Artist's Father*, 1927
 Plaster, 275 x 230 x 205
 Collection P.C.C.

16. *Portrait of Giovanni Giacometti*, 1929–30
 Bronze, 279 x 200 x 232
 Kunsthaus Zürich, Bequest Bruno Giacometti,
 2012

17. *The Artist's Father (Flat and Engraved)*, 1927
 Bronze, 275 x 210 x 140
 Kunsthaus Zürich, Alberto Giacometti-Stiftung,
 Gift of the Artist

18. *Portrait of the Artist's Father*, c.1932
 Oil on canvas, 424 x 325
 Kunsthaus Zürich, Bequest Bruno Giacometti,
 2012

19. *Ottilia*, 1934
 Oil on canvas, 460 x 400
 Private Collection
 Photo: Claude Mercier

20. *Self-portrait*, 1935
 Pencil on paper, 297 x 240
 Robert and Lisa Sainsbury Collection, Sainsbury
 Centre for Visual Arts, University of East Anglia, UK
 Photo: James Austin

21. *Head of Isabel*, 1936
 Plaster, 303 x 235 x 219
 Collection Fondation Giacometti, Paris,
 inv.1994-0343 (AGD 400)

22. *Head of Isabel*, c.1938–9
 Plaster and pencil, 216 x 160 x 174
 Collection Fondation Giacometti, Paris,
 inv.1994-0344 (AGD 401)

23. *Rita*, c.1938
 Bronze, 220 x 133 x 165
 Kunsthaus Zürich, Vereinigung Zürcher
 Kunstfreunde, Gift of Bruno and Odette
 Giacometti, 1978

24. *Head of Rita*, 1938
 Bronze, 83 x 54 x 74
 Robert and Lisa Sainsbury Collection, Sainsbury
 Centre for Visual Arts, University of East Anglia, UK
 Photo: James Austin

25. *The Artist's Mother*, 1937
 Oil on canvas, 600 x 500
 Private Collection

26. *Portrait of the Artist's Mother*, 1947
 Oil on canvas, 670 x 435
 Private Collection
 Photo: Claude Mercier

27. *The Artist's Mother*, 1950
 Oil on canvas, 899 x 610
 The Museum of Modern Art, New York. Acquired
 through the Lillie P. Bliss Bequest, 1953
 © 2015. Digital image,The Museum of Modern
 Art, New York/Scala, Florence © Alberto
 Giacometti Estate, ACS/DACS, 2015

28. *The Artist's Mother in the Studio*, 1962
 Oil on canvas, 650 x 460
 Kunsthaus Zürich, Bequest Bruno Giacometti, 2012

29. *Woman of Venice VIII*, 1956
 Bronze, 1210 x 150 x 330
 Kunsthaus Zürich, Alberto Giacometti-Stiftung

30. *Annette Seated*, c.1951–2
 Oil on canvas, 588 x 388
 Collection Fondation Giacometti, Paris,
 inv.1994-0617 (AGD 728)

31. *Portrait of Annette*, 1954
 Oil on canvas, 650 x 544
 Staatsgalerie Stuttgart
 Photo: Staatsgalerie Stuttgart

32. *Bust of Annette*, 1954
 Oil on canvas, 290 x 220
 Private Collection

33. *Seated Woman, Annette*, c.1954
 Pencil, 486 x 317
 Robert and Lisa Sainsbury Collection, Sainsbury
 Centre for Visual Arts, University of East Anglia, UK
 Photo: James Austin

34. *Annette IV*, 1962 (cast 1965)
 Bronze, 578 x 236 x 218
 Tate, purchased with assistance from the Friends
 of the Tate Gallery, 1965
 © Tate, London 2015; © Alberto Giacometti
 Estate, ACS/DACS, 2015

35. *Annette VI*, 1962
 Bronze, 605 x 253 x 201
 Loaned by The Kasser Mochary Foundation,
 Montclair, New Jersey
 © Kasser Mochary Foundation, photo Tim Fuller;
 © Alberto Giacometti Estate, ACS/DACS, 2015

36. *Annette Without Arms (Annette IX)*, 1964
 Bronze, 450 x 190 x 155
 Robert and Lisa Sainsbury Collection, Sainsbury
 Centre for Visual Arts, University of East Anglia, UK
 Photo: James Austin

37. *Portrait of Annette*, 1964
 Oil on canvas, 700 x 500
 Kunsthaus Zürich, Alberto Giacometti-Stiftung,
 Gift of the Artist

38. *Portrait of the Artist's Brother Diego*, 1948
 Oil on canvas, 730 x 597
 Private Collection

39. *Diego Seated*, 1948
 Oil on canvas, 806 x 502
 Robert and Lisa Sainsbury Collection, Sainsbury
 Centre for Visual Arts, University of East Anglia, UK
 Photo: James Austin

40. *Portrait of the Artist's Brother*, 1948
 Pencil, 490 x 310
 Robert and Lisa Sainsbury Collection, Sainsbury
 Centre for Visual Arts, University of East Anglia, UK
 Photo: 1948 James Austin

41. *Diego*, 1950
 Oil on canvas, 800 x 584
 Robert and Lisa Sainsbury Collection, Sainsbury
 Centre for Visual Arts, University of East Anglia, UK
 Photo: James Austin

42. *Man Seated on the Divan while Reading the
 Newspaper*, 1952–3
 Oil on canvas, 920 x 710
 Kunstmuseum Winterthur, purchased in 1961
 Photo: © Reto Pedrini, Zürich

43. *Diego in a Sweater*, 1953
 Bronze, 490 x 280 x 225
 Kunsthaus Zürich, Alberto Giacometti-Stiftung

44. *Bust of Diego*, 1954
 Bronze, 267 x 205 x 110
 Private Collection

45. *Bust of Diego*, 1955
 Bronze, 565 x 320 x 145
 Tate, purchased with assistance from the Friends
 of the Tate Gallery 1965
 © Tate, London 2015; © Alberto Giacometti
 Estate, ACS/DACS, 2015

46. *Diego*, 1959
 Oil on canvas, 610 x 498
 Tate, purchased 1960
 © Tate, London 2015; © Alberto Giacometti
 Estate, ACS/DACS, 2015

47. *Louis Aragon*, 1946
 Pencil on paper, 525 x 370
 Private Collection c/o Lefevre Fine Art Ltd.

48. *Silvio Berthoud*, 1948
 Oil on canvas, 322 x 253
 Private Collection

49. *Self-portrait*, 1954
 Pencil on paper, 490 x 317
 Thomas Gibson

50. *Portrait of James Lord*, 1954
Pencil on paper, 493 × 317
Thomas Gibson

51. *Jean Genet*, 1954–5
Oil on canvas, 653 × 543
Tate, accepted by HM Government in lieu of tax
and allocated to the Tate Gallery 1987
© Tate, London 2015; © Alberto Giacometti
Estate, ACS/DACS, 2015

52. *Portrait of G. David Thompson*, 1957
Oil on canvas, 1000 × 930
Kunsthaus Zürich, Alberto Giacometti-Stiftung

53. *David Sainsbury*, 1959
Pencil on paper, 557 × 389
Lefevre Fine Art Ltd., London/Thomas Gibson
Fine Art Ltd.

54. *Portrait of James Lord*, 1964
Oil on canvas, 1170 × 815
Thomas Gibson Fine Art Ltd., courtesy of Guzon Ltd.

55. *Portrait of Nelda*, 1964
Oil on canvas, 545 × 460
Kunsthaus Zürich, Alberto Giacometti-Stiftung
Gift of the Artist, 1965

56. *Portrait of Caroline*, 1961
Oil on canvas, 1162 × 889
Private Collection

57. *Caroline*, 1961
Oil on canvas, 1000 × 820
Fondation Beyeler, Riehen/Basel, Beyeler
Collection
Photo: Robert Bayer, Basel

58. *Portrait of Caroline*, 1962
Oil on canvas, 920 × 730
Private Collection, New York

59. *Portrait of Caroline*, c.1964
Oil on canvas, 1302 × 889
Private Collection

60. *Caroline*, 1965
Oil on canvas, 1302 × 813
Tate, purchased with assistance from the Friends
of the Tate Gallery 1965

61. *Caroline*, 1965
Oil on canvas, 1295 × 806
Tate, purchased with assistance from the Friends
of the Tate Gallery 1965
© Tate, London 2015; © Alberto Giacometti
Estate, ACS/DACS, 2015

62. *Chiavenna Bust I*, 1964
Bronze, 410 × 197 × 152
Tate, purchased with assistance from the Friends
of the Tate Gallery 1965
© Tate, London 2015; © Alberto Giacometti
Estate, ACS/DACS, 2015

63. *Bust of Lotar I*, 1965
Bronze, 258 × 283 × 149
Kunsthaus Zürich, Alberto Giacometti-Stiftung,
Gift of Bruno and Odette Giacometti, 2012

64. *Bust of Lotar II*, 1964–5
Bronze, 582 × 375 × 259
Fonte Susse (1981), 2/8
Collection Fondation Giacometti, Paris,
inv.1994-0189 (AGD 1765)

65. *Diego Seated*, 1964–5
Bronze, 590 × 185 × 330
Louisiana Museum of Modern Art, Humlebaek,
Denmark. Donation: The New Carlsberg
Foundation, The Augustinus Foundation and
The Louisiana Foundation

FIGURES

The National Portrait Gallery would like to thank
the copyright holders for granting permission to
reproduce works illustrated in this book. Every effort
has been made to contact the holders of copyright

material, and if any omissions will be corrected in
future editions if the publisher is notified in writing.

Page 3: Giacometti on rue d'Alésia,
14th arrondissement, Paris, photographed by
Henri Cartier-Bresson, 1961
Henri Cartier-Bresson/Magnum Photos

Page 9: Giacometti drawing in his studio
photographed by Sabine Weiss, July 1954
Getty images © Getty Images
© Alberto Giacometti Estate, ACS/DACS, 2015

Fig. 1 Giacometti outside his studio on rue
Hippolyte-Maindron photographed by Emmy
Andriesse, 1948
© Joost Elffers/Universiteitsbibliotheek Leiden
(inv.nr. PK-F-A.06809)

Fig. 2 Isaku Yanaihara sitting for Giacometti
photographed by Mac Domag, 1960
© reserved
© Alberto Giacometti Estate, ACS/DACS, 2015

Fig. 3 The Giacometti family. From left: Alberto,
Diego (front, seated), Bruno (on his father's knee),
Giovanni, Ottilia and Annetta photographed by
Andrea Garbald, 1909
Bündner Kunstmuseum Chur, Depositum der
Fondazione Garbald (2010)
© Fondazione Garbald, Castasegna
© Alberto Giacometti Estate, ACS/DACS, 2015

Fig. 4 *Portrait of the Mother*, Alberto Giacometti, 1915
Pencil on paper, 305 × 220
Fondation Alberto et Annette Giacometti, inv.1994-2094
© Giacometti Estate (Fondation Giacometti, Paris
and ADAGP, Paris) 2015

Fig. 5 *Still Life with Apples*, Alberto Giacometti, c.1915
Oil on cardboard, 362 × 366
Collection Fondation Giacometti, Paris,
inv.1994-0617 (AGD 228)
© Alberto Giacometti Estate, ACS/DACS, 2015

Fig. 6 *Self-Portrait*, Alberto Giacometti, 1921
Oil on canvas, 825 × 700
Kunsthaus Zürich, Alberto Giacometti-Stiftung
© Alberto Giacometti Estate, ACS/DACS, 2015

Fig. 7 Clockwise from top left: *Crouching Nude*,
Alberto Giacometti, c.1922–3
Pencil on paper, 503 × 330
Kunsthaus Zürich, Alberto Giacometti-Stiftung
© Alberto Giacometti Estate, ACS/DACS, 2015

Standing Nude, Alberto Giacometti, c.1922–3
Pencil on paper, 436 × 277
Kunsthaus Zürich, Alberto Giacometti-Stiftung
© Alberto Giacometti Estate, ACS/DACS, 2015

Three Standing Nudes, Alberto Giacometti, c.1922–3
Pencil on paper, 438 × 280
Kunsthaus Zürich, Alberto Giacometti-Stiftung
© Alberto Giacometti Estate, ACS/DACS, 2015

Woman Sitting, Alberto Giacometti, c.1922–3
Pencil on paper, 445 × 278
Kunsthaus Zürich, Alberto Giacometti-Stiftung
© Alberto Giacometti Estate, ACS/DACS, 2015

Fig. 8 *Woman with Her Throat Cut*,
Alberto Giacometti, 1932
Bronze, 220 × 750 × 580
Kunsthaus Zürich, Alberto Giacometti-Stiftung,
Gift of the artist, 1965
© Alberto Giacometti Estate, ACS/DACS, 2015

Fig. 9 *Head of The Artist's Father*, 1927
Bronze, 280 × 215 × 230
Kunsthaus Zürich, Alberto Giacometti-Stiftung,
Gift of the artist, 1965
© Alberto Giacometti Estate, ACS/DACS, 2015

Fig. 10 *Head of Bruno*, Alberto Giacometti, 1929–30
Plaster, 310 × 185 × 245
Kunsthaus Zürich, Alberto Giacometti-Stiftung,
Gift of Bruno and Odette Giacometti, 2005
© Alberto Giacometti Estate, ACS/DACS, 2015

Fig. 11 Giacometti's studio photographed by an
unknown photographer, 1938
© reserved
© Alberto Giacometti Estate, ACS/DACS, 2015

Fig. 12 Giacometti's studio at 46 rue Hippolyte-
Maindron, photographed by Sabine Weiss, 1938
© Getty Images

Fig. 13 Giacometti working in his room at the Hôtel
de Rive in Geneva photographed by Eli Lotar, 1944
© reserved
© Alberto Giacometti Estate, ACS/DACS, 2015

Fig. 14 *Annette au Chariot*, Alberto Giacometti, 1950
Oil on canvas, 730 × 490
Private Collection, Switzerland, courtesy of Thomas
Gibson Fine Art Ltd.
© Alberto Giacometti Estate, ACS/DACS, 2015

Fig. 15 Plaster busts and figurines of Giacometti's
studio on rue Hippolyte-Maindron photographed by
Brassaï, October 1947
Paris, fonds Gilberte Brassaï
© Estate Brassaï – RMN-Grand Palais
Photo © RMN-Grand Palais/René-Gabriel Ojéda
© Alberto Giacometti Estate, ACS/DACS, 2015

Fig. 16 Alberto, Annette and Diego in the studio on
rue Hippolyte-Maindron photographed by Alexander
Liberman, c.1954
Alexander Liberman Collection of Photographs
The Getty Research Institute, Los Angeles (2000.R.19)
© J. Paul Getty Trust
© Alberto Giacometti Estate, ACS/DACS, 2015

Fig. 17 *Isaku Yanaihara*, Alberto Giacometti, 1958
Oil on canvas, 920 × 730
Private Collection
© Alberto Giacometti Estate, ACS/DACS, 2015

Fig. 18 Giacometti with Samuel Beckett in Paris
photographed by Georges Pierre, 1961
© Georges Pierre/Sygma/Corbis
© Alberto Giacometti Estate, ACS/DACS, 2015

Fig. 19 Giacometti working on a bust of his wife,
Annette, photographed by Christopher Dean, c.1962
© Christopher Dean/Photo: Loomis Dean
© Alberto Giacometti Estate, ACS/DACS, 2015

Fig. 20 A cabinet in Stampa, painted by Giovanni
Giacometti, photographed by Ernst Scheidegger, 1932
© 2015 Stiftung Ernst Scheidegger-Archiv, Zürich
© Alberto Giacometti Estate, ACS/DACS, 2015

Fig. 21 Stampa, Switzerland photographed by
Isaku Yanaihara, 1961
© Suki Yanaihara/Permission granted through Misuzu
Shobo, Ltd. Tokyo

Fig. 22 Students at the Evangelical Secondary School
at Schiers by an unknown photographer, 1917
Bündner Kunstmuseum Chur

Fig. 23 Alberto with his wife Annette photographed
by Andrea Garbald, 1949
Bündner Kunstmuseum Chur, Gift of Bruno and
Odette Giacometti, Zollikon (2010) © Bündner
Kunstmuseum Chur

Fig. 24 Giacometti in his studio photographed by
Sabine Weiss, 1950s
Photo by Sabine WEISS/Gamma-Rapho/Getty Images
© Alberto Giacometti Estate, ACS/DACS, 2015

Fig. 25 Alberto and his mother Annetta outside the
house in Stampa, 1960, photographed by Ernst
Scheidegger
© 2015 Stiftung Ernst Scheidegger-Archiv, Zürich

Fig. 26 Giacometti working in his studio in Maloja
photographed by Ernst Scheidegger, late 1950s
© 2015 Stiftung Ernst Scheidegger-Archiv, Zürich
© Alberto Giacometti Estate, ACS/DACS, 2015

Page 102: Giacometti at the stairway in the studio,
Paris, photographed by Denise Colomb, 1954
© Alberto Giacometti Estate, ACS/DACS, 2015
© RMN-Grand Palais – Gestion droit d'auteur
Localisation: Charenton-le-Pont, Médiathèque de
l'Architecture et du Patrimoine
Photo © Ministère de la Culture – Médiathèque du
Patrimoine, Dist. RMN-Grand Palais/Denise Colomb

INDEX

Note: page numbers in **bold** refer to captions; page numbers in *italics* refer to titles of exhibition works.

ACKNOWLEDGEMENTS

Encountering a painting or sculpture by Giacometti for the first time can be an unforgettable experience. My own epiphany took place as a visitor to the Tate Gallery in 1974. I cannot now remember what else I saw that day – there would have been many wonderful things to discover. But one work of art in particular stood out, and the memory of seeing it has never faded. That object was a portrait of Caroline, Giacometti's final model. The Tate has two of these extraordinary paintings. It is impossible now to be sure which one I saw, but I recall the sensation of deep shock. The figure appeared roughly sketched and for the most part hardly there. Even so, it seemed to me that the portrait had gone further than any other. The treatment of Caroline's head, and especially her eyes, had a raw intensity that I still find unique. Going beyond the facts of appearance, the painting conveyed a penetrating sense of the sitter's very existence.

I began thinking about *Giacometti: Pure Presence* in 2009. Perhaps unconsciously there was a desire to recover something of that initial, vivid encounter. The aim of creating an exhibition that would focus exclusively on Giacometti's portraits and on his main sitters began to take shape. In bringing this project to fruition I am indebted to numerous individuals. Sandy Nairne, former Director of the National Portrait Gallery, gave vital support at the outset. His successor, Nicholas Cullinan, continued that commitment and has been a steadfast ally. In the early days of the project, the generous support given to me by Christian Klemm in Zürich and Véronique Wiesinger in Paris was critically important.

Since then, several others have played a major role in securing loans and providing information. I am especially grateful to Christoph Becker, Philippe Büttner, Alexander Colliex, Pieter Coray, Alex Corcoran, Thomas Gibson, Catherine Grenier, Claire Hoffmann, Stéphanie Barbé-Sicouri, Simon Stock and Calvin Winner. To the many lenders I extend my profound thanks. I am indebted to the exhibition sponsor Bank of America Merrill Lynch, especially Simon Mackenzie Smith and Andrea Sullivan. In developing the exhibition design it was a great pleasure to collaborate again with Paul Williams, and with André Baugh.

Many colleagues at the National Portrait Gallery have contributed to this project significantly. In particular I would like to thank: Pim Baxter, Rosie Broadley, Nick Budden, Robert Carr-Archer, Naomi Conway, Tarnya Cooper, Joanna Down, Andrea Easey, Neil Evans, Clare Freestone, Ian Gardner, Michelle Greaves, Justine McLisky, Ruth Müller-Wirth, Andrew Roff, Nicola Saunders, Jude Simmons, Fiona Smith, Liz Smith, Christopher Tinker, Sarah Tinsley, Ulrike Wachsmann, Helen Whiteoak, Rosie Wilson and Lucy Wood.

Finally, my personal thanks go to Rosemary, Sarah, Anne and Sam.

Paul Moorhouse